MIRRORS OF MEMORY

A volume in the series

CORNELL STUDIES IN THE HISTORY OF PSYCHIATRY

Edited by Sander L. Gilman and George J. Makari

A list of titles in the series is available at
www.cornellpress.cornell.edu.

Mirrors *of* Memory

Freud, Photography, and
the History of Art

M ARY B ERGSTEIN

C ORNELL U NIVERSITY P RESS
Ithaca ℣ London

First published 2010 by Cornell University Press
Printed in the United States of America

Library of Congress Cataloging-in-Publication Data

Bergstein, Mary.
 Mirrors of memory : Freud, photography, and the history of art / Mary Bergstein.
 p. cm. — (Cornell studies in the history of psychiatry)
 Includes bibliographical references and index.
 ISBN 978-0-8014-4819-5 (cloth : alk. paper)
 1. Freud, Sigmund, 1856–1939. 2. Psychoanalysis and art. 3. Art and photography. 4. Photography—Psychological aspects. 5. Memory—Psychological aspects. I. Title. II. Series: Cornell studies in the history of psychiatry.

 BF109.F74B46 2010
 150.19'52092—dc22 2010001345

Cornell University Press strives to use environmentally responsible suppliers and materials to the fullest extent possible in the publishing of its books. Such materials include vegetable-based, low-VOC inks and acid-free papers that are recycled, totally chlorine-free, or partly composed of nonwood fibers. For further information, visit our website at www.cornellpress.cornell.edu.

Cloth printing 10 9 8 7 6 5 4 3 2 1

Contents

MIRRORS OF MEMORY

Introduction

Reading Freud's Visual Imagination

In 1994 a book titled *Reading Freud's Reading* was published to the claim that nothing is more revealing of a person's intellectual life than what he reads. For two months, specialists from history of medicine, literary studies, and classical scholarship had explored topics raised by Freud's reading habits and the contents of his library at the Freud Museum in London.[1] Their findings, collected and edited by Sander Gilman, provided a guided tour of Freud's intellectual tools and, by association, a key to the intellectual development of his contemporaries and followers.

In this book I seek to understand the nature of Freud's *visual* imagination and its role in the development of his thought. The visual culture that Freud shared with his contemporaries and followers was largely photographic and Freud spent hours poring over such photos in his private study. I believe that examining Freud's photographic resources in their cultural context can open fresh perspectives on

both the history of early twentieth-century Central Europe and on the birth of psychoanalysis.

In the chapters that follow, I provide a tour of these primarily photographic visual resources, employing an interdisciplinary approach, and seeking to understand the impact of such images on the visual imaginations (collective and singular) of a specific time and place. Working through Freud and his ideas, I endeavor to synthesize the history of visual culture with the historiography of art and the history of psychoanalysis. How did photography participate in the principles of archaeology, art history, medicine, and psychoanalysis in Freud's world? How were Jewish ethnography and other forms of Orientalism advanced in photographic culture? How did photographic representations shape the historiography of art in fin-de-siècle Vienna?

In "Lonely Aphrodites: On the Documentary Photography of Sculpture," I argued that the historiography of art is intimately bound up with the history of visual documentation.[2] In the chapters that follow, I explore the historiography of art by reviewing the visual resources in Freud's library with specific attention to documentary photography of various kinds. In doing so I discover how photography penetrated the cognitive style of Freud and his contemporaries, and explore some of the ways that documentary photography—of art and archaeology, but also of medicine, science, and ethnography—influenced the formation of Freudian psychoanalysis.

Freud rarely, if ever, articulated these influences. Most of his photographic thinking (and envisioning) was so thoroughly knitted into the culture as to be involuntary, or even unconscious. Though I do not attempt to psychoanalyze Freud, in the spirit of psychoanalysis I undertake to discover the ways in which the culture of photographs and photographic usage shaped the visual thinking of Freud and his contemporaries. This form of cultural history, like psychoanalysis itself, naturally involves a degree of speculation and interpretation.

This book discusses many different "photographs" and "photographies," with no single photographer-as-author emerging as primary. Rather, photography's mechanisms and processes help to analogize ways of thinking or seeing. Photographic images are configured as objects to be analyzed, but also as phantasm and as evocations of dream-spectatorship and memory. Photography also plays a role as a visual index of architectural and archaeological specimens and views, replicated many times over in publication. Photographs also function as collected objects in Freud's life and in his writings. These forms inevitably overlap and recombine, adding extra depth to the visual experience.

The book also addresses important questions. What were the photographic images Freud beheld and absorbed in his studies of archaeology and art? And in a broader sense, how did photographic images (and memories thereof) feed and shape the visual fields of art history and psychoanalysis? How were these ideas advanced in photography-to-text relationships found in Freud's visual archive?

The first chapter, "Memories and Dreams," introduces photography as a cultural system in the Europe of Freud's time. It explores the idea of photography as involuntary memory and the metaphorical role of photographs as phantasms and dreams. Freud's "Rome Dreams" (1900) and his *Disturbance of Memory on the Acropolis* (1936) introduce certain themes that resonate in the subsequent chapters.

Chapter 2, "Freud's Michelangelo," takes up Freud's involvement with the history of art, and his engagement with classical and Renaissance visual culture, particularly his 1914 essay on Michelangelo's *Moses*. Freud's reception of Vasari's *Lives of the Artists*, his Galician Jewish background, his practice of art history as cultural history, his personal identification with classical art, and the relationship of the medical gaze to art-historical observation are among the topics brought together and synthesized in an analytic critique of *The Moses of Michelangelo*.

Chapter 3, "Delusions and Dreams," emerges from a close reading of Freud's *Delusions and Dreams in Jensen's* Gradiva (1907) and a consideration of his greater archaeological metaphor for the psychoanalytic process. How did photographs provoke art-historical fantasies? And how did those fantasies expand the greater realm of the imaginary? Here I explore the dreamlike qualities of archaeological photography around 1900. Again, I ask, how is a photograph like a memory or a dream? And how are dreams shaped as photographs in human memory? The chapter investigates Freud's perception of the published and captioned photographs in his own extensive art-historical library, as well as the meanings, latent and manifest, of text and image in his books. The analysis of several photographic images, together with art-historical and psychoanalytic texts, aims at achieving an understanding of both the Freudian visual imagination and the general turn-of-the-century perception of the Greco-Roman past.

Chapter 4, "Uncanny Egypt and Roman Fever," initiates a double-pronged inquiry that begins with Freud's apprehension of Egypt (ancient and modern) through photographic material. I take up the ethnography of Egyptians and Jews, as well as Jewishness and anti-Semitism as species of Orientalism in Freud's imagination. The photographic culture mixes Pharaonic Egypt with ethnographic observation in an extraordinary suspension of time.

Jewish life in modern (pre-*Shoah*) Europe is a major theme that emerges from the life and work of Freud. Without having intended to, this inquiry returns time and again to the history of Jewish assimilation and to the variously expressed phenomena of anti-Semitism in Europe. In a net cast wide, I have found this material to be inextricable from the cultures of photography, art history, medical science, anthropology, psychoanalysis, and literature as practiced in the Austro-Hungarian Empire around the *fin-de-siècle*. We shall see, and perhaps it is no surprise, that

Orientalism and anti-Semitism merge in much of the visual (as well as written) culture of nineteenth and early twentieth-century Europe. The chapter goes on to examine Freud's personal case of "Roman fever." His view of Italy as an archaeological and ethnographic alternative to northern Europe—a place for dreaming, desiring, and emotional release—is examined in visual and photographic terms.

In the concluding chapter I conduct a brief anthropological query, suggesting that Freud was aware of, if not entirely immune to, certain superstitious convictions, or mythologies, about photography. The chapter explores the efficacy of photographic surrogates as charms or talismans in terms of Freud's emotional life, where photography and its uses bore in on emotions such as regret, jealousy, fear, pleasure, and desire.

At its most ambitious, this book amounts to a study of fields of visual knowledge and the workings of the visual imagination. It concerns photography as memory, and photographs as surrogates for the direct apprehension of people, places, and works of art. Nowhere will the reader find a hard and immutable code by which photography mimics the mental apparatus or vice versa. So flexible a simile can be applied to abstract as well as concrete examples. I hope to show that looking at Freud in relation to a photographic ambience can be richly suggestive for our understanding of both him and modern European culture.

The following institutions have facilitated my research: the New York Academy of Medicine; the Archaeological Academy of the University of Vienna; the Sigmund-Freud Museum Vienna; the Freud Museum London; the Archives and Special Collections of the R. C. Long Health Sciences Library of Columbia University; the Bildarchiv, Institute for the History of Medicine, Vienna; the Bibliothèque Nationale de France, Paris; Harvard University Libraries; the Avery Library at Columbia

University; New York Public Library; the Department of Photography, Albertina; the Austrian National Library in Vienna. All reasonable efforts have been made to ascertain the rights status for reproduced images.

Freud's writings are cited and quoted from *The Standard Edition of the Complete Psychological Works of Sigmund Freud,* 24 vols., ed. and trans. James Strachey in collaboration with Anna Freud, assisted by Alix Strachey and Alan Tyson (London: Hogarth Press, 1966–74). This edition is abbreviated as *SE* in the bibliography. Any other brief translations quoted in the text from French, German, or Italian are my own unless otherwise credited in the notes.

A grant from the American Association of University Women 2002–3 allowed me to undertake the research and writing of this book. The Fulbright/Sigmund-Freud Privatstiftung granted me residency as the Sigmund Freud Scholar of Psychoanalysis at the Sigmund-Freud Museum in Vienna in the spring of 2005. The Humanities Fund of the Liberal Arts Division, Rhode Island School of Design, has helped with the purchase of photographs from various institutions.

Among the many colleagues who have assisted and inspired me along the way are Rita Apsan, Paul Barolsky, Denise Bastien, Lanny Bell, Susan Bielstein, Linda Carter, Monika Faber, Lory Frankel, Florence Friedman, Marco Galli, Marc Gotlieb, Karl Holubar, Irene Jefferson, Maurizia Natali, Arlene Shaner, Brigitte Maurer, Michael Molnar, Christfried Tögel, Inge Scholz, and Barbara von Eckardt. I am indebted to the late Lydia Marinelli of the Sigmund-Freud Museum in Vienna; she was the very model of a young woman scholar, and I wish she could have lived to see this book in print.

Diane O'Donoghue, archaeologist and theorist of psychoanalysis, has been a most valuable friend and consultant since the beginning of this project. I am similarly indebted to Ron Golinger for his rare kindness and lucidity in our discussions. Vera Camden's eloquent critique of a previous draft was instrumental in

many revisions. Peter L. Rudnytsky has read more than one draft of the book: his erudition and tactful advice have helped me in innumerable ways. I am particularly grateful to photographers Rebecca Hinden and Richard Hurley for their help with illustrations. Sander L. Gilman, George J. Makari, and John G. Ackerman, of Cornell University Press, deserve great thanks, as do Karen Laun and Lou Robinson, also at Cornell, and copyeditor Irina Burns.

The concept of "Roman fever," comes from a story by Edith Wharton of 1937.[3] I am grateful to Louise Rice for having recommended it one summer in Rome. Last but not least Norberto Massi encouraged me in this project from the beginning, and this book is dedicated to my many luminous memories of him.

1 | Memories and Dreams

"When finally, on the afternoon after our arrival, I stood upon
the Acropolis and cast my eyes around upon the landscape,
a remarkable thought suddenly entered my mind: 'So all this
really *does* exist, just as we learnt at school!'"
—Freud, *A Disturbance of Memory on the Acropolis.*

Sigmund Freud (1856–1939) was an eloquent master of introspection, speculation, and interpretation. As the inventor of psychoanalysis, he cast a strong spell on the twentieth-century imagination. Analysis of human memory—a mysterious and ever-elusive phenomenon that invades all aspects of life—was one of Freud's overarching themes. It is significant, of course, that he believed repressed memories were unconscious, and that the most potent memories would emerge in psychoanalysis from deep inside, via dreams, and could not be arrived at by purely intellectual efforts.

Freud's idea that "we all dream predominantly in visual images," and that these images were transfigured through time but never really lost, is an important assumption for the visual culture of modernity.[1] In psychoanalytic terms, visual images—as a species of memories (individual, in series, or conflated)—would never simply disappear, even if they were consciously suppressed or unconsciously repressed. As Freud maintained, and later theorists have emphasized, the unconscious mind was a fertile storage place for representations of any kind.[2]

Because photographs were so frequently perceived as mirrors of memory around the turn of the twentieth century, they have a special relevance to the imaginative vision of Freud.[3] As light impressions, photographs seem to mimic—at least in a metaphoric sense—the mental phenomena of memories and dreams. Because the constructing language of photography was more or less "invisible" (compared to paintings for example) and photographs were considered powerful documents of factual truth, their expressive content could operate in the minds of beholders without conscious critique, like unconscious or pre-conscious material.

Let us begin by looking at how photography operates as an organizing metaphor of some Freudian principles, and how photographs take on the metaphorical guise of memories and daydreams in his works. An example drawn from Freud's first "Rome dream" illustrates these issues.

The Dream: *Roma—Veduta del Tevere*

Reproducible images, like memories and dreams, are eminently portable, mutable, and bound up with desire. Goethe stated in 1789 that all the dreams of his youth came to life when he finally went to Rome and saw in reality what he had seen for so long in the engravings in his childhood home: everything was just

as he imagined it, yet everything was different.[4] Freud (whether or not he was consciously following Goethe's observations) recognized the fluid transportation of images in his own dream vocabulary when in the first of the series of dream-memories based on a longing to visit Rome, he saw a view of the river Tiber and the Ponte Sant'Angelo from a train window. He recollects that image as follows,

> I dreamt once that I was looking out of a railway carriage window at the Tiber and the Ponte Sant'Angelo. The train began to move off and it occurred to me that I had not so much as set foot in the city. The view that I had seen in my dream was taken from a well-known engraving which I had caught sight of for a moment the day before in the sitting-room of one of my patients.[5]

Indeed, this particular view of the Tiber with the dome of Saint Peter's and Castel Sant'Angelo was a favorite subject for engravers and photographers. It was widely reproduced in Freud's day in engravings made from photos, printed photographs, and photogravures. Giacchino Altobelli's languidly atmospheric photographic view of the Ponte Sant'Angelo with fishermen in the foreground was made in 1868 and was reproduced in the hyper-clear medium of photogravure as well as albumen prints (figure 1).[6] The view was also a great favorite among postcards sent by Viennese tourists back to Vienna (figure 2). Among the photographers to have circulated variations of this image were James Anderson, Ignazio Cugnone, Altobelli, and Giacomo Brogi. Their photographs were published repeatedly in postcards and stereoscopic view cards, as well as books about history, art history, and travel.

As Freud stated, it was a "well-known" composition; and he had probably seen it reproduced in many photographs, not merely once "caught sight of for a moment" in a patient's home. Brogi's picture, for instance, which is limpid and "dreamy" in its effect, with the fishermen (retouched?) in silhouette, entered Freud's library

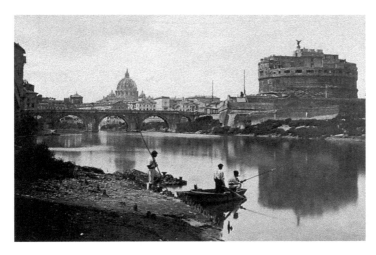

Figure 1. Giacchino Altobelli, *Roma, San Pietro e Castel Sant'Angelo,* Rome, 1860s. Author's collection.

in 1912 when Ernest Jones sent him Edward Hutton's *Rome* (figure 3).[7] But he had surely seen the picture many times before 1912 and even before he published his memory of the dream in 1900. The frequent replication and apparently seamless visual construction (carpentry) of photographic prints made their mental absorption faster and less conscious than that of a traditional work of art. According to twenty-first century theories of cognition, the repetitions of image-word relationships, as in postcards and publications, fortify the synapses in neural circuits, thus producing permanent connections in the mind's eye, connections that ultimately lead to deeper meaning and interpretation.

What is most interesting about the frequently replicated *Roma—Veduta del Tevere* is that this particular composition could never have been visible from a train window. Nevertheless it is reframed in that position within the condensed visual

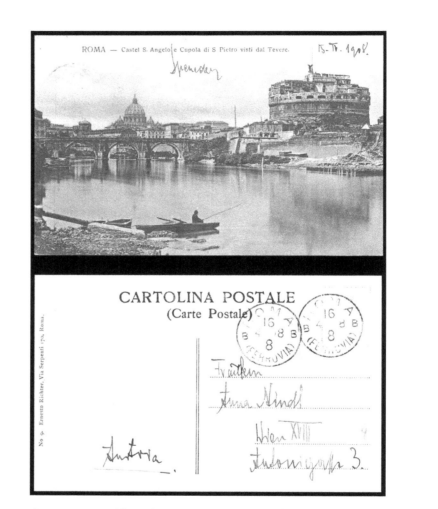

Figure 2. Postcard by Richter, ca. 1900 *Rome, View of the Tiber,* sent from Rome to Vienna in the first decade of the twentieth century. Author's collection.

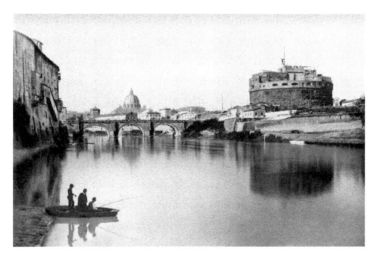

Figure 3. Giacomo Brogi, *Roma—Veduta del Tevere*. In Hutton 1909.
Author's collection.

composition of Freud's dream. The view Freud glimpsed in the format of his
dream was eminently photographic, framed and yet fleeting, a beautiful vision—a
synecdoche for the whole concept of *Roma*—that slipped away with the departure
of the train, leaving the dreamer both anxious and desiring.

In *The Senses of Modernism* Sara Danius addressed the impact of modern tech-
nology, such as train and automobile travel, on ways of seeing. The windows of
a railway carriage, for instance, could create a series of aesthetic views that the
desiring viewer simultaneously memorized and fantasized as they slipped by in
sequence.[8] Danius's observation is pertinent here, because in Freud's Rome-dream
the train window serves as a framing device containing an "ideal" view known to
him through postcards and other photographs, consciously or unconsciously re-
membered. Point of view and the framing (or photographic "cropping") of reality

determined everything about the image that was glimpsed by Freud from the rail-way window of his dream. This is just one example of the way in which his visual imagination (in memory and dream analysis) was modern and photographic.

Not only did Freud's personal dream feature a view of Rome from a moving train; he recommended the train-window simile to the analyst treating a patient with free association:

> After the patient has made himself comfortable on the couch, the physician sits down behind him. Please tell me what you know about yourself, he begins the first analysis session, say whatever goes through your mind. Act as though, for instance, you were a traveler sitting next to the window of a railway carriage and describing to someone inside the carriage the changing views which you see outside.[9]

Educated visitors to cultural sites were almost always primed a priori with illus-trations in a documentary mode. These scenes, be they picturesque or sublime in the eighteenth-century style, or modern in their conception, provided an archive of mental imprints, conscious and not, that were brought along to the site of encoun-ter. In a long letter to his family from Sorrento in 1902, for example, Freud quoted from Goethe's poem "Mignon," and then turned to the view from the frame of his window at the Hotel Cocumella: "This is very beautiful, but it is different from the way we imagine it. The mobility of seeing and the changing of point of view are not imaginable."[10]

It is different from the way we imagine it. Such is the condition of many first en-counters with a long desired situation or visual experience. Freud noticed that the landscape of southern Italy was different than he had imagined it because of the "mobility of seeing" and the constant shifting of points of view. His horizon of ex-pectation had been primed with static, self-contained photographic pictures, with

verbal poetic descriptions, fixed views that could not be maintained—even when looking through a framed window—in lived experience. The scene was "beautiful" but quite "different" from the way Freud had fantasized it in his visual imagination. In working with Freudian material, we see that photographs in various guises are analogous to diverse kinds of memories, fantasies, or dreams, and ways of envisioning what was expected. Now, before returning to the specifics of Freud and Vienna, let us look for a moment at the way photography functioned as a cultural system during his lifetime.

Photography as a Cultural System

Great numbers of photographs were made and consumed during the lifetime of Sigmund Freud, and to speak of a "golden" age of photography" may be redundant. In the period considered in this book (approximately 1860 to 1939), photography was everywhere. But photographs were still "invisible" to the extent that they seemed to communicate in a direct documentary style, without the intervening vagaries of representation. Authorship more or less vanished under the searching gaze of the beholder. Photographs (including portraits and street scenes) were apprehended, like dream images, as an exquisite visual residue, as traces "taken" from the continuum of lived experience. In a metaphoric sense, photographic images could be received as involuntary mirror images, or memories.

The nature of photographs as purveyors of incontrovertible visual truth, against which fantasy (interpretation) could be measured and checked, was broadly apparent in the West throughout the nineteenth and twentieth centuries.[11] In 1939, the year Freud died, Paul Valéry gave his famous "*Discours du Centenaire de la photographie*" at the Sorbonne. Valéry spoke of the authenticity of a photographic image as

visual evidence as opposed to mere human testimony (inscription versus description); and endorsed photography's claims to historical objectivity.[12] He spoke of the way that within the preceding hundred years the very idea of photography ("la seule notion de photographie") had entered into the fields of philosophy, history, and historiography.[13]

At the beginning of the twenty-first century, Jonathan Crary has cited theorists from the heart of the twentieth century such as Siegfried Kracauer and Roland Barthes, who have long discussed what Crary calls the "reality effect" of photography; that is, the idea that photography is an inextricable part of modern documentation, and therefore vital to the historiography of the nineteenth and twentieth centuries.[14] Here I recognize Paul Valéry and Jonathan Crary as being among the many writers who have set out to define in philosophical and technical terms how photography has informed modern vision. My study does not attempt to recapitulate the work of these theorists. Nor is this the place to retell the narrative history of photography. Rather I deal with specific instances of photographic documentation pertinent to the thinking of Freud and his psychoanalytic project.

Photographs, of course, are representations with their own visual conventions, and they did their cultural work in the society of fin-de-siècle Europe as vehicles of affective memory, as instruments of scientific "proof," and even as talismanic objects or fetishes. Most printed photographs resided in albums and books; these reproductions were meant to be inspected as evidence in a private setting, with verbal texts and captions accompanying the image on the page. Published photographic images together with their captions provided moments of cognition that were so unself-conscious as to be almost involuntary or even unconscious. Men and women pondered photographic images one person at a time, in libraries or homes, in a process as intimate and automatic as the act of reading or daydreaming.[15] Freud's personal library served as an enormous archive of photographic

images interwoven with captions and texts. Such photographic reveries belong to the "styles and episodes of beholding," to which I refer throughout.

On an institutional level photographs were received as documentation in fields such as criminal investigation, ethnography, psychology, the physical sciences, medicine, archaeology, and art history. Scientific and medical culture intersected with the study of archaeology and art in photographic images; cultural anthropology presented itself in documentary photographs and their texts; occult speculations and death had a special place in photographic practice; and photographic portraiture was part and parcel of the emotional life of poor people as well as the bourgeoisie.

Photographs as Involuntary Memory

Because photographs were so frequently associated with memory, they had a special relevance to Freud's imaginative vision. Because the constructing language of photography was more or less "invisible" and photographs were considered deadpan documents of factual truth, their expressive content could operate in the minds of beholders without conscious critique, like unconscious or preconscious material. Moreover, photographic images are themselves structured in such a way that the manifest informational content of documentation overlies deep latent meanings, as in the visual material of dreams.

Walter Benjamin's idea that we discover the "optical unconscious" through photography, just as the instinctual unconscious is uncovered through psychoanalysis, becomes pertinent as well.[16] Benjamin, writing in 1931, meant that what was registered within a fraction of a second, like the mechanics of a person taking a step, was not possible to analyze without the help of chronometric photographs that decomposed

the action, or halted the moment, like those by Eadweard Muybridge and Etienne-Jules Marey. Later in the twentieth century, Roland Barthes was fascinated with the seemingly involuntary nature of photographs in his *Camera Lucida,* and with the inadvertent inclusiveness that he referred to as the photographer's "second sight." The optical unconscious for Barthes included material that was unintentionally included in the perceptual margins.[17] Barthes demonstrated that there was always some visible and implied matter in a photograph that the camera operator did not consciously intend. (We now experience this on a daily basis, as the "zoom" enlargement feature in digital-imaging programs allows twenty-first-century beholders to see material in photographic images that had been invisible or dormant.)

Is unconscious material operative in every photograph? If we accept the premise that unconscious material resides in photographs whether it motivates the composition, seeps in unintentionally at the margins, is nested in the nearly invisible minutiae, or is revealed in chronometric views, then the answer is yes. It is important to add that conscious and unconscious intention is also present in the subjective selection, placement, and juxtapositions of photographs in private albums and published books.

In human perception, photography is comparable to images in memory and remembered dreams; and the recognition of such metaphorical affinities is vital to understanding photographs of architecture and art. Photographs compose an important diachronic stratum of the historiography of art.[18] They are used to fantasize the work of art as a primary referent object. In the world of archaeology and art history, photographs of fragments of ruined objects or human statues can serve as highly emotional reminders of the passage of time. In Freud's psychoanalysis, fragments, traces, or clues engage the imagination to release streams of emotion.

Freud's psychic location for memory is a place within the mind, but some of his ideas suggest that this mental picture also worked like a slideshow, with the

projection of images from outside enlarged on a psycho-spatial screen. One late summer evening in 1907 he experienced a lantern slideshow in Piazza Colonna (Rome) where a canvas screen was hung from a rooftop. The show consisted of a series of slides (diapositives) with brief intervals of cinema projected by the Italian Association of Advertising Photography (Società Italiana di Fotoreclami). Interspersed among the advertisements (*fotoreclami*) were fantastic subjects: landscapes, ethnographic scenes (from Congo for instance), and glacial ascents.[19] The series of projections was a kind of *omnia gatherum* of typical photographic topics, like the postcards, stereoscopic cards, and individual photographs that people purchased at kiosks and shops throughout Europe.

The act of looking at projected slides, stereoscopic viewers, or handheld photographic prints, either in series or individually, provoked a detachment like the Freudian phenomenon of spectatorship in a dream. This pleasurable detachment provided a space for the preconscious mind to play out its reveries before the spectator's eyes. The nighttime episode in Piazza Colonna with its sequence of dissimilar subjects can be perceived, like the public viewing of cinema, as a kind of a shared dream-state.

In a different mode, certain close photographic details, which are excerpted from the context of a larger view, such as the details of Michelangelo's *Moses* (see chapter 2), can stand in for Freudian screen memories. In their overly vivid magnification and brilliance, these details come to the foreground, filling, or even blinding, the mind's eye.[20]

In yet another vein, as a scientist in turn-of-the-century Vienna, Freud dwelt in the visual world of microscope slides, x-rays, and telescopic photography. In *Interpretation of Dreams,* he ventured to describe the psyche as a visual tool "resembling a compound microscope or a photographic apparatus."[21] Freud's theoretical work, which was so frequently visual in its language, was closely allied with the photographic

culture that prevailed across the nineteenth and twentieth centuries. The phenomenon of photographic details in art-historical investigation corresponded to the detective's view of the "clue" through a magnifying glass that revealed inadvertent evidence of a fact. Every involuntary clue was of interest to the archaeologist, the psychoanalyst, the criminal investigator, and the connoisseur of art. Carlo Ginzburg famously observed that a world of traces, symptoms, evidence, and clues was common to the Italian physician-connoisseur Giovanni Morelli, the fictional detective Sherlock Holmes, and the psychoanalyst Sigmund Freud.[22]

Preliminary reveries and surrogate images surpass the experience of the material thing, or primary referent object, in Freud's writings. The fantasy borne of photographic and other images merges with desire in a kind of transitional space, which then must be negotiated with an experience of real encounter and perception if the viewer meets the original object. This can be observed in an example that has to do with the direct apprehension of an architectural ruin after having fantasized the building in photographic terms. The actual architecture under observation seems almost a by-product of envisioned expectations, melting into an environment of quotidian distractions. This time, Freud is not recalling a dream, but rather the memory of an uncanny feeling.

A Disturbance of Memory on the Acropolis

A Disturbance of Memory on the Acropolis (1936) is one of Freud's most beautiful and evocative essays.[23] A work of Freud's old age, the essay analyzes a memory from his own adult past, and was composed as an open letter to Romain Rolland on the occasion of his seventieth birthday. Freud remembered the experience of "derealization" upon viewing the Acropolis of Athens for the first time a generation

earlier, in 1904. This uncanny feeling had come about from the sum of his prior expectations. Although Freud does not specify that his visual imagination had been primed by photographs, it is clear that he had viewed the Parthenon in books about classical archaeology and that these images, as well as verbal texts, helped to establish a highly emotional mood of expectation as well as a visual fantasy of the Parthenon rising on the Acropolis.

At eighty Freud remembered his incredulity on the Acropolis at forty-eight as an *après coup* or an "after effect," of what he had learned as a child. As in his quotation of remembered thoughts: "So all this really *does* exist, just as we learnt at school!"[24] In a negative counterpart of the phenomenon of déjà vu, the derealization was a kind of "making strange" of that which, upon recognition, should have been familiar and fully internalized—its sight a source of inspiring pleasure. Freud reasoned that what he must have been expecting from himself on this splendid excursion was "some expression of delight or admiration," rather than the disconcerting confusion that he felt in the presence of the actual ruins.[25]

Freud suspected that it might have been a memory of remembering his father that provoked him to write about this disturbing estrangement so many years later. There were several reasons that Freud's visit to Athens felt, as he wrote in English, "too good to be true." Perhaps Freud was torn between the proverbial poles of Athens and Jerusalem. As he approached the Acropolis for the first time he experienced an undertow of Jewish memory as he thought of his father.

Jakob Freud, a Galician Jew, who knew Yiddish and Hebrew as opposed to Latin and Greek, had probably never even aspired to sightseeing in Athens. Jakob belonged to the past, to the precarious and "mystical" life of the Jews in the eastern crownlands of the Austro-Hungarian empire. Sigmund Freud naturalized the Parthenon in terms of his gymnasium education in classical civilization. But the concrete transgression of his father's worldview may have haunted him as an

Figure 4. Artist and photographer unknown, *The Parthenon Reconstructed and in Ruins,* in Luckenbach 1905, pp. 34–35. Freud Museum, London.

Oedipal crime. The immense distance between past and present, from the thriving Acropolis of antiquity to the deserted ruin it had become, was a source of thrilling perplexity for any educated beholder—Romanticism at its finest! The distance between the past and present in Freud's own personal history seems to have at once paralleled and disturbed the traditional experience of visiting the Acropolis.

Whatever the most profound motive for Freud's disturbance of memory, it is interesting to note that a year after his visit to Athens Freud acquired Hermann Luckenbach's *Die Akropolis von Athen,* which featured an ideal restoration of the

temple (a photographically reproduced drawing) juxtaposed with a photograph of the ruins on facing pages (figure 4). In a tactic not uncommon in archaeology books at the time, both images conform to the ideal view of the Parthenon as approached from the Propylean Gate, as proof positive that the ruins corresponded to the stunning historical temple of antiquity. Thus past and present were reconciled in visual terms.

Time and Space

It is pertinent to theories of photography that in general terms Freud regarded the unconscious mind, the state of sleep, and preconscious thought as being somehow outside the continuum of physical time.[26] If psychoanalysis was a methodology for seeing into the past and collapsing time, so was photography. Just as the telescope was an instrument for seeing into spatial distance and bringing distant objects near, the camera was an instrument that could look into the forgotten past, isolate enlarged details, and bring them to the present. The view through a lens was not foreign to Freud's method of retrieving fragments from the unconscious mind.

Certainly a telescope is not a camera, but both instruments work with lenses and light, and Freud had also used the metaphor of a telescope, when in *The Interpretation of Dreams* he stated, "Everything that can become the object of our inner perception is *virtual,* like the image in the telescope made by the passage of light-rays."[27] Cameras and developed photographs have a complex relationship with time. The physical and metaphorical essence of photography has long been perceived as soft and transparent, a rapid, mechanically automatic medium that aspired to neutrality and objectivity—a visual system in which authorship vanishes. In the late nineteenth and early twentieth-century imagination the photographic process consisted of a relatively compressed survey of continuously concatenated

but separable moments, like the continuously fugitive views framed by train windows, as in the Rome-dream, or more radical examples residing in the chronometric photographs of Muybridge and Marey.

Roland Barthes coined the famous metaphor that cameras were essentially "clocks for seeing," and that photographs provide a "certain but fugitive testimony" to the passage of time.[28] James C. A. Kaufmann put it differently in his essay on photographs and history, contending that, "History is temporally evolved, the product of time, and the photograph deflates time."[29] In the unfolding of time, photographs are also ghostly, in that they are images made of light, and are, like fugitive memories, "all that remain" of the metamorphosed or the departed—memories.[30] Thierry de Duve has written about the paradox inherent in the nature of photographic time, in the constantly opposite ways a photographic image can be perceived. In Duve's terms the photograph is seen as either, "natural evidence and live witness (picture) of a vanished past," or as "an abrupt artifact (event)." As live evidence, Duve states, the photograph designates "the accomplished past" and the "suspension of time." If apprehended in its opposite state, as a "deadening artifact," the photographic image indicates that the captured event has slipped away into the oblivion of time passed.[31]

Revelations

Photography as a cultural system was associated with revelation as well as recollection and projection. When photographs were developed, images were made manifest and within those images truths were revealed. Freud knew something about the chemical and light-induced processes of photography, and he thought of photographs as having a quality of "latency." Like the traumatic impressions repressed in the unconscious mind, a photographic exposure can be developed after any interval

of time and transformed into a picture. The drama of experience, therefore, is held latent but accurate in a negative image that can be, as it were, developed at any time after the event. Freud described the relation of unconscious to conscious activity in terms of the photographic metaphor: that is, if the photographic negative is a latent (unconscious) image, it is only made manifest in the chemical process of development (psychoanalysis) by which it forms a positive picture.[32] Latency is a persistent theme in the language of photographic process. Indeed, Freud's great Viennese contemporary, the pioneering photo-chemist Josef-Maria Eder (1855–1944) referred to negatives as "latent" pictures" (*latenten Bilder*).[33]

Photographs of Art

How did Freud and his contemporaries fantasize works of art or monumental ruins like the Parthenon? How did the photographic reproductions internalized in his studies of art and archaeology shape Freud's particular style of visual thinking? And how did Freud's own theoretical concerns prime him for the reception of photographs of art? How did reveries with photographic surrogates overdetermine the actual encounter with the referent art object? Louis Rose has written that art historians and psychoanalysts both work with repositories of images; and whether it be the material of a photo archive or the private stock of an individual's dreams, visualization results from "dramatic fragments of the past coming into renewed contact with the present."[34] In archaeological photography the process of visualization from dramatic photographic fragments is deepened by the fact that the primary referent objects are usually themselves fragments or ruins that require reconstruction on the part of the viewer.

Veiled with the mantle of familiarity that came from their frequent replication in published materials, and supported by informational captions, photographic

"reproductions" functioned as transparent views of their primary referent objects. It has always been difficult, therefore, to recognize photographic reproductions as objects unto themselves, constructed interpretations of referent objects under discussion.[35] Paradoxically, the more photographs were looked *into* for archaeological or iconographic information, the more difficult it was to see them as constructed representations.[36] It was easy to internalize these images, so that the recipients' minds were presaturated with photographic expectations when confronted with the lived experience of the work of art itself. Twenty-first-century cognitive psychology confirms what art historians already know, grosso modo, from the empirical practice of their work: namely, that combined caption and image firm up the validity of their proper connection in the mind of the viewer/reader.

By the late nineteenth century photographs had come to constitute the primary visual study material in the discipline of art history. The art historian's work was to analyze photographs of painting, sculpture, and architecture from various historical periods—from antiquity to modernity. Handmade reproductions of paintings (translations of paintings to the print medium in variously expressive kinds of engravings, etchings, and lithographs) were probably more beautiful and spirited than photographic reproductions, especially with refined techniques of aquatint and the controlled wiping of printers ink on the intaglio plate. Prints were more elegant and essential—they explained more, but photographic reproductions were taken to be more dispassionate and revealing.[37]

Emanuel Löwy: Freud's Art Historian

Freud's aesthetics were steeped in the Romantic Classicism that was typical of his time, place, and social group. The two broad trends—Classicism and

Romanticism—formed his cultural preparation and cognitive style. Harry Trosman has long observed that Romanticism and Classicism provided much of Freud's impetus and formal structure for empirical observation.[38] Freud's idea that the origins of beauty were essentially sexual, and art a sublimation of libidinal desires, was no doubt linked to his cultivated reception of classical statuary. The photographs of ancient sculpture that were in his library expressed such views in an oneiric style. Much of modernist erotica is based on the principle that photography invests the act of looking at a human body with an empowering voyeuristic charge. The medium of photography redoubled the spectator's simultaneous sense of looking and detachment, and this is true of sculptured bodies as well as living ones.

Any study of Freud and ancient sculpture must acknowledge the role of Emanuel Löwy (1857–1938), a key figure in the cohort of friendships around Sigmund Freud. Born of immigrant parents in the Leopoldstadt section of Vienna, Löwy received a classical education side-by-side with Freud. Löwy would eventually travel to Rome, where he had an important academic career at the University of Rome "La Sapienza" as professor of art history and archaeology. He was the first archaeologist since Johann Joachim Winckelmann to address fundamental questions about the origins and development of Western art.[39] Löwy wrote the definitive textbook on Greek sculpture (*La Scultura Greca*) in Rome and it was published as *Die Griechische Plastik* in 1911. Freud owned twelve books by Löwy, nine of which he had received as gifts from the author. His private library also included signed copies of Löwy's articles from the 1909 and 1911 yearbooks of the Austrian Archaeological Institute.[40] Freud wrote to Wilhelm Fliess in 1897 of Löwy spending his fall vacation (from his professorship in Rome) in Vienna, where the two men would converse late into the night about art, archaeology, and the excavations that Löwy had witnessed at Pompeii.[41] Löwy and Freud remained close into their eighties: Löwy gave Freud a Dürer etching for his eightieth birthday, and

Freud wondered what gift he would present Löwy with when he turned eighty on 1 September 1937.[42]

In 1900, the same year Freud published *The Interpretation of Dreams* (written in 1899) Löwy's *Die Naturwiedergabe in der älteren griechischen Kunst* (*Naturalistic Representation in Ancient Greek Art*) appeared.[43] It has been speculated that Freud's theory of dreams, in which there is a process of *regression* in the dream-image to the most primitive and symbolic state of visual material, is a structural reversal of Löwy's phylogenic theory about the *progression* toward naturalism in Greek figurative sculpture from the seventh and sixth century BC (the Archaic period) to the work of the Hellenistic sculptor Lysippos (fourth century BC).[44] Freud was, of course, familiar with Löwy's writings on the transformation of types and with the attendant photographic illustrations selected by the author.[45]

Although hardly a household name today, Löwy was one of the premier "new" art historians of the first decade of the twentieth century. His texts were said to have replaced the "superfluous moral comment and aesthetic make-believe" of the nineteenth century with "strict scientific discussion" of forms and their apprehension in space, discussions that were proven by photographic evidence.[46] It is no coincidence that Löwy was the pupil of Otto Benndorf, who excavated Ephesus on the Turkish coast for the Austro-Hungarian Empire. Benndorf, whose excavation reports were routinely published in the *Neue Freie Presse* presented the new discipline of archaeology as both scientifically rigorous and visually accessible, recommending the use of photography in its service.[47] Löwy was also praised for his psychological and analytical insights into the production of art. John Fothergill, the translator of Löwy's work into English, asserted that, "It is this psychological criterion which is applied with remarkable power of analysis and synthesis to explain the artistic phenomena, and the reader will find that it illuminates the study not only of Greek art but the art of every nation and period."[48]

Forced to leave Italy when it entered World War I against the Austrian empire in 1915, Löwy returned to Vienna with a formidable personal library of photographs, which are now conserved at the Austrian National Institute of Classical Archaeology (Institut für Klassische Archäologie). The archive includes his photographs of ancient sculpture and their plaster casts as well as "Arcadian" scenes and characteristic Italian views. As a body of images, many of which were published, the collection is considered here (see chapters 3 and 4) as a key to Freud's own visual attitudes toward ancient art and Italian culture of the past and present.

Disguised Symbolism

Photographic images of works of art provided Freud with a wide range of visual material presented in condensed and dramatic language. Some of these visualizations played into the imagination that shaped his theoretical structures of psychology. In turn, as if to complete the cycle, psychoanalytic precepts made a deep impression on art-historical practice in modernity, as in the deciphering of "indirect," "disguised," or "saturated" symbols. In 1966 Ernst Gombrich declared correctly that Freud's influence on the practice and criticism of art was so pervasive that we were rarely aware of his actual reticence on such matters.[49] Gombrich's observation has proved true in the late twentieth century and the early twenty-first century.

The influence on the interpretation of art as derived from Freud's first psychoanalytic manifesto *The Interpretation of Dreams* (1900) and his dream studies that followed, including *Delusions and Dreams* (1907), is so plainly present as to be practically invisible to art historians. After the publication of the *Interpretation of Dreams,* dream interpretation seems to have become a paradigm for the interpretation of visual art, and just as Freud's work stated that dreams consisted of ideas

cloaked in images, concepts such as "disguised" and "saturated" symbolism became central to the iconographic work of art scholars.[50] Erwin Panofsky coined the term "disguised symbolism" in his famous *Early Netherlandish Painting*.[51] Panofsky spoke of "the principle of disguising symbols under the cloak of real things" in the newly naturalistic paintings that were produced north and south of the Alps during the fifteenth century. In the Melbourne *Madonna and Child* (ca. 1433), then attributed to Jan van Eyck, for example, Panofsky speaks of still-life features that are symbolic to the same extent that they are vividly naturalistic (figure 5). The sun illuminates three pieces of fruit on the windowsill and a carafe of clear glass at the (viewer's) left of the panel. The fresh, intact fruit can be read as the *gaudia Paradisi*—with reference to the Terrestrial Paradise—lost through the original sin, but regained through Mary, the "new Eve." And in a painterly tour de force the transparent carafe stood for Mary's intact virginity before and after the birth of Christ. Specifically, says Panofsky, "it brings to mind a stanza from a Nativity hymn demonstrably known to Jan van Eyck, because he quoted its beginning in another picture: 'As the sunbeam through the glass, Passeth but not breaketh, so the Virgin, as she was, Virgin still remained.'"[52] Symbolic meaning, therefore, is implicit throughout the visual field of a naturalistic picture.[53] Charged as such iconological observation was, art scholars would never again see a depicted object without the possibility of metaphorical cathexis. Just as Freud's influence can be perceived in art-historical writing of the twentieth century, art-historical strategies can be located in Freudian interpretation. Recognition, then, of the impact of the historiography of art (including art-historical photographs) on psychological theories, and a proposal that documentary photographs of art from the turn of the century be read under a Freudian lens, can also illuminate the psychological shaping of art-historical biases, and a corresponding stream of reciprocal effects between psychoanalytic theory and art-historical techniques of interpretation.

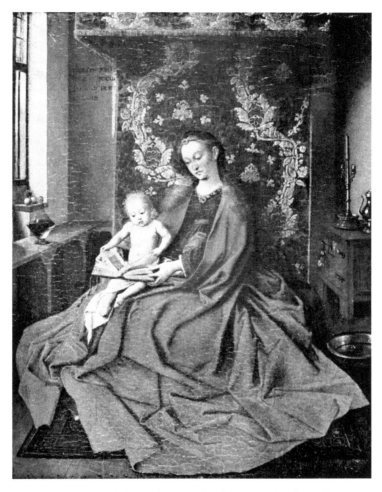

Figure 5. Jan van Eyck (?), *Madonna and Child*. National Gallery of
Australia, Melbourne, monochrome photo published in Panofsky 1953.

Visualization as a process and its mental materials are intrinsically related to the visual apparatuses of art history. In my view, the term "visual culture" includes the study of images that fill the imaginations of people from a particular time and place. Presumably the collective "visual imagination" (itself impossible to imagine as a finite entity) is like dream material insofar as it is fed by—but not absolutely contiguous with—human-made representations that are also operative in the culture. To the extent that the visual imagination can be subjected to historical inquiry, it may be likened to the culturally specific modes of reception and cognition. The term "cognitive style," as coined by Michael Baxandall, is used to refer to habits of viewing found within a specific culture.[54]

Photographic images of art and architecture, at the turn of the twentieth century, prepared the initiate-beholder for viewing the real object, and served as memory-prompters both before and after the fact of an actual encounter, which was therefore, like Freud's first view of the Parthenon, highly overdetermined. Freud was so primed by his study of reproductions, for example, that he visited the entire Gemäldegalerie in Dresden in just one hour in 1883, recognizing many of the works from photographs, and was able to describe four paintings in minute detail in a letter to his future wife, Martha Bernays.[55]

Freud was not atypical of cultivated Viennese scientists in his preparatory study of monuments and works of art. Jakob Erdheim, the professor of pathology who examined numerous cancerous specimens from Freud's mouth, for instance, took travel to Rome very seriously, studying art, architecture, and history in Vienna for a full two years before his departure. Once in Rome, he proceeded with the fervor of an archaeologist: "A German tourist spoke to me in the Forum," Erdheim stated, "and asked me where he was. Of course, I not only told him about the Forum, but even gave him the complete history of the very stone on which he stood."[56] Just as Freud required a strong glass of red wine to revive his strength after his first sight

of the *Laocoön,* Erdheim needed a week's stay at a sanatorium to rest up from his vacation in Rome.[57]

If first encounters with great works—like Freud's with the *Laocoön* in Rome— were invested with a kind of rare, numinous energy in their telling, the many hours spent pondering photographs were equally vital in the process of visualization. The thrill of déjà vu, after all, can provoke feelings as strong as those of its uncanny opposite, derealization. But as we have already seen Freud recognized that just as the face-to-face encounter with a work of art or architecture could be filled with inspiration, it could also be a shattering, disappointing, or disturbing experience, particularly when anticipated with a heavy backlog of desire and expectation, as at the Acropolis in Athens.

Photography, like archaeology, art history, and psychoanalysis, was a "new science"—and a science that was also an art. The process of deep scientific image-reading in dream analysis, connoisseurship, and iconology, was a modern activity that the psychoanalyst and the art historian shared.

2 | Freud's Michelangelo
The Sculptural Meditations of a Hellenized Jew

"How far he can assimilate what is best of Hellenic influence without prejudice to his individuality is clearly one of the chief problems that beset the modern Jew."

—Solomon J. Solomon, "Art and Judaism"

In his introduction to *The Moses of Michelangelo* Freud stated, "Works of art do exercise a powerful effect on me, especially those of literature and sculpture, less often of painting."[1] Sculpture, with all its ambivalence as a surrogate for the human body, and its uncanny potential for "coming to life," was at the heart of Freud's writings about visual art (figure 6). Freud's vision of sculpture was related in several ways to the photographic paradigms and practices of his day. But this did not take place in a void, for Freud's special interest in Michelangelo's sculpture was

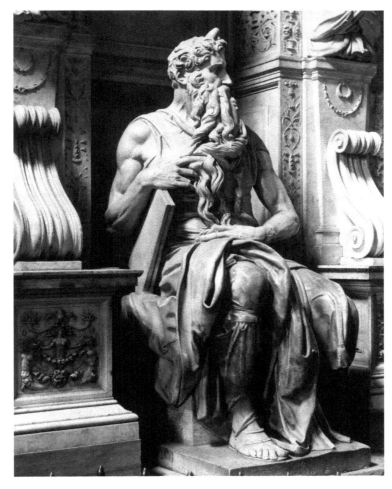

Figure 6. Fratelli Alinari, *Michelangelo's Moses in the Church of San Pietro in Vincoli, Rome*. Alinari no. 6205. Alinari/Art Resource.

deeply rooted in his own identity as a humanist, a scientist, and an assimilated Jew in turn-of-the-century Vienna.[2]

Figurative sculpture had a privileged place in Freud's intellectual formation that was perplexing in terms of his Jewish identity. Although Jewish law theoretically prohibited figurative art, and discouraged the ethos of classical heroic nudity, Freud told his fellow analyst Sandor Ferenczi—a purveyor of antiquities for Freud—that he felt, "strange secret longings—perhaps from the legacy of my forebears, for the Orient and the Mediterranean," and sought his own Jewish patrimony in the ancient Mediterranean world.[3] Indeed, in his so-called self-analysis, Freud traced his family's history from Vienna, Leipzig, Moravia, Galicia, Lithuania, and Cologne to Palestine and then Rome.[4] The theme endured and developed in Freud's thought, interwoven with Lamarckian assumptions about the evolution of the individual and his race: in a 1934 letter to Suzanne Cassirer Bernfeld he wrote, "none of us [Jews] has ever lost his longing for the Mediterranean."[5] And in *Moses and Monotheism* he proclaimed—probably in response to writers such as the Jewish industrial magnate Walther Rathenau, who called the *Ostjuden,* "an alien and isolated race...an Asiatic horde"—that, "Jews are not fundamentally different, for they are not Asiatics of a foreign race, as their enemies would maintain, but composed for the most part of remnants of the Mediterranean peoples and heirs of the Mediterranean civilization."[6] He went on to claim that the "archaic heritage" of the Jews was present in innate phylogenic "memory traces."[7] This quest for memory traces is, together with the entire archaeological metaphor, profoundly allied with the process of psychoanalysis. Freud apparently maintained the idea of seeing his ancestral heritage in sculptured artifacts, because the poet H.D. described his relation to his collection of antiquities as follows: "He is part and parcel of these treasures...He has his family, the tradition of an unbroken family, reaching back through this old heart of the Roman Empire, further into the Holy Land."[8]

Berggasse 19

Freud articulated the great archaeological metaphor for psychoanalysis to one of his most famous patients, Sergei Pankejeff, known as the "Wolf Man," explaining that the analyst had to excavate through successive strata of the patient's mind in order to arrive at the most deeply buried, valuable, and meaningful treasures. Pankejeff also observed that Freud fashioned his offices at Berggasse 19 to look like an archaeologist's study rather than a physician's ambulatory.[9] Freud showed the ancient sculptured objects on his desk to Ernst Lanzer, known as the "Rat Man," for instance, to demonstrate the unalterable nature of the unconscious.[10] The young Freud was inspired in this by his early mentor Jean-Martin Charcot, whose personal office he described in detail to his fiancée, Martha, in 1886, stating that Charcot had cases of Indian and Chinese antiquities, and that his study was, "in short—a museum."[11] H.D. later observed that, "Sigmund Freud is like a curator in a museum, surrounded by his priceless collection of Greek, Egyptian, and Chinese treasures."[12]

Freud was an ardent collector of antiquities, and most numerous in his rooms were small-scale sculptured anthropomorphic figures arranged in ranks on desks and bookshelves like idols or votive offerings on altars (figure 7). The objects themselves, which came from the ancient Near East, Greece, Rome, China, America, and New Guinea, were purchased from art dealers in Paris, Rome, or Vienna. Many of them had actually been used as idols, dolls, or votives in antiquity; some of his smaller objects were thought to have been charms used for personal protection in magical religious systems. H.D. reminisced of her analysis at Berggasse 19: "Around us are the old images or 'dolls' of predynastic Egypt, and Moses was perhaps not yet born when that little Ra or Nut or Ka figure on the Professor's desk was first hammered by a forger-priest of Ptah on the banks of the Nile."[13] Although

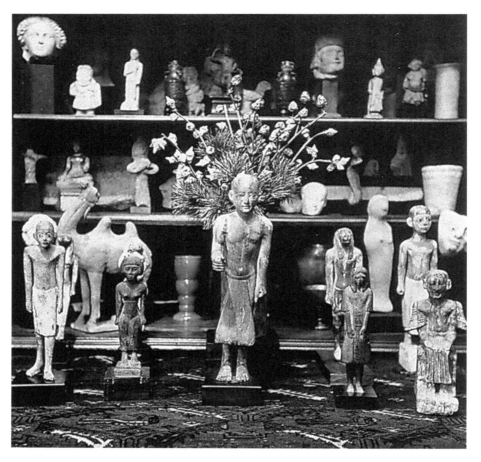

Figure 7. Edmund Engelman, *View of Freud's Study at Berggasse 19*, 1938 (detail). Thomas Engelman.

only a few of his statuettes could be properly classified as authentic *lars* (the little sculptured household deities of ancient Rome), the collection seemed to function for Freud as the charms of a very personal *lararium.* In other words, the function of most of the sculpture was precisely opposite the Mosaic teaching that abhorred the lure of graven images along with magic and sorcery.[14] They stood silently, like so many sphinxes, rich with the secrets of ancient history and the mysteries of the human mind. These meaningful figures, even charged as they were historically with a kind of interior efficacy, were not meant to be worshipped in this new context of the consulting rooms, but rather to be contemplated toward psychological revelations. As instruments of the imagination these works of sculpture constituted a working museum of the most therapeutic and provocative kind, for doctor and patients alike. Freud considered the collection a source of inspiration for his work and a personal solace in which the anthropomorphic statuettes spoke to him as old friends during difficult periods of his life.[15]

The environment of Berggasse 19—dense with antiquities, plaster-casts, paintings, engravings, and illustrated books—can be considered a kind of *Selbstdarstellung,* or total self-representation, a construct that was typical of Freud's time and place. Similarly dense interior spaces, the home as *Gesamtkunstwerk* as arranged by Viennese intellectuals (Carl Moll and Peter Altenberg for example) have been characterized by Tag Gronberg in terms of retreat from the mass political movements and growing anti-Semitism in turn-of-the-century Vienna.[16] How true this must have been for Freud, then, who, in the most difficult phase of his career, experienced the resurgence of anti-Semitism that prevailed in Vienna before and after the suicide of Crown Prince Rudolph.[17] Following his father's death in 1896 Freud saw the election of the fanatical anti-Semite Karl Lueger to Mayor of Vienna in 1897. Then came anti-Semitic student riots at the University of Vienna in 1897 and 1905 (less than thirty years later Freud's own writings would be burned at

universities in Germany). The year 1903 brought the publication of Otto Wein-
inger's misogynist and anti-Semitic (self-hating) treatise, *Geschlecht und Charakter
(Sex and Character),* followed by Weininger's suicide.[18]

Max Pollak's etching and aquatint portrait of Freud at his desk with a row of an-
cient statuettes before him, undeniably a work rich with the commingling strands
of Romanticism and Classicism, was made in 1914, the year *The Moses of Michel-
angelo* was first published in *Imago* (figure 8). The chiaroscuro style and the high-
lighted presence of sculpture in the portrait-sitter's interior space is eminently
comparable with the *Self-Portrait in the Studio* by Carl Moll, a painting made in
Vienna around 1906 (figure 9). Moll's painting also focuses on a work of sculp-
ture, but in this case it is a modern expressionist work—the anguished emaciated
torso of a nude boy, a cast of George Minne's 1897 *Kneeling Boy,* which was shown
at the eighth Vienna Secession exhibition in 1900.[19] In each case the sculptural
presence is to be read as a manifestation of the intellectual life and cognitive style
of the man portrayed.

In June 1897 Freud's brother Alexander, an avid amateur photographer, made a
picture of Freud standing among his travel photographs, which are pinned to the
wall behind him (figure 10). Among them are photos of the Riva dei Greci, Piazza
San Marco, and the Grand Canal (Venice); the Palace of Theodoric (Ravenna); the
two medieval towers of Bologna and details of sarcophagi from the Campo Santo
there; and a detail of the relief of frenetic *putti* from Donatello's *Cantoria* in Flor-
ence.[20] This informal portrait identifies Freud with his Italian travels and a hand-
ful of the monuments he had seen firsthand. It represents Freud's art-historical
interests and values. The same applies to a photograph (probably taken by a family
member around 1912) portraying Freud seated on his veranda with a reduced-scale
replica of Michelangelo's *Dying Slave* (Louvre) at his side (figure 11). Clearly this
photographic portrait is a product of self-representation, no matter how casually

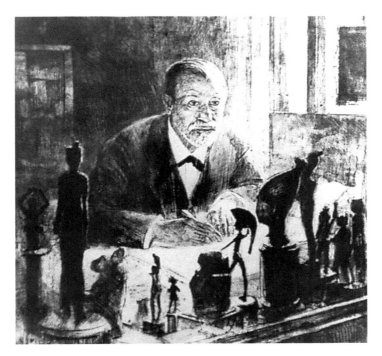

Figure 8. Max Pollak, *Portrait of Sigmund Freud,* etching and aquatint, 1914. Sigmund-Freud Privatstiftung, Vienna.

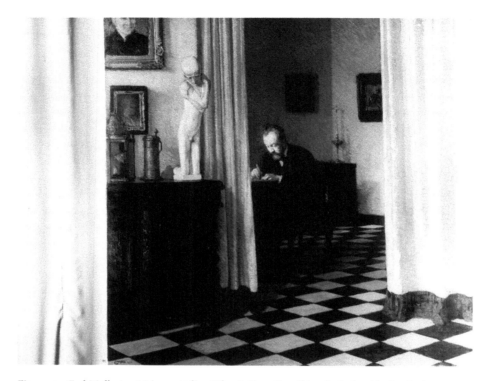

Figure 9. Carl Moll. *Aus Meinem Atelier.* Oil painting. Gemäldegalerie der Akademie der bildenden Künste Wien, Vienna.

posed or composed, and represents one of the several ways in which Freud used Michelangelo's sculpture in his search for historical self-definition.

His self-description as a "godless Jew" (a concept used to denote his acculturated, secular status) indicated the possibility of scientific and philosophical adventure, but the paradoxical words also referred to the modern insecurity and doubt of residing outside a historical tradition. Freud's historical fate was predicated upon discontinuity, from his family's arrival in Vienna to his escape to London after the Anschluss of 1938. It is not difficult to imagine, then, that the building up of a little

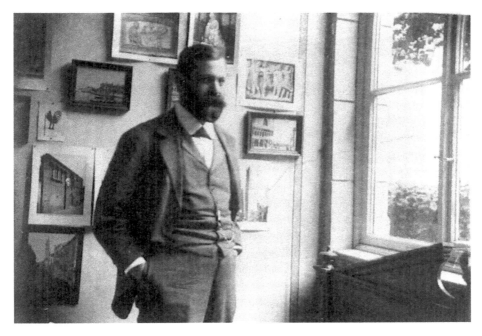

Figure 10. Unknown photographer (Alexander Freud?), *Am historischen Eckfenster, 17 June 1897, Vienna*. Freud Museum, London.

musée de l'homme in his work-space must have had an integrating effect on his life and work, setting his own insights within a physical realm of deep historical precedent. For Freud, who dealt on a daily basis with the soft, spectral, material of memories and dreams, sculpture seemed to belong to a superior order of historical monumentality and durability. Sculpture may well possess the advantage of fixity and durability, as another of Freud's favorite artists, Leonardo da Vinci, grudgingly admitted in the *Paragone* (comparison of painting to sculpture) in his sixteenth-century *Trattato della pittura* (*Treatise on Painting*).[21] But in Freud's writings on literature and art, sculpture was far from inanimate—it came to life in

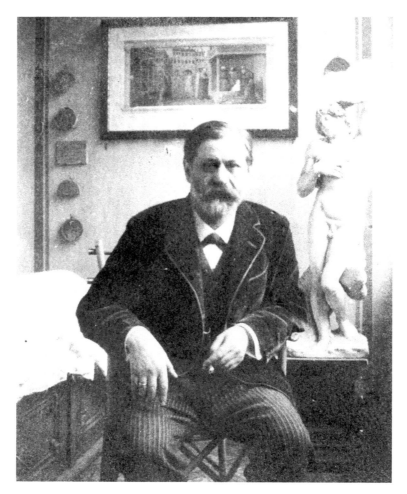

Figure 11. Unknown photographer (Alexander Freud?). *Portrait of Sigmund Freud*. Freud Museum, London.

memories and representations. In nineteenth-century photography marble and plaster figures, which pose without moving and hold the light so beautifully, were among the most popular actors.[22]

The Sculpture of Michelangelo

Freud's personal library contained many books illustrated with photographs of the idealized heroic nude in classical or Renaissance sculpture, including the sculpture of Michelangelo. Many works of sculpture by Michelangelo were present at Berggasse 19 in both two and three dimensions, that is, in plaster reproductions as well as photographs in books.

Returning to the photographic portrait of Freud with Michelangelo's *Slave* we may now probe into its meaning. In a letter to Wilhelm Fliess of 6 December 1896 Freud communicated several important new concepts, including the distinction between unconscious and preconscious thought. He added that, "I have now adorned my room with plaster casts of Florentine statues [the Dying Slave]. [Italy] was a source of extraordinary invigoration for me; I am thinking of getting rich, in order to repeat these trips. A congress on Italian soil! [Naples, Pompeii]."[23] The photographic portrait of Freud with Michelangelo's *Slave* openly defies the Jewish prohibition against the lure of carved images, athletic beauty, and the anthropomorphism of divinity. The Hebrew tradition was fundamentally opposed to the institution of Greek athletic nudity and glorification of the naked body, whether in life (gymnasia, military events, athletic games) or in art.[24] In Jubilees 3:31 the rabbis forbade the nudity and idolatry associated with Greek sport to the Jews: "They should cover their shame, and should not undress themselves as the Gentiles [Greeks] uncover themselves."[25] In Freud's day Jewish scholars, especially those

writing in the Protestant culture of England and North America reemphasized the principle that Hellenic and Jewish cultures were mutually antagonistic. Hellenic civilization created a highpoint of anthropomorphic, pagan art, the alluring forms of which inspired "sumptuousness and perfidy" as opposed to Jewish monotheism, where the pursuit of pure spirit was counter to the Greek multiplicity of gods and the frailties of their bodies and passions.[26] The distinguished scholar of Renaissance sculpture, Howard Hibbard, described the *Dying Slave* as Michelangelo's "most hedonistic and voluptuous homage to the male body."[27] Thus Freud's photographic self-alignment with a three-dimensional reproduction of the sculpture proclaims a kind of manifesto of Classicism, Romanticism, and psychological (if not visual) modernity that is at once defiant and self-defining. Within the casually parallel syntax of the two figures in the photograph (one living and the other plaster) Freud's own gaze is outward, penetrating, and full of agency, an expression that Francesco Saverio Trincia has particularized as "lo sguardo di Freud" ("the Freudian gaze"), an attitude of particular intensity and observative power.[28]

This vivid gaze is juxtaposed with the mental state of the somnolent, epicene statue, which is drawn inward, as though pulled irresistibly toward unconscious realms. The art-historical literature read by Freud at this time described Michelangelo's *Slave* as a nude athlete-hero suspended in a state in which, according to John Addington Symonds, "the sleeping mind of the immortal youth is musing upon solemn dreams."[29] Freud's main art-historical resource for Michelangelo studies prior to 1914 was Henry Thode's illustrated *Michelangelo: Kritische Untersuchungen über seine Werke* (*Michelangelo: A Critical Examination of His Oeuvre*), in which the most dramatic and poetical statements about Michelangelo's works by earlier art historians were reiterated, excerpted, and quoted. Authors such as Symonds, Grimm, Wölfflin, and Justi emphasized the fluidity between the waking state and dream state, and the fruitful conditions of sleep, death, and enchantment in this

statue.[30] The words of these art historians recall those of contemporary psychologists whose books were also in Freud's library. These psychologists included the Italian Sante de Sanctis, who discussed concepts of slippage between the waking and dream states in cases of intoxication and hysteria in *I Sogni* (*Dreams*); the American William A. Hammond of Bellevue Hospital in New York, who wrote about sleep, somnambulism, reverie, and hypnotism; and G. Stanley Hall, whose two-volume work on adolescence was published in 1904, four years before Henry Thode's *Michelangelo*.[31] Granville Stanley Hall (1844–1924), Freud's American advocate, was president of Clark University where he invited Freud to receive an honorary degree, and to give the famous *Five Lectures on Psychoanalysis* in 1909.

Hall's poetic ruminations upon the beneficial education of the beautiful, athletic *epheboi* (males between the ages of eighteen and thirty) by the ancient Greeks, and the developmental processes of sleeping and dreaming in adolescence, are in perfect accord with Thode's classicizing, spiritual style of art history.[32] Hall might just as well have been talking about Michelangelo's nude youth, when in his textbook on adolescent psychology, he wrote:

> [The] presentiments and previsions of love, which often first arise spontaneously and naturally in sleep, seem to illustrate the old trope that the stars of other and larger systems come out best when the sun of our own personal consciousness has set. Indeed in the reverie and daydreaming common at this stage [adolescence], when the soul transcends its individual limitations and expiates over the whole field of humanity, past, present, or future it is perhaps quite as near the world as our habitual, but generally unremembered dreams, as it is to the waking world of memory. In the new horizon now opening to the mind, unconscious cerebration generally has a larger role and for a time it is more uncontrolled by the consciousness, over into which it shades by imperceptible gradations.[33]

To the extent that the accessibility of the unconscious mind to acute observation by an outside analyst was the crucial basis for psychoanalysis, Michelangelo's *Slave,* dressed in the guise of heroic nudity, ennobles much of the enigmatic or arcane material of Freudian thought. A venerable Renaissance source, like this important sculpture by Michelangelo (originally destined for the Tomb of Pope Julius II), which Freud had first encountered in the Louvre when he moved to Paris in 1885, lent a retrospective seal of approval to Freud's most innovative work. Indeed, for the beholder of this photographic image, Michelangelo's famous sonnet, "Caro m' è'l sonno" ("Sleep is dear to me") can take on a new, Freudian, meaning.

> "Caro m' è 'l sonno, e più l'esser di sasso
> Mentre che'l danno e la vergogna dura:
> Non veder, non sentir, m'è gran ventura;
> Però non mi destar, deh, Parla basso."

> "Sleep is dear to me, and being of stone is
> dearer, as long as injury and shame endure;
> not to see or hear is a great boon to me;
> therefore, do not wake me—pray, speak softly."[34]

Masolino and Masaccio

Visible behind Freud in the photo-portrait with the *Slave* are framed reproductions of Masolino's Florentine frescos in the Brancacci Chapel, which were relevant to Freud in his role as a healer. Ernest Jones was in Florence in November 1912 and promised Freud he would obtain photographs of works of art. "I saw this morning [in the Brancacci Chapel of Santa Maria del Carmine, painted by Masolino and

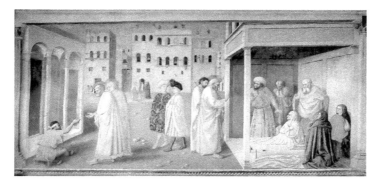

Figure 12. Masolino and Masaccio, *Saint Peter Healing the Cripple and the Raising of Tabitha,* Florence, Brancacci Chapel, Santa Maria del Carmine. Photo by author.

Masaccio] a picture where cripples were healed even by touching the *shadow* of Saint Peter as he walked by. I suppose you wished to avoid Christian topics in your articles, but if you would like photographs of any particular idea depicted in religious art, I could surely find them for you."[35] Jones believed that Masaccio's *Saint Peter Healing with His Shadow* reference to the magic power of touch, the "laying on of hands," would interest Freud. From Freud's point of view, it is important to remember that Saint Peter was an apostle of Christ with miraculous healing powers, but he was also the first pope, the bearded chief patriarch of the Church of Rome, Pontifex Maximus.

Jones evidently did bring Freud photographic reproductions of the Brancacci Chapel murals, one of which Freud had matted and framed, and installed on his veranda. Here in the scene painted by Masolino (figure 12), are two episodes in continuous narrative: *Saint Peter Healing the Cripple* and *The Raising of Tabitha* as narrated in the Acts of the Apostles (3:1–10, 9:36–41). The photos show Saint Peter healing a beggar who had been crippled from birth, and then dispelling the death of Tabitha. Acts has it that when Saint Peter healed the crippled beggar, people were

astounded, utterly stupefied at the transformation. The story of Tabitha is more dramatic yet. Peter is called to the couch where Tabitha's washed and anointed body had been laid out. Insisting on being alone with the woman, he tells her to rise. "He gave her his hand and helped her to her feet. The next thing he did was to call in those who were believers and the widows to shown them that she was still alive" (Acts 9:36–91).

In Masolino's painting Tabitha sits up facing the commanding Peter with crossed arms, the typical Renaissance gesture of gratitude and humility as three bearded men express profound surprise. Here Saint Peter is nothing less than a miraculous physician whose actions were rewarded with immense astonishment and gratitude in religious history. Surely it is no coincidence that Freud harbored similar ambitions for himself in the world of secular medicine. The poet H.D. elaborated on Freud's virtues as almost miraculous when she stated, "He did not pretend to bring back the dead, who had already crossed the threshold. But he raised from dead hearts and stricken minds and maladjusted bodies a host of living children."[36]

Freud and Italy: Michelangelo's *Moses*

Michelangelo's *Moses* has had a long life in art-historical study: carved about 1515 for the tomb of Pope Julius II, it had been visible in situ—and in various forms of representation—for about four hundred years before Freud's essay "Der Moses des Michelangelo" (1914) was published anonymously in *Imago*. Insofar as the cognitive stance of the beholder determines the meanings of visual images, Sigmund Freud's version of Michelangelo's statue can be examined in terms of his personal biography, contemporary social history, and art-historical methods.

Although the essay was (ostensibly) not intended as a vehicle for psychoanalytic concerns, it, like all writings about art, has both latent and manifest content. Psychoanalysis, together with a variety of postmodernist precepts, has already shown us that subjectivity has forever interfered with objectivity. Given these circumstances, the "primary object" under investigation here is not the life or sculpture of Michelangelo, nor is it Vasari's biographical text, nor Freud's life, nor the Biblical figure of Moses.

Summarily stated, Freud interpreted Michelangelo's *Moses* as the culmination of an unfolding of states of mind. The earlier mental states can be gleaned retrospectively from the sculpture's final composition, which in its condition of monumental stasis concludes an emotional narrative. After having descended from Sinai, Moses was distracted by cries of his people dancing around the golden calf. In a common nineteenth-century reading of the work, Michelangelo shows the prophet responding to the disturbing scene, turning his head to see it and pressing on his foot to rise in anger and smash the stone tablets. Scholars including Jacob Burckhardt, Heinrich Wölfflin, and Henry Thode had recognized that Michelangelo's figure expressed the potential energy to spring up and shatter the tablets as related in Exodus 32.[37] In the words of Fritz Knapp "The storm is about to begin" ("Der Sturm hebt an").[38]

Freud took Thode (1908) and the German-language literature as a point of departure for his own interpretation, which, in its identification of a particular episode, inflected the meaning of the work.[39] Freud postulated a determinate narrative moment outside the Pentateuch, presumably ideated by Michelangelo. He contended that while rising and letting the tablets slip, Michelangelo's *Moses* gained control of his rage; thus, the right hand was retracted in the beard, pulling it along in the wake of his gesture, and clamping down on the slipping tablets along with the beard, with the tension of his inner right arm. Freud believed that Michelangelo's

sculpture was and always will be a figure in the act of restraining himself from rising in the anger of his own passion.

Subsequent art-historical study has framed the issue of interpretation quite differently. Bernard Berenson, working in Italy in the 1930s, considered all the German *Sturm und Drang* about Michelangelo to be a product of an overanxious Teutonic striving to problematize him: "The Germans surrendered themselves, with all their confused energies, with all their metaphysical passion, to the 'problem' of Michelangelo. They are attracted by the titanic, the violent, the almost monstrous elements they can find in him."[40]

Modern consensus, as originally defined by Erwin Panofsky, Howard Hibbard, and Charles de Tolnay, is that the meaning of Michelangelo's *Moses* is "symbolic—evocative of inner spiritual life, charged with potential thought and action."[41] This view is historically consonant with that of Ascanio Condivi (Michelangelo's personally chosen sixteenth-century biographer) who described *Moses* as "seated in an attitude of thought and wisdom," "full of life and thought, and capable of inspiring love and terror."[42]

In sixteenth-century terms *Moses* is primarily a tomb statue—synthetic, symbolic, and monumental—and not a figure caught in any particular moment of historical narrative. In the words of Erwin Panofsky, who fervently denied the "still popular" (1939) idea of the Moses in a narrative moment: "Michelangelo's *Moses* sees nothing [certainly not the Hebrews dancing around an idol] but what the Neoplatonists called 'the splendour of the light divine.'"[43] Michelangelo's iconographic intention is as legible as it is polyvalent, arising as it does from a flexible syncretism of Hebraic, Christian, and Neoplatonic ideas. He absorbed Neoplatonism, which infused his mature work, in his youth in the circles of Lorenzo de' Medici. Further, Platonic transcendence was already expressed by way of dynamic torsion in the prophets, sibyls, and *ignudi* of the Sistine Chapel ceiling and in the *Slaves* for

the Julius Tomb, climaxing about 1530 in the elegant *psychomachia* of the *Victory* (Florence, Palazzo della Signoria), which was also intended for the Julius Tomb.[44] The *locus classicus* for all these works was the Greco-Roman *Laocoön,* installed by July 1506 in the Vatican Belvedere, Michelangelo having been present at its excavation the previous January (figure 13).[45]

Freud's early twentieth-century "explanation" of a sixteenth-century work of art is in some ways more flavorful for what is not overtly stated than for what is. To cast Freud's interpretation in terms of the social historiography of art, we may assume that he was in no way innocent of the prevailing mentalities of his time, place, social class, and ethnicity, all of which he applied to his study of the historical past. Thus this chapter concentrates not on Michelangelo's *Moses* as a Renaissance sculpture, but on Freud's early-twentieth-century interpretation of the statue, placing his methodologies under the lens of the historiography of art, and considering the representational and written apparatus of that discipline, which were admixed with abiding and Jewish and Oedipal concerns. It then becomes apparent that Freud's cognitive style was catalyzed by the psychological direction of his gaze.

Freud and Vasari

Freud's interest in the *Moses* may have been sparked by Giorgio Vasari's *Life of Michelangelo* (1568), which he read for the first time in the late 1890s.[46] Vasari particularly praised the *Moses* for the virtuoso handling of marble, stressing the bravura technique of the long, flowing beard. He added the famous remark that in his own day the Jews of Rome flocked like starlings to worship the statue on the Jewish Sabbath, and what they adored in the sculpture of God's favorite was a thing not human, but truly divine. In the German edition of the *Lives* (1849), which

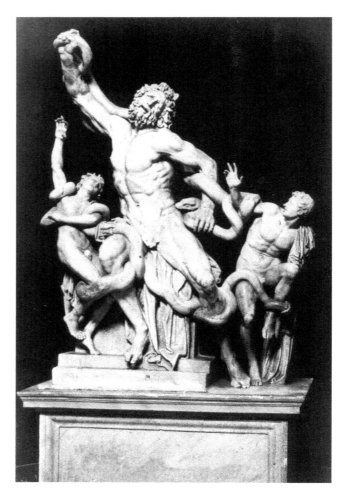

Figure 13. Robert Macpherson. *Macpherson's Vatican Sculptures,*
1 March 1868 (Rome), no. 56, *Laocoön.* The Trustees of the
National Library of Scotland, Edinburgh.

was the first version read by Freud, Ernst Förster added in a note that the anecdote about the Jews was probably not true, citing eighteenth-century art authorities Giovanni Bottari and Abbot Cancellieri, who claimed that no Jew in Rome ever visited the churches.[47] Vasari's claim and Förster's rebuttal must have been particularly meaningful to Freud, who later, at the time he was writing about the *Moses*, underlined the reference to Vasari's Jewish anecdote in his personal guidebook to Rome.[48] In 1912 he wrote to Ernest Jones, then on his way from Florence to Rome: "Bring my deepest devotion to Moses and write me about him."[49]

Throughout his life, Freud (together with many of his Viennese contemporaries) longed for a reconciliation of his own Jewish identity with Western culture through the vehicles of science and the humanities. Social history need not be pathologized in the individual, but Vasari's biography of Michelangelo clearly intersected with Freud's ambivalence as reflected in his autobiographical observations. His father, Jakob Freud (figure 14), was an itinerant merchant who told his ten-year-old son that he had remained passive when an anti-Semite ordered him off the sidewalk and knocked his fur hat into the mud.[50] In a letter to A. A. Roback of 20 February 1930, about Roback's book *Jewish Influence in Modern Thought* Freud wrote: "It may interest you to know that my father did indeed come from a Hassidic background. He was forty-one when I was born and had been estranged from his native environment for almost twenty years."[51] Biographers have long assumed that a persistent awareness of his beloved parents' status as *Ostjuden* made Sigmund Freud feel simultaneously guilty (of parricide) and defensive (of his Jewish origins).[52]

We recall that Freud remembered that he had experienced guilt feelings toward his father when he first visited the Athenian Acropolis, an achievement that would have been impossible—and meaningless—for a person in his father's circumstances.[53] His first impression of the Acropolis, as he wrote in a postcard to his wife was that it was, "indescribably beautiful," transcending anything he could

Figure 14. Photographer unknown, Vienna. *Portrait of Jakob and Sigmund Freud.* Freud Museum, London.

have imagined.[54] This was travel of the most significant kind, bringing to life a monument he had known only from books. Yet below the heartening thrill of experiencing the Parthenon in Athens ran a dark current of Oedipal misgiving. Freud's travels to Rome must have been similarly freighted.

Freud journeyed to Italy whenever he could, and Rome had a special meaning in his psychological makeup as a place that was at once intellectually sacred and erotically charged. Freud's "Rome Dreams" probably date from December 1896 to January 1897, around the same time that he first read Vasari's *Lives of the Artists,* and have been interpreted by the dreamer and his critics to represent Freud's fear of papal Rome (the father) and his contradictory desire for the ancient and eternal Urbs (the mother).[55] As in the *Veduta del Tevere* that slipped away as the train passed, Rome could be imagined but not possessed. He spoke of a desire for Rome and Pompeii throughout his correspondence with Wilhelm Fliess, stating in December 1897, "my longing for Rome is, by the way, deeply neurotic."[56] The equation of Rome with sexual love as well as intellectual fecundity was deeply embedded in culture, and the centuries-old play on the words ROMA and AMOR was well known to him from Goethe's *Römische Elegien* (1795), among other sources.[57] Ernest Jones sent Freud Edward Hutton's book titled *Rome* (1909), rhapsodizing on those pages that "in her name is married domination and love ROMA-AMOR," and that "men have always longed for her as an insatiable mistress."[58] As a Hellenized Jew, these fears (papal Rome) and wishes (ROMA = AMOR) fed into his own theory of the Oedipus complex, and to a great extent fueled his analysis of Michelangelo's *Moses.*

The Florentine psychiatrist Graziella Magherini, who formulated the concept of the "Stendhal syndrome," has proposed that part of Freud's pleasure in his Mediterranean travels arose from the idea of fleeing the oppressive atmosphere of family.[59] Paradoxically, Freud also sought his ancient Jewish roots in Rome. Because

there were no Jewish representations of the Prophets, Michelangelo's *Moses* personified the quintessential patriarch for Freud, especially by way of Vasari: it was the best image of the most powerful Jewish father. He underscored Thode's citation of the French sculptor Eugène Guillaume to the effect that the physiognomy of Michelangelo's *Moses* modeled the imprint of the entire Jewish race.[60] In terms of ethnographic authenticity, the hyper-serious, bearded sculpture of Moses was in some ways a "real" Jew, like the *Ostjuden* who had settled in the Leopoldstadt section of Vienna, where Freud lived as a youth. But Michelangelo's bearded patriarch was not a victim like Jakob Freud. Moses was an ancient hero, who defended a Hebrew worker mistreated by an Egyptian, and who was able to reverse the tragedy of his own people worshiping the golden calf. And Michelangelo had represented this Jewish father as a muscular, classicizing figure, as strong and beautiful as the pagan river gods and the *Laocoön* in Rome.

Freud's *Moses* and the Photography of Art

Freud's observations of the *Moses* were predicated on the practice of photography in art-historical study. Carlo Ginzburg—in a famous essay first published in English in the Marxist journal *History Workshop*—showed how when it came to visual analysis, Freud was inspired by the photographic, clue-seeking methodology of the Italian art historian Giovanni Morelli (d. 1891).[61] Freud had purchased Morelli's *Della pittura italiana: Studii storico-critici* in Milan in September 1898.[62] Deliberately following Morelli's precepts, Freud attended to what he called the "un-noticed features from the rubbish heap of our observations," seeking details in the *Moses* that had "not even been properly described [by art historians]."[63] Morelli had been an avid consumer of photographs, and his mode of connoisseurship located a

painter's "signature style" in the inadvertent rendition of details, such as earlobes, nostrils, or fingernails.

Photographs of works of art produced by firms such as Alinari, Braun, and Anderson enhanced this system of close observation. Morelli could sit at his desk in Verona comparing a nose from a portrait in Frankfurt with the nose of Botticelli's *Venus* at the Galleria degli Uffizi. Not that Morelli or Freud lacked the "eye" for objects in the flesh, for they were keen observers; but documentary photography, with all its cultural expectations of objective accuracy, was to validate the study of art history in the humanistic and scientific realm thenceforth. Photographs of works of art served as movable *topoi,* which, arranged in sets and subsets, could tell narrative stories about the history of representation. This was the "new art history" of the early twentieth century: Adolfo Venturi, Morelli's great compatriot, for instance, employed photographic illustration on a grand scale in his multi-volume *Storia dell'arte italiana* (1901–40). Venturi voiced the consensus of major art scholars around the turn of the twentieth century, when he claimed that the study of art had consisted of "an overwhelming burden of arid erudition" prior to the use of evidentiary photographs.[64] The circle of associations tightens when we realize that Venturi was a colleague of Emanuel Löwy—Freud's close friend—at the University of Rome "La Sapienza."

Throughout the course of his research on the *Moses,* Freud used a quantity of photographs as well as the photographically illustrated books from his library. Among the least recherché of artifacts in Freud's crowded study at Berggasse 19 were the individual photographs used in his investigations of works of art. In keeping with the habits of art-history libraries of the time, Freud bought quantities of photographs of art including a series of Luca Signorelli's mural paintings from the Cathedral of Orvieto, paintings and drawings from the Gemäldegalerie of the Academy of Fine Arts in Vienna, various monuments of classical art and architecture

such as the *Temple of Castor and Pollux at Agrigento,* and some Italian genre scenes (figure 15). Freud's living and working space was itself the object of a photographic documentation commissioned by August Aichhorn and photographed by Edmund Engelman in 1938.[65] One of them shows a photograph of Leonardo's *Madonna and Child with Saint Anne* (Louvre) together with a large-scale photograph of Michelangelo's *Moses* presumably kept as emblems of his studies earlier in the century.[66]

Ernest Jones tells us that Freud had studied a plaster cast and various photographs before and between his trips to Rome to encounter the original statue of Moses.[67] Freud spoke of studying the large plaster copy at the museum of the Viennese Academy of Fine Arts in October and November of 1912 (figure 16).[68] Jones sent Freud two photographs from Rome, and at Freud's request special ordered some photographic views of the lower edge of the tablets.[69] Upon finding that the actual statue squared with the photos, Freud pointed out an error in the Vienna plaster copy, noting that in the original the lower of the two tablets had a slight bump on the part nearest the viewer and that, "the tables touch the stone seat precisely with this protuberance."[70] A footnote in *The Moses of Michelangelo* to the effect that this passage was reproduced incorrectly in a plaster cast in Vienna indicates that he had checked the cast against a photograph for accuracy. It was an appropriate test, because by this time in the historiography of art photographs had surpassed three-dimensional casts in terms of credibility as the most reliable way to reproduce sculpture. Published photographs had become the mainstay of the discipline of art history, and scholars were exposed to innumerable photographic representations of works of art whether or not they specially sought them out.

Unlike Morelli, who used photographic details to determine authorship or date, Freud used them to identify a specific narrative moment. In the 1914 *The Moses of Michelangelo* essay Freud wrote about Michelangelo's *Moses* with Morellian

Figure 15. Photographer unknown (Kurt Hielscher?), *Agrigento—Temple of Castor and Pollux*. Freud Museum, London.

Figure 16. Josef Löwy, *Plaster Cast of Moses and the "Dying Slave" at the Vienna Academy of Fine Arts,* photograph ca. 1870. Kupferstichkabinett der Akademie der bildenden Künste, Vienna.

morphological exactitude, as if working from photos and enlarged photographic details. The details that concerned him most were the exact placement of the tablets of the law and the way the statue's right index finger pressed into the abundant beard:

> At the place where the right index finger is pressed in, a kind of whorl of hairs is formed, strands of hair coming from the left lie over strands coming from the right, both caught in by that despotic finger. It is only beyond this place that the masses of hair, deflected from their course, flow freely once more, and now they fall vertically until they are gathered up in Moses' left hand as it lies open on his lap.[71]

In descriptions such as this one, presumably made from a photographic detail studied at close range (figure 17), Freud broke through what he considered the paralyzing spell cast by the total impression of the statue itself, by the various experiences of its three-dimensional presence in situ, toward what was at once a more intimate and more "detached" visual observation. Such evidence was like the knowledge that could be garnered in medical science from searching X-rays or microscopic slides for diagnostic clues. Visual examination was a discipline Freud learned early in his medical training, beginning with his zoological studies in Trieste, whence he wrote to Eduard Silberstein (5 April 1876) that he sat at the microscope eight hours a day studying the organs of eels and making drawings from the microscope slides.[72] Apropos close visual examination, it is important to remember that works of art and architecture are typically studied not just from the primary referent object, but rather from various interpretations (plaster casts, photographs, engravings, drawings) aspects of which are encoded in the memory in a complex manner.[73] In the human visual imagination the prototype may be less potent than an amalgam of more or less vivid representations.

The assumption that Freud wrote this particular descriptive paragraph directly from a photograph may be an educated speculation, but it is significant that he wrote *as though* he were looking at isolated details in photography, following the art-historical practice of the day. On a more psychological level, the photographic methodology may have also served to keep Freud at a "neutral" or scientific distance from his disturbing personal feelings about the statue and all that it meant to him in a Roman environment. By using the "new" art-historical method, Freud found a way to look at the *Moses* without really seeing it. Even though documentary photography made certain aspects of the statue ultra-clear, the photographic close-up may have simultaneously served as a kind of a screen for the overwhelming,

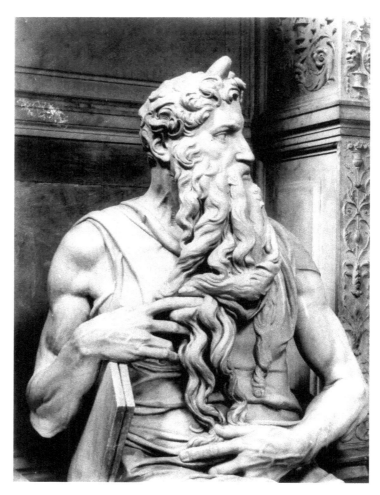

Figure 17. Anderson, *Detail of Michelangelo's Moses*, Alinari/Art Resources.

even paralyzing, experience of the work of art in its physical context. Here Freud's own optical unconscious may have come into play.

Photographic details of works of art can be likened to screen memories insofar as they are mnemic images of overly vivid clarity, brightness, and aesthetic pleasure, veering toward abstraction, which are taken out of the context of the whole, and fill the visual field of the page—or of the mind's eye.[74] In Freud's case, the brilliant photographic memory of the trajectories of the statue's beard may have functioned to elide from consciousness some material about the total effect of the *Moses,* as well as ambivalence about the cultural context of the beard.

Freud's actual visits to the *Moses* statue were fraught with a special kind of angst. Two nights before Freud saw the statue for the first time (1901) he was overtaken by a kind of emotional "Roman fever" that nineteenth-century tourists often fell prey to—not malaria, but a kind of night fever of passionate and chilling delirium following the fatiguing heat of the day.[75] He wrote to his wife that that night there was a heavy storm, so terrible and overwhelming that "it could have been created by Michelangelo." The flashes of lightning were so intense that certain Egyptian hieroglyphs on the obelisk outside his window from the third floor of the Hotel Milano (in Piazza di Montecitorio) were thrown into startlingly "legible" relief. The preceding day had been filled with the *scirocco*—the hot wind from Africa—becoming more and more oppressive until the terrible release of the storm.[76] It is pertinent to remember that Freud's reactions to his experiences in Rome were culturally as well as empirically determined. Before ever visiting Rome, he had read the Florentine physician Jacopo Finzi's comments on the unhappy effects of the *scirocco:* feelings of fatigue, idleness, and melancholy, factors that supposedly heightened a Romantic receptivity to nature and art, but clouded the intelligence.[77]

This particular episode of Roman fever served as a prelude for the *terribilità,* or *Sturm,* that Freud expected to discover in *Moses.* In a postcard to his wife dated

6 September 1901, Freud stated that after having visited the Pantheon that afternoon, he suddenly, through a misunderstanding ("plötzlich durch Missverständnis") found himself at San Pietro in Vincoli standing before the *Moses,* his language suggesting that his first viewing of the statue on site was somehow disturbing, surprising, or out of his control.[78]

He later described this feeling in as the "state of intellectual bewilderment [that] is a necessary condition when a work of art is to achieve its greatest effects."[79] This sense of consternation is what Magherini calls the "Stendhal syndrome," the sensation of malaise, illness, abandonment, or confusion experienced by a tourist when he suddenly finds himself in an atmosphere saturated with memories and history, an atmosphere that at once compounds and alienates his own fantasies or disappoints or overwhelms visual expectations.[80]

In September 1912, when the essay was germinating in Freud's mind, he visited the *Moses* on a daily basis. In a letter to his family of 25 September 1912, Freud described his inspired Roman solitude—his traveling companion Sandor Ferenczi was in Naples—as an exquisite, somewhat melancholy loneliness under the enchantment of which he explored the ruins of the Palatine, the park of the Villa Borghese, and the *Moses.*[81] He vividly narrates solitary pilgrimages to San Pietro in Vincoli, describing the viewing of the object in situ in a dark church as evoking a response of uncertainty, anxiety. Or, as he also described it, a state of paralysis, in which he felt transformed to stone.

> How often have I mounted the steep steps from the unlovely Corso Cavour to the lonely *piazza* where the deserted church stands, and have essayed to support the angry scorn of the hero's glance! Sometimes I have crept cautiously out of the half-gloom of the interior as though I myself belonged to the mob upon whom his eye is turned—the mob which can hold no fast conviction, which has neither faith nor patience, and which rejoices when it has regained its illusory idols.[82]

Freud *was* in Rome to rejoice in the presence of illusory idols, those three-dimensional works that he knew so well from photographic reproductions. He was in Rome to look at pagan and Christian sculpture, thus defying the Jewish stricture against graven images, and paradoxically engendering the anger of the patriarch's gaze.[83] Such heightened emotions, visual uncertainties, physical numbness, and shocking disorientation could be screened out by the scientific use of photographs at Berggasse 19. Rather than exploring his own fears in the lived experience of the Julius Tomb, from the lonely piazza to the "half-gloom of the interior," Freud, like many fashionable art historians of his day, chose to lose himself in formalism. Thus, he contemplated, in the service of his iconographic argument, a close view of the almost abstract meandering beauty of the statue's beard.

Photographic Portraits of Moses

Styles of beholding in Freud's day focused on the character content of individual figures. Nineteenth-century portrait photographers, for whom the camera was primarily a kind of "insight machine," reinforced this tradition of visual character study, which continued into the twentieth century, as in the portraits of Freud by his son-in-law Max Halberstadt.[84] Halberstadt was an "artistic" photographer who made scenic views as well as technical photos and portraits (figure 18).[85] His earliest portrait of Freud was first published as an illustration to the article "Der Schöpfer der Neuen Seelenkunde (Professor Sigmund Freud)" by Theodor Reik in 1914.[86] The photograph was clearly made and then selected for publication, as a character study of a remarkable person, the creator of a new psychology. Some of Halberstadt's portraits of Freud have become what popular culture calls "iconic" and instantly recognizable (figure 19).

Figure 18. Photographer unknown, *Portrait of Max Halberstadt in His Frankfurt Apartment ca. 1902*. Private collection. Courtesy of Eva Spangenthal and Peter Rosenthal.

Freud considered *The Moses of Michelangelo* a kind of character study of a historical personage (Moses, not Michelangelo). And it was accompanied by a waist-length view of the *Moses* in portrait format in *Imago* (figure 20), which was taken from the Michelangelo publication in Karl Robert Langewiesche's "Die Blauen Bücher" series.[87] This followed a predominant convention as seen in the *Moses* frontispiece of the Philippson Bible, from which Freud was educated as a child and which he later received as a gift from his father. Freud read from the Philippson Bible again as a young adult under the tutelage of his professor of religion,

Figure 19. Max Halberstadt, *Portrait of Sigmund Freud,* 1932. Freud
Museum, London.

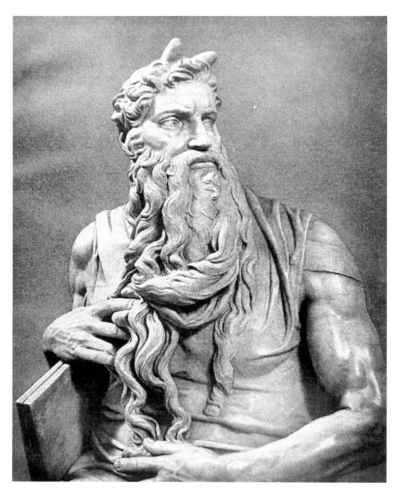

Figure 20. Photographs from "Der Moses des Michelangelo" in *Imago* 1914. Author's collection.

Samuel Hammerschlag.[88] The steel engraving of Philippe de Champaigne's *Moses Presenting the Tablets* was produced by August Weger in Leipzig and published by Philippson as the frontispiece (figure 21). Champaigne (1602–74) was a French Baroque painter trained by Poussin who produced several variations of the work that is represented in the Weger engraving. Moses rests the tablets (configured as a folio codex) on a foreground balustrade with his right hand holding the rod with which he struck natural rock to produce water.[89] Moses is dressed in fictional Renaissance garb, with a white *camicia* emerging from the voluminous sleeve on his right arm. Were it not for the first six characters of the Hebrew alphabet on the tablets, this *Moses* could be taken as a sixteenth- or seventeenth-century portrait (Poussin comes to mind) of an aristocrat or a humanist scholar. The waist-length figure turned slightly in space, gazing intensely out beyond the limits of the frame was common in European portraiture of the sixteenth through nineteenth centuries, and was continued by portrait photographers at the turn of the century. In a similar way, it was not unusual in art-historical practice to crop and publish photographic representations of religious statues as dramatic portraits. Ernst Steinmann's 1899 *Rom in der Renaissance,* given to Freud as a gift by the author, presented Michelangelo's *Moses* as a waist-length portrait, in a cropped detail of a much replicated Anderson photograph—a photograph that was also present in the archives of Steinmann's friend Bernard Berenson at Villa I Tatti in Florence (see figure 17 above).[90]

Freud's belief in the capacity of portraiture to reveal great truths was embedded in the mentality of his time and place, and sometimes photographs of art served as ideal vehicles for the private contemplation of what German-speaking viewers considered the most *geistig* (spiritually uplifting) qualities of a work of art, namely the interior character of an individual portrayed. In 1966, E. H. Gombrich wrote about a lady of Freud's generation who kept a large monochromatic photograph of Titian's *Tribute*

Figure 21. Philippe de Champaigne, *Moses*. Engraved by August Weger, Frontispiece, *The Philippson Bible* (1858). Photo by author.

Money from the Dresden Gemäldegalerie in her parlor (figure 22).[91] In a letter to his fiancée from Dresden in 1883 Freud had extolled this very head of Christ as if it were a searching portrait of a modern man, open to physiognomic interpretation.

> The picture that really captivated me was the "Maundy Money" by Titian, which of course I knew already [through photographs] but to which I had never paid any special attention. This head of Christ, my darling, is the only one that enables even people like our selves to imagine that such a person did exist. Indeed, I felt I was compelled to believe of the eminence of this man because the figure is so convincingly presented. And nothing divine about it, just a noble human countenance, far from beautiful yet full of seriousness, intensity, profound thought, and deep inner passion; if all these qualities do not exist in this picture, then there is no such thing as physiognomy.[92]

Here Freud is describing the character of Christ rather than the painterly depth of Titian. Gombrich's acquaintance, who was steeped in the same cognitive tradition as Freud, under the full impact of Goethe's legacy, explained to Gombrich that she preferred the black and white photograph to the original painting in Dresden, where the color would have distracted her mind from the spiritual content of the image.[93] A Renaissance painting, then, by one of the greatest colorists of all time, functioned in the golden age of portrait photography as a black and white portrait photograph of Christ. Chiaroscuro photographic portraits of Michelangelo's sculptured *Moses* were equally, if not more, effective. Just as Freud wrote about the character of Christ rather than the artistic expression of Titian in 1883, he concentrated on the inner thought of Moses rather than the sculptural expression of Michelangelo in his 1914 essay. For Freud the revelatory insights of "portraiture" were not far from his reception of historical works of art.

Figure 22. Alinari, Titian's *Tribute Money*, Dresden, Gemäldegalerie.
Alinari/Art Resources.

At one point in his research Freud followed up on a remark made by Thode in *Michelangelo und das Ende der Renaissance* (*Michelangelo and the End of the Renaissance*), published in 1912, the year of Freud's most intensive study of the statue, that the *Moses* was ultimately based on Donatello's seated *Saint John the Evangelist* (1415) (figure 23) in Florence.[94] Ernest Jones sent Freud a photograph of *Saint John* as well as of an unidentified statue at the museum of the Florentine Opera del Duomo (possibly Donatello's leonine "*Moses*" or the *Abraham*).[95] Jones later stated that, "This [photograph of Donatello's *Saint John the Evangelist*] shook Freud badly since it opened the possibility of the reason for the pose [of Michelangelo's *Moses*] being a purely artistic one without any ideational significance."[96] Freud admitted to Ferenczi that the photos Jones sent him of Donatello's statues had "shattered my conception somewhat."[97] And on 21 September 1913 Freud notified Jones that, "I have visited old Moses again and got confirmed in my explication of his position, but something in the comparative material you collected for me did shake my confidence which is not yet restored."[98] In other words, art-historical evidence about the history of Renaissance sculpture, and historical conventions of representation (as documented in photography) could actually turn the tables and contradict Freud's idea of the portrayal of a significant psychological moment in a (portrait-like) representation of a specific historical individual. Donatello's seated *Evangelist* (beard, book, *contrapposto,* and gaze) is clearly a stylistic and typological "grandfather" figure to Michelangelo's *Moses*. Michelangelo, throughout his long career, maintained Donatello as his favorite sculptor, and never shed his Florentine formation.[99]

With regard to portraiture, it is interesting to note that the same innocent disregard for the language of artistic conventions and for the gap between the artist and the beholder had characterized Freud's comments in his "Notes on Faces and Men" written in the National Portrait Gallery in London in 1908. The installation of the gallery, in which pictures were arranged by epoch and profession of the

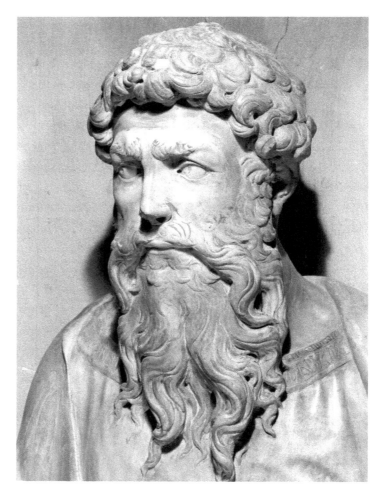

Figure 23. Donatello, *Saint John the Evangelist,* Florence, Museum of the Opera del Duomo. Alinari/Art Resources.

sitter, constituted a kind of laboratory of types for Freud.[100] "Notes on Faces and Men" attempted to classify the subjects' physiognomic (spiritual) types according to their vocations (scientist, artist, military leader) rather than viewing the portraits by artist or the culture in which the painting was made. The painted or sculptured portrait was to have revealed the soul of the individual subject.[101]

It is no coincidence that the expectation of transparency in portraiture was confirmed in Emanuel Löwy's textbook on the development of Greek sculpture, which had pride of place in Freud's library. According to Löwy, Greek sculptors across the centuries progressed by gradually refining anonymous symbolic figure "types" (seventh and sixth centuries BC) to the sculpture of Lysippos (fourth century BC), who in the words of the Roman historian Pliny worked from "no other model but nature." In Löwy's view, the accurate naturalism of Lysippos and the art of his age evolved naturally toward the facture and concept of the loftiest art form—that of individual portraiture.[102]

Time and Space

Details and portraits played a part in Freud's interpretation of Michelangelo's *Moses*. But in a more abstract and overarching sense, the essay also emerged from a photographic idea of temporality. Astute postmodern critics, such as Peter Fuller, Malcolm Bowie, and Peter Buse, have observed that Freud's analysis of Michelangelo's statue is in many ways centered on the experience of photographic ways of documenting unfolding events.[103] These writers have described Freud's analysis of Michelangelo's *Moses* as "cinematographic," thus invoking the dreamlike medium of cinema but also sequential, chronometric series of still photographs like those of Eadweard Muybridge or Etienne-Jules Marey.

How to imagine and represent the movements of a static body of marble? Chronophotography and the animated image were extremely pertinent to Freud's visualization of the *Moses* in action. This is true on several levels, and Mary Ann Doane has drawn interesting parallels between Marey's chronometric photographs of humans and animals in motion and Freud's conception of memory as a trace.[104] Photographers of motion such as Etienne-Jules Marey, Albert Londe, and Eadweard Muybridge were pioneers in the tracking of movement and duration.[105] Muybridge's masterpiece (*Animal Locomotion* 1887) changed the way static sculpture was apprehended. For example, the *Discobolus* of Myron was held to represent "the moment before the throw" until photographs of a discus thrower in sequence in Muybridge's *Animal Locomotion* series "revealed" that Myron's work could be seen as a synthesis of a number of distinct sequential positions melded into a single pose (figure 24).[106] According to turn-of-the-century medical and art-historical semantics, a theoretical series of film stills or documentary photographs of the *Moses* in actions resulting in the final pose would serve as proof positive that Freud's formal-iconographic analysis was correct. Freud studied at the Salpêtrière Hospital in Paris in 1885–86, under the direction of Jean-Martin Charcot.[107] Charcot and his pupils pioneered the use of psychiatric photography. They witnessed the phenomenon of hysteria in terms of an enacted fit with a chronologically ordered series of distinct emotional moments, and they photographed the sequential stages of hysterical episodes in a documentary style (figure 25). Pictures were captioned according to the precise attitude—scorn, menace, paralysis, mockery, or amorous supplication—demonstrated by the patient in a predictable phase, such as a picture of muscle contracture within a seizure of hysterical epilepsy (figure 26). This sequencing in stopped time as the recorded attack proceeded from one distinct mood to another created a kind of cinematographic "flip-book" effect. Such photographs were considered more useful as evidentiary material than

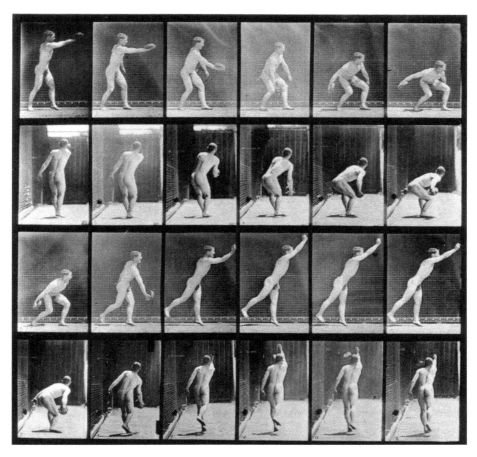

Figure 24. Eadweard Muybridge, *Man Throwing a Discus*, Callotype, 1887. New York, The Metropolitan Museum of Art. Gift of the Philadelphia Commercial Museum, 1964 [64.661.6.35].

Figure 25. Anonymous engraving. Charcot's photographic procedure, in Eder, *Ausführliches Handbuch der Photographie,* 1891, Photo Kunsthistorisches Museum, Vienna.

a fleeting visit with a patient as recalled in human memory, especially in phases of attacks that followed one another too fast to be studied by the unaided eye. Photography could freeze a series of actions in time to be studied at leisure, without the embarrassment of the direct observation of human pain or anguish.

Four line drawings (which Freud says "an artist" made for him) illustrate the two presumed anterior states and final pose of the statue in the *Imago* article (figure 27).[108] Functioning almost as though they were components of an animated cartoon or a flip-book, three drawings are sequential, and a fourth is a close-up

Figure 26. Bourneville and Regnard, *L'Iconographie photographique* 1: Plate 30. *Hysterical Epilepsy: Contracture*. Archives and Special Collections, Columbia University Health Sciences Library, New York.

Figure 27. *Imago* III/1 (1914), Figs. D, 1, 2, and 3. Freud
Museum, London.

view of the final state of the statue's hand and beard. These illustrations all have the ungrounded look of contour-line drawings copied from (perhaps traced from) photographs. In fact the third, final, or actual, pose corresponds precisely to Alinari photograph number 6205 (see figure 6, p. 35) in which the *Moses* is viewed from 30 degrees to the left, a view in which the tablets and prophet's hand intertwined with his beard are most prominently featured.[109] Whoever produced the set of drawings seems to have made them from the Alinari photograph. I propose that Freud himself made these drawings to illustrate his essay on Michelangelo's *Moses*.

Incomplete archival evidence reveals that Freud tried having various artists make the two drawings that accompanied the final view. A letter from Ferenczi of 9 February 1914 expresses the hope that his friend, the Hungarian painter Róbert Berény (1887–1953) would prove to be a better illustrator than "Heller's protégé."[110] Freud responded two days later that he would be pleased to have Berény attempt the drawings, because the ones by "Fräulein Wolf" had proved unsatisfactory, and that the artist Max Pollak (1886–1954), who made the portrait of Freud in his study, "has also promised to deliver these drawings." But Freud insisted that he would definitely hold up publication if he could not get effective, convincing drawings in time to go to press.[111] It seems obvious that Berény, "Heller's protégé," Wolf, and Pollak, rather than traveling to the statue in Rome, worked from photographic reproductions under Freud's direction. None of their results were satisfactory to Freud however.

On 15 February 1914 Freud planned an evening devoted to the *Moses* at his home, which was to be attended by "Heller, Rank, Sachs, Pollak, the artist who has delivered very good drawings to me." This statement makes it sound as though it was Pollak who supplied the drawings for the meeting. In any event the soirée was not a total success, as Freud later claimed, "I wanted to hear a proper rejection from the artist, but I couldn't get it out of him."[112] The story as it stands suggests that

some nicely executed "extra" drawings (contour-drawings apparently made from photographs), recently located in Freud's papers by Ilse Grubrich-Simitis, may have been the ones provided by Heller's protégé, Fräulein Wolf, Ferenczi's friend Berény, or Max Pollak.[113]

In the illustrations published with Freud's article, the clumsiness with which the hands of figure 2 are sketched, rather than drawn, suggests that the "artist" had little or no training, excluding, then, Max Pollak who was an accomplished draftsman. The students I have queried at the Vienna Academy of Fine Arts, where Pollak was trained, and at the Rhode Island School of Design in Providence observed that the body of *Moses* had been traced from a photograph and the "revealing" gestures were fiddled in after the fact, because the arm and hand gestures occur without any sense of torsion in the body.

As far as the drawings in *Imago* are concerned, visual evidence suggests that Freud made them by copying or tracing contours from photographs and adding the invented gestures to endorse his own argument. Alinari number 6205 is the most obvious model for this graphic strategy. If Freud was, as I propose, the "artist," then the illustration-pages would be the only part of his anonymous essay to remain anonymous even after his death.

The standpoint from which Alinari photograph number 6205 was made was also the empirical view in San Pietro in Vincoli that received the best light and that cast the *Moses,* photographically as it were, in the most violent, dramatic, and emotive chiaroscuro, especially regarding the currents and countermovements of the beard. Qualities of luminosity as well as qualities of time entered into Freud's photographic style of seeing the *Moses,* and, as Grubrich-Simitis has observed, "aspects of the sculpture which bear out his views are glaringly spotlighted, while contradictory elements are faded down."[114] For Grubrich-Simitis (whose metaphoric usage betrays her own photographic style of viewing the essay) Freud's entire argument

is constructed in terms of highlighting and fading, or what might be otherwise termed photographic chiaroscuro.

Not least to be considered is the suggestive aspect of photographic representation. Photographs of sculpture from the nineteenth and early twentieth centuries typically display dramatic chiaroscuro effects under the varnished looking overallness of the surface of the photographic print. This effect can resemble the muffled qualities of remembered dream images, thus drawing upon the imagination of the analysand or the "viewer" to complete, or in the case of fragmentary sculpture to "restore," the image, both in time and in space.[115]

It is pertinent to note that for Freud, as well as his art-historical contemporaries, who were to a certain extent captive to the ideal of "truth in photography," a photograph of Michelangelo's *Moses* functioned as a photograph of Moses, rather than a representation of a representation. The illusionary "transparency" of the glossy photographic skin substitutes Leon Battista Alberti's Renaissance notion of the transparent "window" of the picture-plane. If Quattrocento painters opened a window to reveal the narrative moment, or *istoria,* behind it, then the viewer of photographs paralleled the view of the photographer, looking through the transparent apparatus of the camera's lens directly at a living scene. In Freud's analysis, as in most other contemporary writings about sculpture, the language of photography (chiaroscuro, cropping for design, focus, enlargement, depth of field) remains outside the critique.[116] Thus, the photographic paradigm, together with actual photographic prints of the *Moses,* protracted the illusion of transparency in representation, exposing the work of art as though it were a living body, with volition and involuntary affect.[117] We have ascertained that Freud wrote about Michelangelo's *Moses* as though it revealed a view to the behavior of an individual protagonist in biblical history seen through the medium of photography.[118] Ernest Jones nurtured Freud's notion of Michelangelo's *Moses* as a statue with feelings and agency. He

wrote from Rome, "My first pilgrimage the day after my arrival was to convey your greetings to Moses, and I think he unbent a little from his haughtiness."[119]

The Medical Model and Styles of Beholding

We have seen that the photographed *Moses* was open to morphological examination on the medical model—a system of observation that Morelli (who was trained as a physician), Jean-Martin Charcot, and Freud shared. The divining of psychic states from somatic actions was Freud's stock-in-trade in practical psychoanalysis, and he applied it to the *Moses* much as he would have applied it to a human patient.[120] In short, photography was an extension of Freud's morphological approach to mental life, that is, deciphering the inside (psychic phenomena) from observing the outside (physical or motor phenomena).

In Freud's day, photography, art, and psychiatry were woven into a unified cultural system. And in *The Moses of Michelangelo* Freud's outlook and methodology incorporated that of Charcot who called the Salpêtrière hospital his "living pathological museum."[121] Charcot's workshop used photographs of patients at the Salpêtrière to diagnose and categorize neurotic pathologies and various forms of intoxication, seizure, or hysteria.[122] Charcot first worked with Guillaume-Benjamin Duchenne de Boulogne (1806–75) on the photo documentation of human physiognomic facial expression. These electric stimuli activated facial muscles in order to mimic states of pain, fear, surprise, or mental pathology. What was the moral nature of human pain? Was it possible to suppress an expressive response to physical stimuli? Could these questions be reduced to purely mechanized physiognomic formulae, rather than delving into philosophical thought and the study of the soul? Like many educated people of his day, Duchenne was attuned to the cultural

impact of ancient sculpture and attached to its abiding arguments. He then com-
pared the physiognomies of human patients who had the faradic stimulus with
facial expressions in Greco-Roman sculpture such as the famous *Laocoön* in the
Vatican. It is not surprising that Freud owned a copy of Duchenne's *Mechanism of
Human Physiognomy* (*Mécanisme de la physionomie humaine*).

Duchenne studied the facial configuration of *Laocoön,* and attempted to verify
Laocoön's expression of pain by applying electric shocks to a human head, and
then making a photograph of the human being in pain, which he called "*Lao-
coön*" (figure 28). This research led Duchenne to the conclusion that *Laocöon*
was indeed suffering and crying in the soul-felt psychic pain of fatherly pity for
his sons.[123] Duchenne's blurring of the fields of biology and art history, for all its
use of new photographic technology was essentially conservative in its message,
having less to do with modernist expressionism, say, than with the tradition of
Romantic Classicism in painting. But that was the prevailing spirit of the day,
and just as physicians looked to the traditional fine arts in their discernment of
psychiatric problems, academic art students throughout the nineteenth century
were fascinated by the anatomical aspects of their study. A statement made by the
physiologist Pierre Gratiolet in a lecture at the Sorbonne, for example, articulated
the complexity of the issue: "The essence of physiognomy is to relate the feelings
and passions which affect the living human being...how could these [electrically
stimulated] movements, communicated to my muscles by a foreign will, relate my
feelings and my wishes?"[124]

For his recording of medical data, Duchenne, who was trained as a physician,
selected dramatic photographic strategies. He first began photographing around
1854–55 with Adrien Tournachon (1825–1903), the younger brother of the famous
French portrait photographer, Gaspard-Félix Tournachon, called Nadar (1820–1910).
Duchenne advocated the *tenebroso* lighting used by such painters as Rembrandt

Figure 28. Duchenne de Boulogne 1876, illus. 7. Freud
Museum, London.

and José de Ribera. And systems of atmospheric chiaroscuro were always opera-
tive in methods of clinical representation by Duchenne and by his successors at
the Salpêtrière, Paul Regnard and Albert Londe, whether they were photographing
plaster casts or human subjects. In his foreword to the *Album de photographies
pathologiques complémentaire du livre intitulé "De l'electrisation localisée"* Duchenne
stated that he chose the photographic medium for its visual description of, "the

relief, the capricious and infinitely varied modeling, the *je ne sais quoi* that facilitates diagnosis."[125] Although Duchenne's apparent subjectivity was controversial among scientists, the French surgeon Aristide Verneuil found that the "artistic intelligence" in Duchenne's photographic work was an indispensable component of his medical research.[126] And the scientific data contained in photographs of expressed passions was also intended for the use of academic artists, blurring distinctions between science and art in Duchenne's work.[127]

In 1875, the year of Duchenne's death, Charcot accepted Paul Regnard as an intern, who then together with Désiré-Magloire Bourneville composed a three-volume album of photographic views of seizures and hysterical attacks, titled *L'Iconographie photographique de la Salpêtrière* (1876–80).

In 1882 the direction of the photographic studio passed to Albert Londe, whose documentation was also centered, among other issues, on cases of female and male hysteria.[128] The journal *Nouvelle Iconographie de la Salpêtrière: Clinique des Maladies du Systeme Nerveux* was produced by Albert Londe, together with Paul Richier (physician, sculptor, draftsman), and Gilles de la Tourette (chief physician of the clinic). Photographs were made of interesting cases of catalepsy, seizures, hysteria, atrophies, contractures, deformations, and other rare conditions (frequently associated with the central nervous system) correlating visual morphology with identified pathological states for diagnostic purposes. The photographic records were to aid the reader in arriving at his own conclusions in cases he encountered in daily practice. Physicians were assumed to be art-historically literate, and clinical photographs of patients' bodies were frequently juxtaposed with photographs of ancient Greco-Roman sculpture and European paintings from the Renaissance and early modern periods, for the most part works of art that were perceived as highly naturalistic.[129] Art history, which carried its own burden of diagnostic prejudices, became the handmaiden of medical diagnosis in photographic representation.

The most famous photographs to issue from the Salpêtrière were representations of hysteria. For example, Londe's treatise on applied medical photography arranged a series of eight shots of the attitudes of a hysterical patient in a cataleptic episode as she was subjected to various physical stimulants, including various vapors such as chloroform, colored light, and the imposition of cold or the sound of bells. These are charted on a single page as though the administration of stimuli had been sequential in time (figure 29).[130]

One of the ways in which the medium of photography is suited to the message of the hysterical phases has to do with the supposed ocular symptoms of hysteria. Charcot maintained, for example, that hysterical women saw the world in monochrome. They could, according to the phenomenon of hysterical vision, become completely achromatopsic (without color in their vision) and see everything as though in a photograph.[131] In turn, these women became the objects of photography, and were observed via black and white chiaroscuro photographs. Hysterical episodes were photographed phase by identifiable phase in sequential series of captioned photographic prints.

The images were legible to an initiated audience. But they were profoundly Romantic in that they exuded an air of atmosphere and mystery. For example, the photograph devoted to a terminal phase of "melancholic delirium" ("Période Terminale, Délire Mélancholique") (figure 30), communicates a maximum sense of psychological withdrawal and introspection; the patient's gaze is unavailable to the spectator, and most incidental or contextual information is suppressed in deep shadow. Here the boundaries between art and science are relaxed.

In the photographs of hysteria that isolate fully enacted moments of scorn, mockery, or erotic reverie, the emotional tenor of the dramatic instant was everything. One such image, which features a young woman named Augustine—Charcot and Regnard's star hysteric—in a particular emotional phase of an attack, is labeled

Figure 29. Albert Londe, *Attitudes Obtained during Catalepsy under the Influence of Various Stimulants,* in *Photographie médicale,* 1893, 95, pl VII. Art and Architecture Collection, Miriam and Ira D. Wallace Division of Art, Prints and Photographs, The New York Public Library, Astor, Lenox and Tilden Foundations.

"Scorn" ("Dédain"; figure 31). The mentality behind these psychiatric photographs was not far from that of art historians like Henry Thode, who recognized in the head of Michelangelo's *Moses* the expression of three specifically identifiable emotions: scorn, pain, and contempt. It is no accident that Freud underscored that phrase "Zorn, Schmerz, und Verachtung," in his copy of Thode's monograph and quoted it throughout his *The Moses of Michelangelo*.[132] In addition to deciphering particular spiritual and emotional states for art historians and psychiatrists, the morphological method fitted the aesthetic system of the "significant moment" that was advocated by pre-photographic thinkers such as Anton Raphael Mengs and G. E. Lessing.

Figure 30. Bourneville and Regnard, *L'Iconographie photographique* 1: Plate 21. *Melancholic Delirium*. Archives and Special Collections, Columbia University Health Sciences Library, New York.

Figure 31. Bourneville and Regnard, *L'Iconographie photographique* 1: Plate 31. *Hysterical Epilepsy: Hallucination—Disdain.* Archives and Special Collections, Columbia University Health Sciences Library, New York.

Freud's *Laocoön*

One of the most prominent works of art on Freud's visual horizon was the *Laocoön* group in the Vatican Belvedere. The idea that the *Laocoön* was popular in the Austro-Hungarian empire is evident from a photographic portrait by Mertens of Budapest: two ladies sit in an elegant studio set-up, looking at a photograph of *Laocoön* in a folio-size travel album (figure 32). The *Laocoön* photograph within a photograph functions as a badge of the intellectual cultivation and social status of the sitters. Early nineteenth-century engravings and later photographs of the *Laocoön* group—from the earliest Vatican photographers Macpherson and Braun, to those published by Löwy and Furtwängler—have portrayed the work in an atmosphere of haunting, even Caravaggesque, chiaroscuro. The *Laocoön* was illustrated photographically in several of the books Freud owned, including those by Furtwängler, Löwy, and Duchenne.

The *Laocoön* was perhaps the most discussed work of art in the eighteenth and nineteenth centuries of German literature on aesthetics and art criticism. Freud paid special attention to it on his first trip to Rome in 1901.

According to legend, the Trojan priest Laocoön warned the people of Troy to beware the Greeks' gift of a wooden horse. Athena (in her role as patron deity of Athens) punished him severely for this act by setting giant serpents on him and his sons. The sculptural group represents the struggle between Laocoön, flanked by his two sons, and the aggressive serpents intertwined with, and biting and strangling the human figures. As a tourist site, an object represented in engraving and photography, and a subject of literary importance in the aesthetic treatises of Johann Wolfgang von Goethe, Johann Joachim Winckelmann, and Lessing, the *Laocoön* played a large part in how Michelangelo's *Moses* would be studied and interpreted by Freud.[133]

Figure 32. Mertens & co., *Portrait of Two Ladies with a Book*. In
Photographische Correspondenz 1898, Plate after p. 394. Albertina,
Vienna.

Issues of passion and restraint in classical sculpture and in Jewish suffering were familiar to Freud from the works of Lessing and his followers. In 1931 Freud remarked that Lessing, as a critic, was, "the ideal of my youth."[134] In his study of the Greco-Roman sculptural group *Laocoön and His Sons,* Lessing concluded that the heroic priest-father was actually in the act of suppressing rather than expressing a cry of pain.[135] Freud followed this model of heroic *Selbstüberwindung* (self-control, or dominance of what he would later call the superego) in his *Moses* study.[136] He also adhered to Lessing's precept of the "significant moment," wherein a work of art was created "to be contemplated repeatedly and at length," because "the more we see, the more we must be able to imagine [of a narrative sequence]."[137] The most communicative form of visual art was depiction of the moment "from which the preceding and succeeding actions are most easily comprehensible."[138] Freud, like his contemporary, Aby Warburg, inherited Lessing's interest in the connection between images and dramatic action.[139] Warburg's famous art-historical concept of *Pathosformel* was about visualizing the impulse to act and the feelings that accompanied that dramatic movement.[140] Significant to Freud's experience, the cultural historian Sigrid Schade has identified Jean-Martin Charcot, who staged the *Pathosformel* systematically for purposes of observation in his study of hysteria, as Warburg's methodological predecessor.[141]

Indeed, Lessing's essay on the *Laocoön* quoted a remark by Mengs about Raphael's drapery folds in the description of the ongoing physical states of the protagonists they clothe: "We can see from the folds whether an arm or a leg was in a backward or a forward position prior to its movement."[142] For Freud, the beard of *Moses* had the same function as Raphael's drapery folds, revealing anterior actions and intentions at the key moment of a pictorial narrative. We recall that according to Freud, the looped configuration of Moses's beard indicated the trajectory taken by the figure's hand, and that "the Tables, too, have arrived at their present position

as the result of a previous movement."[143] All of these conclusions were based on the assumption that the viewer could discern the artist's intention (and therefore the stone statue's "intention") if observed in a sufficiently accurate manner.[144] For Freud, Michelangelo's statue spoke from photography as if it were made from a "perfect negative"—an innocent view "taken" from reality. In *The Moses of Michelangelo* a sculptured body is read as the complete material expression of a momentary psychological drama as proved by the scientific, medical, and art-historical veracity with which documentary photography was received.

It is germane to this chapter that Freud transposed a Jewish prophet-priest-father (Moses) for a Trojan one (Laocoön). And it is therefore pertinent that another of his favorite works by Lessing was the play *Nathan the Wise* (1779), which was staged in Vienna in 1895.[145] Set in Jerusalem at the time of the crusading Templars the play pleads for tolerance among Christians, Muslims, and Jews. Nathan, a powerful and just Jewish father figure, demonstrates heroic intellectual power in showing tolerance and restraint rather than vengeance in dealing with the bigotry that killed his wife and seven sons.[146] Nathan adopts a Christian daughter, whom he raises as a Jewess, considering her a gift from God. At the conclusion of the play, Nathan has taught tolerance through his own actions and intellect.[147] As early as 1882, when Freud wrote a love letter to his fiancée Martha Bernays, he framed it according to *Nathan the Wise,* comparing Rabbi Isaak Bernays, Martha's grandfather, with the noble character of Nathan in Lessing's play.[148] In its 1895 production, the noble humanity and stoicism of Lessing's protagonist must have struck a resonant chord with the ethos of suffering and self-denial that was so fundamental to the everyday life of the Jews of Eastern Europe. It is also quite likely that the civilizing restraint of *Laocoön* and *Moses* lingered in Freud's imagination in 1923 when he devised the concept of a superego (civilization) that reined in the appetites and rages of the ego and the id.[149]

Fathers and Sons

Themes of paternity and Oedipal conflict have a strong presence in the germina-
tion and trajectory of Freud's *The Moses of Michelangelo*. Freud called his essay a
"love-child," a "favorite son," and an "illegitimate son," yet following its anony-
mous publication, he did not "claim paternity" for the essay until 1924.[150] Because
the Oedipal coming to terms with the father was at the heart of Freud's theoretical
and clinical work, his identity as a Jew, and his status as progenitor of a new sys-
tem of thought, Michelangelo's *Moses*, itself charged with historically recognized
paternal themes, spoke to him in a particularly resonant voice.[151]

How many fathers and whose fathers did Freud see in the *Moses*? Although
Freud never wrote a psychobiography of Michelangelo, he knew that the *Moses*
contained as many father issues for Michelangelo as for himself, and his identifi-
cation with the Renaissance genius seems to have redoubled his own involvement
with the work of art.

The *Moses* had long been seen as a thinly disguised portrait of Pope Julius II
(1504–13), whose *terribilità* as a father figure was notorious, and was elaborated by
German-language scholars read by Freud such as Jacob Burckhardt, Ludwig Pastor,
Hermann Grimm, and Ernst Steinmann.[152] Freud reiterated this when he said:

> The artist felt the same violent force of will in himself [as in Julius II] and, as the
> more introspective thinker, may have had a premonition of the failure to which they
> were both doomed. And so he carved his *Moses* on the Pope's tomb, not without a re-
> proach against the dead pontiff, as a warning to himself, thus, in self-criticism, rising
> superior to his own nature.[153]

While working on the pope's most important commissions, his tomb and the
Sistine Chapel ceiling, Michelangelo characterized himself as a prodigal son who

repeatedly rebelled, fled, and was reconciled.[154] Besides being Michelangelo's most important patron-father, Julius II was also the Holy Father, a man of enormous power in worldly as well as spiritual terms. According to James Beck, Michelangelo's ambivalent and conflicted wishes for the pope's approval paralleled his desire for the approbation of his own father, Lodovico Buonarroti Simoni, whom he had long since outdistanced in terms of worldly education and fame.[155]

Jakob Freud, as opposed to Lodovico Buonarroti, was presumably proud of his son's achievements and pleased to be surpassed by his children.[156] Michelangelo never won the approval that he sought from progenitor or pope.[157] In the authorship of sculpture, painting, and architecture, however, Michelangelo was regarded as a "divine" creator, like the Judeo-Christian Creator.[158]

Whereas *Moses* expressed the power of Julius as priest-king-father, Michelangelo was ultimately father of the *Moses* as a work of art. The statue was frequently identified (in the Romantic art-historical writing of Freud's day) with the sculptor, possessed of the raging energy of a divinely inspired artist who persevered against the odds of political events and the sabotage of inferior competitors—a man who had no teacher and was always contemptuous of inadequate patrons and pupils.[159] Freud's admittedly conflicted feelings for Jakob—as a son who had eclipsed his father—were mirrored in the historical past by Michelangelo's relation with his father and reverberate throughout Freud's long involvement with Michelangelo's *Moses*.

In *The Moses of Michelangelo* Freud created an essay that in eclipsing (if not "killing") the cultural world of his father was vindicated by the example of Michelangelo. As an elegant predecessor for Freud, Michelangelo had stood at the pinnacle of Western culture, and he portrayed in the figure of *Moses* a tormented amalgam of his biological father, his symbolic father (Julius II), and himself. Just as Michelangelo identified with his image of the pope as Moses, it may be no coincidence that Freud referred to himself as "Pontifex maximus" in a letter to Ernest Jones of

1922.[160] All of this reflexive potential opens up an interminable commentary, in which no single fixed meaning can, or necessarily should, stand as truth.[161]

Freud knew well that Jews considered the deity unnamable, unknowable, and unrepresentable. In art-historical terms, he also understood Michelangelo's *Moses* as an appropriate stand-in for the single deity of the Pentateuch, or God the Eternal Father.[162] Vasari acknowledged this visual surrogacy when he spoke of the face of the statue in terms of theophany—a face so resplendent and dazzling, so divine that the human beholder almost required a veil to cover it. Vasari's description was derived from the Bible, where Moses was so radiant that he instilled the children of Israel with fear, and Vasari updated that idea by stating the incredible fact that the Jews of Rome adored Michelangelo's *Moses* as a presence not human, but divine.[163] In Freud's time, a variety of historians and travel writers described Michelangelo's *Moses* as "the Eternal Father" in a manner that called forth the Old Testament God.[164] In his textbook on adolescence, G. Stanley Hall wrote about Mount Sinai as the home of the Jewish deity, calling Jehovah, "a fierce deity, who brewed storms and lightning and rode on the wings of the wind."[165] This passage recalls the way Michelangelo and his *Moses* were associated with storms and lightning in Freud's earliest Roman experience. Freud was apparently still thinking about the way Michelangelo made his *Moses* look like the prime mover when he wrote in *Moses and Monotheism:*

> It was probably not easy for [the biblical Jews] to distinguish the image of the man Moses from that of his God; and their feeling was right in this, for Moses may have introduced traits of his own personality into the character of his God—such as his wrathful temper and his relentlessness.[166]

The character of Moses was a lifelong preoccupation for Freud, and whereas in 1914 he maintained that Michelangelo impressed his own features on the *Moses,* in

1939 Freud's speculations had become far more radical, and conceptual, suggesting that the human Moses shaped "his God" in his own image.

We have seen that the movements of *Moses*'s beard as studied in a close photographic view of the sculpture are central to the mechanics of Freud's art-historical argument. Again we are led back to Vasari, who praising Michelangelo's formal handling and mimesis, had legitimized an obsessive attention to the study of the beard. I have proposed that the hyper-clear photographic detail of the beard, ostensibly used as a trace of the actions of Michelangelo's *Moses,* could screen the latent emotional anxieties that the entire bearded sculpture in situ stimulated for Freud. This brings us to another range of representations, those having to do with beards in the social context of Jewish life.

Beards, Prophets, and Wandering Jews

The beard as a patriarchal symbol gives way in Michelangelo's *Moses* to a spectrum of conflicted emotional meanings with Oedipal overtones. It was a reference to the bellicose power of Julius II, who, in defiance of canon law, let his own beard grow as a symbol of mourning after a battle lost to the French in 1510.[167] At the same time it created a quality of ethnic authenticity that made Michelangelo's *Moses* resemble a "real" Jew, as mystical and uncompromising as those from the East who had sought refuge in cosmopolitan Vienna. In his 1927 essay "The Wandering Jews," Josef Roth characterized the length and style of a man's beard as a barometer of assimilation for Jews living in large cities.[168] A long, untrimmed beard immediately signaled an eastern Jew, with all his stereotyped propensities for servility, mysticism, and the indigent existence that designated him as a permanent refugee in any European country. If a Jew wore a traditional beard and kaftan, he

was "making a highly visible statement about his *incurable otherness*."[169] Freud was aware of J. J. Winckelmann's statement that Michelangelo's *Moses* wore his beard the way [eighteenth-century] Jews had to, "if they wanted to be real Jews."[170] Freud's Philippson Bible, which functioned as a scientific history of Judaism for the non-orthodox, illustrated historically correct beard styles with drawings of Jews from Syria, Arabia, and Persia (figure 33).[171] During the 1895 run of *Nathan the Wise* in Vienna, Adolf von Sonnenthal, the "Jewish Jupiter" of the Viennese stage posed for a photograph in the part of Nathan (figure 34). He is an exoticized, robed figure whose right hand is brought to his imposing beard.[172] Such images were widely circulated in cabinet cards and postcards, and, according to the memoirs of Stefan Zweig, photographs of the great actors were on display in all the stationery stores of Vienna.[173]

Freud did not follow Jewish customs that men are not to shave or cut their hair when in mourning.[174] Nevertheless, it is a strange fact that in Freud's "close-the-eyes" dream he was late to his father's funeral because of the barber.[175] As Peter L. Rudnytsky has pointed out, the tension between filial piety and patricidal wishes is represented by Freud's simultaneous intention and inability to carry out the closing of his father's eyes.[176] The irony of being delayed at the barber can be read in many ways, underscoring this ambivalence as well as the conflict between Jewish codes and the rites of modern urban life.

Beards also have a place in the association between Jews and illness that was debated and documented in the circles of Jean-Martin Charcot. It was commonly held that European Jews were tainted with nervous weaknesses and insanity, whether from an endogenous racial degeneracy or a cumulative Lamarckian effect of the stresses of persecution manifested in the psychological development of individuals.[177] Havelock Ellis, for instance, attributed Marcel Proust's asthmatic condition to his being half Jewish: "I am inclined to find a clue in the differences

Figure 33. Artist unknown, *Beards of Syrian, Arabian, and Persian Jews.* Philippson Bible (1858) 3:1033. Photo by author.

Figure 34. Julius Weisz, *Adolf von Sonnenthal as Nathan the Wise,* postcard, 1895. Author's collection.

of race…such racial blends of rather unlike genes certainly lead to unusual psycho-neurotic conditions."[178] Sarah Bernhardt's anti-Semitic detractors called on her Jewish origins to account for her "pathological madness" and her Levantine sense of excess.[179] Eastern European Jews in particular were considered unhealthy people whose long submission to superstition and mysticism made them prone to hysteria and psychosis. Anatole Leroy-Beaulieu stated that Jews were especially prone to "the disease of our age, neurosis." He recounts that a French physician once told him that throughout his practice he had observed that "with the Jew, the emotions seem to be more vivid, the sensibility more intense, the nervous reactions more rapid and profound."[180]

Zionists, including the psychiatrist Max Nordau, responded to such prevailing attitudes by calling for "muscle Jews" who would leave the confinement of the ghetto to develop a healthy mind in a strong body—a classical, Hellenic ideal.[181]

One of Charcot's followers, Henry Meige, wrote a doctoral dissertation titled "Étude sur certains neuropaths voyageurs: Le juif-errant à la Salpêtrière" ("Study of Certain Pathological Travelers: The Wandering Jew at the Salpêtrière"), and published an illustrated article on the subject in the *Nouvelle Iconographie* (1893), which was in Freud's library. Meige's study examined the case histories of eastern Jews who suffered from the psychic pain of hysterical malaise coupled with a manic compulsion to travel incessantly.[182] Clearly these individuals—"permanent refugees," as Josef Roth later described them—suffered from poverty, prejudice, and severe social limitations, rather than purely psychological ills. Meige conflated the condition of European Jews with insanity in a mode that was typical of late-nineteenth-century racialist thinking. Meige elaborated the case histories with notes on their physical appearance: thin faces, sunken features redolent of suffering, and, above all, curly, unkempt, sometimes chest-length beards. Photographic and lithographic illustrations accompanied Meige's article, which Freud read in

1893 (figures 35 and 36). Leroy-Beaulieu wrote a long sympathetic discourse on the physiology of the Jew around the same time Meige made his documentary pictures of "wandering" Jews at the Salpêtrière. Leroy Beaulieu quotes Heinrich Graetz as saying that "The Jew is early withered by life." The French historian goes on to say of the typical Jew that, "His youth has, in many cases, lost its bloom; his drawn features, old before their age, have a wasted look; his brow is furrowed with premature wrinkles; one might almost say that the Jew is born old; his glance, so piercing and intense, has frequently an oldish expression. There seems to be an air of decay about his person, as about the houses of the [typical] Judengasse."[183] These descriptive words resonate with the bearded figure of "Gottlieb M." as pictured in photography and lithography by Henry Meige.

But at the same time the photograph of "Gottlieb M." conforms to a stereotype, namely the picturesque Jewish beggar of Eastern Europe. A postcard made in a Krakow photographic studio in 1910, for instance, features a Galician Jew dressed in a tattered kaftan, with beard and sidelocks, carrying a walking stick and an alms box (figure 37). This illustrated postcard (labeled in Polish, German, English, French, Hungarian, and Russian) was brought to Vienna as a souvenir from a more obscure part of the empire. Ethnicity is made picturesque and endearing here as a curiosity of Galician folk life. In Meige's article the same kind of Jewish traveler is pathologized and studied as a "specimen."

If their status as victims of a peculiarly Jewish illness was defined in part by their bearded faces, then the beard of Michelangelo's *Moses,* also apprehended in documentary photography, perforce represented the reverse of the same Jewish coin. To Freud, as well as to other spectators, Michelangelo's *Moses* was a "muscle Jew," a muscular Greco-Roman hero, made in the image of a pope, wearing the untrimmed, even audacious, beard of a "real" eastern European Jew—a "Jewish Jupiter" for all time.

Figure 35. Albert Londe, *Gottlieb M.: Neuropathic Jewish Traveler,* in Meige 1893. Archives and Special Collections, Columbia University Health Sciences Library, New York.

Figure 36. Photolithograph of drawing by Henry Meige, *Gottlieb M.,* in Meige 1893. Archives and Special Collections, Columbia University Health Sciences Library, New York.

Figure 37. *Galician Jew,* postcard, Krakow, 1910. Author's collection.

Postcards and Palimpsests

Around the 1880s, illustrated postcards came into use, with photographic souvenirs of monuments and views collected and mailed by tourists around the world. Freud made use of photographic postcards as *aides-memoire*. In September 1913, Freud sent a photo postcard from Rome of the *Moses* to Sandor Ferenczi (figure 38): with a brief greeting on the verso, he inscribed the photograph as a palimpsest.[184] The greeting on the picture side of the postcard, is inscribed at the base of the *Moses,* as though the statue were speaking: "13.9.13 Roma / Chiesa di S. Pietro in Vincoli / Mosè di Michelangelo / Returns your greeting and is entirely of the same opinion as you about the Congress in Munich / Your Freud." This rebus-like combination of words and image, established a Freud-to-Moses equation front and center: "Moses returns your greeting and is entirely of the same opinion as you about the congress in Munich." On the column bases left and right of the statue he inscribed the date "13.9.13" and his signature "Your Freud," as if claiming authorship of the *Moses,* and thereby as the creator of psychoanalysis proclaiming identification with the creator Michelangelo.[185] Ferenczi wrote back that he was "especially honored by the Moses greeting."[186]

Perhaps, as Ernest Jones first suggested, Freud saw himself reflected in the statue of the Jewish patriarch: the betrayed founder of psychoanalysis in his self-restraint to be compared with the betrayed founder of Judaism.[187] Freud, as the founder, was then an angry father to his wayward disciples, namely Carl Jung. As Peter Fuller has so aptly noted, "Freud's own grip on the tables of the law was loosening."[188] In fact the slippery nature of Freud's personal identification with the biblical Moses was apparent in these very years. He wrote to Jung in 1909, "we are moving ahead, and you, if I am Moses, will take possession, like Joshua, of the promised land of psychiatry."[189] Complaining to Ferenczi about Hanns Sachs having botched the

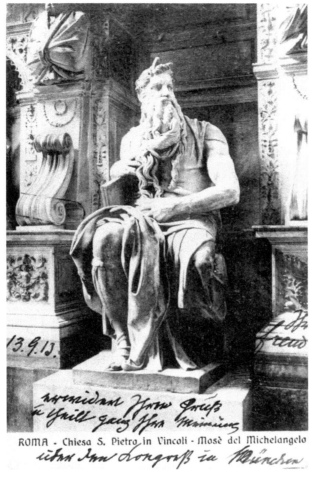

ROMA - Chiesa S. Pietro in Vincoli - Mosè del Michelangelo

Figure 38. *Inscribed Postcard of Michelangelo's Moses from Freud to Ferenczi*, 1913. Austrian National Library, Vienna.

theory of instinct, Freud admitted that, "according to my mood, I would sooner compare myself with the historical Moses [who cannot suppress his anger] than with the one by Michelangelo, which I interpreted."[190] In August 1912 Ferenczi had spoken negatively to Freud of Jung, stating that, "The other Swiss are all too much under the influence of [Jung's] suggestion, and they are all a bunch of anti-Semites."[191] And a letter from Jung to Freud of 18 December 1912 casts Freud as a caricature of a bearded Old Testament prophet:

> You go around reducing everyone to the level of sons and daughters who blushingly admit their faults. Meantime, you remain on top as the father, sitting pretty. For sheer obsequiousness nobody dares pluck the prophet by the beard and enquire for once what you would say to a patient with a tendency to analyze the analyst instead of himself.[192]

Freud's preoccupation with the beard in conjunction with Thode's "scorn, pain, and contempt," may be explained by Jung's having dared to "pluck the prophet by the beard" and by Freud's own earlier identification with Moses, paving the way for Jung as Joshua/Jesus. The anti-Semitism implicit in Freud's eagerness to adopt Jung as his "crown prince" now mutates into an angry reaffirmation of his own Jewishness and the scapegoating of his formerly favored Aryan "son."

After a negative encounter with Jung, Freud sent a picture postcard of the *Arch of Titus* (figure 39) to Karl Abraham. The relief sculpture on the inner walls show Roman soldiers carrying off spoils from the Temple of Jerusalem including a large menorah. Superstition holds that bad luck will befall a Jew who walks under the arch. Freud used this postcard in much the same way he had used the *Moses* postcard to Ferenczi. On the surface of the face-on view of the *Arch of Titus*, Freud inscribed triumphantly to Karl Abraham, "The Jew survives it."[193] One could read

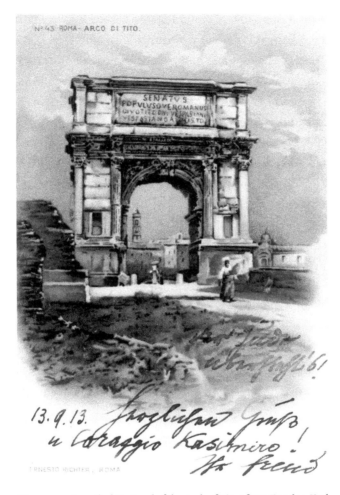

Figure 39. *Inscribed Postcard of the Arch of Titus from Freud to Karl Abraham,* 1913. Freud to Abraham, Box 14 folder 26, Sigmund Freud Papers, Sigmund Freud Collection, Manuscript Division, Library of Congress, Washington, D.C.

the composite inscription in terms of proof of a Barthesian "having been there" as a *graffito* made in Rome by a Semitic (Hannibal-like) conqueror of Rome.[194] Or, it could be the triumphal autograph of the conqueror of the unconscious mind. Or perhaps the inscriptions on both postcards were those of a Jewish pilgrim—a man who overcame his father's Galician *shtetl* origins to become a Renaissance Jew.

Perhaps most important, Michelangelo's *Moses* was a classical-style work that Vasari gave Freud permission to apprehend and understand *as* a Jew, thus historically trumping Jewish prohibitions against figurative art, Greco-Roman sensuality, and the Catholic Church, and thereby rescuing him from the Oedipal repudiation of his beloved parents.

The perplexity about the Jewish denial of figurative art was never truly resolved in Freud's identity. In *Moses and Monotheism* he returned to the problem that for the Jews the prohibition against images resulted in "the compulsion to worship a god whom one cannot see." This in turn led to a triumph of abstraction (or intellectuality) over sensuality, and the "harmony in the cultivation of intellectual and physical, such as was achieved by the ancient Greeks, was denied to the Jews."[195]

Returning to Vasari and the plastic arts we may ask: Denied or not denied? And who was a "real" Jew? These seem to have been among the most persistent riddles of Freud's life. It is probably no mere coincidence that at the end of his life Freud developed the thesis that the biblical Moses was not a Jew at all but an Egyptian. Surely such thoughts germinate in the psyche long before they flower into prose, and Freud's experiences with Michelangelo's *Moses* must in some way have determined the direction of his most surprising intellectual adventure, composed in old age and under tragic historical circumstances, the *Moses and Monotheism*.

3	# Delusions and Dreams

<div align="center">

Freud's *Gradiva* and the Photography
of Ancient Sculpture

</div>

> A basket of orchids gives me the illusion of splendor and
> glowing sunshine; a fragment of Pompeiian wall with a
> centaur and faun transports me to my longed-for Italy.
>
> —Freud to Fliess, 8 May 1901

Freud's *Delusions and Dreams in Jensen's* Gradiva (1907)—a psychological analysis of the protagonist of Wilhelm Jensen's novella *Gradiva: ein pompeijanisches Phantasiestück (Gradiva: A Pompeiian Fantasy)*—was in many ways an extension of the archaeological metaphor for psychoanalysis. The essay, like the novel from which it sprang, belongs to a constellation of attitudes about ancient sculpture that prevailed at the turn of the twentieth century. Like Morelli, Duchenne, Charcot, and Freud, Wilhelm Jensen, who was born at Kiel and studied in Berlin and Munich, had been trained in medicine. He then went on to study

philosophy. When queried about Freud's essay, Jensen stated that although he was a physician he had not written *Gradiva* under the impact of current psychological theories, but only according to his personal inspiration. That was fine with Freud, who let the novel speak its manifest content for itself, and sought the latent or unconscious meaning in the actions and dreams of its central protagonist.[1] Once again, it is important to remember that *Delusions and Dreams* was not a psychobiography of Wilhelm Jensen. Rather, it engaged in a deep analysis of the spiritual life of an already created representation (like Freud's studies of Michelangelo's *Moses*) for which the reader had to suspend disbelief to participate in the game. Freud himself claimed to read *Gradiva*, "as though the author's mind were an absolutely transparent medium and not a refractive or obscuring one."[2] As with Michelangelo's *Moses*, Freud approached Jensen's story as if it were a seamless whole existing in a reality contiguous with life, and protracted the illusion of art, suspending any and all critical judgment as he subjected the fictional characters embedded in the text, Hanold and Zoe-Gradiva, to a profound biographical analysis.

The plot of Jensen's novel *Gradiva* is full of bizarre twists and turns, but can be summarized as follows.[3] The hero, Norbert Hanold, is an archaeologist in search of his own repressed desires, which are rediscovered and reanimated by viewing a plaster-cast of an ancient Roman marble relief of *Gradiva*, "the girl splendid in walking," from Pompeii. In Jensen's novel Hanold's passion for archaeology subsumes every other, and absorbs all of his visual interest.

Hanold's archaeological interests turn to "lithophilia" (fetishized love of sculpture) when provoked by the sight of the *Gradiva* relief, which he believes represents a real individual person, who lived and died in Pompeii. The archaeologist then travels to Pompeii to discover evidentiary traces of her actual existence. Hanold plays out various fantasies about Gradiva in a series of dreams and hysterical

delusions that he then experiences in Rome and Pompeii, where he encounters her as a positive hallucination, or a ghost, walking through the ruins of Pompeii, speaking German.

Gradually Hanold realizes that the woman who haunts him is not a ghost at all, nor is she a statue come-to-life, but rather she is a certain Zoe Bertgang, a childhood acquaintance, on vacation at Pompeii with her zoologist father. The essential clue to this puzzle is that Zoe had the same manner of stepping as seen in the foot and ankle of the Pompeiian relief. The name "Gradiva" is revealed to be nothing more than a linguistic equivalent for "Bertgang" and it was an unconscious memory of Zoe's gait that triggered Norbert's interest in the inanimate representation in the first place, which he then gazed upon and "studied" at length. Among the pathologies Freud located in Hanold's case history were various episodes of fetishism, necrophilia, and voyeurism experienced by the archaeologist in the ruins of Pompeii. In the end, a normal love affair with Zoe replaces Hanold's obsession with Gradiva and he realizes that the sculptured figure had been only a surrogate for Zoe all along. With the help of the real Zoe, Hanold is thus liberated from his delirium and delusions (if not from his foot fetish) and, like a patient cured in psychoanalysis, is released to embark on a normal life with real problems and desires.

In his essay on Jensen's *Gradiva,* Freud claimed that Hanold's archaeological interests acted at the service of a complex hysterical delusion, serving as an intellectual pretext for unconscious erotic desires. Freud identified closely with young Hanold's obsessive personality, dedication to professional study, and his particular association of Italy with erotic love.

The relief sculpture in question (figure 40)—which is characterized in the novel as a single figure of a young girl—may have originally been a detail of a fragmentary frieze of three girls (probably representing the three Horae, or Kharites)

Figure 40. Alinari, *Dancer (Gradiva) Displayed at the Vatican Museum.*
Alinari/Art Resources.

dancing. Emanuel Löwy had sent Freud a postcard of the three-figure reconstruction as proposed by the archaeologist Friedrich Hauser (figure 41).[4] Hauser's project was to recontextualize the *disiecta membra* of the relief fragment.[5]

Freud hung a framed plaster reproduction of the single-figure *Gradiva* that had obsessed Jensen's Hanold above the couch in his consulting rooms, where it cohabitated with other antiquities, reproductions, and works of art (figure 42).[6] He happily encountered the "real" *Gradiva,* whom he identified as a familiar friend, for the first time on a trip to Rome in September 1907. On that day he wrote to his wife, "Think of my joy when, after such a long loneliness I saw today in the Vatican a dear acquaintance; the recognition was one-sided however because it was the *Gradiva* high above on a wall."[7] Freud's involvement with the reproduced sculptural fragment and its milieu was extensive, and Jack J. Spector coined the term "the *Gradiva* principle," for Freud's search for personally significant aspects of works of literature or art.[8]

Italian writers particularly appreciated the joy with which Freud approached the topic of sculpture in the study of the psyche. For example, Marco Levi-Bianchini (1875–1961) took the opportunity to praise Freud's *Gradiva* essay, as translated by Gustavo de Benedicty, in terms of its plastic or "sculptured" prose ("la parola scultorea del Maestro").[9] The admiration went both ways, as in 1914 Freud had written the preface to Levi-Bianchini's translation of his *Five Lectures,* stating that, "For many years it has become a need for me to gather strength for new works from the beauties of the country of Italy, in whose literature I will no longer be a stranger."[10] Levi-Bianchini, who was psychiatrist and professor at the University of Naples, and founding member (1925) of the Italian Psychoanalytic Society (Società Psicoanalitica Italiana), made sure that the "sculptured words of the master" found a place in Italian intellectual life, culminating in the interpretive writings of the twentieth-century psychoanalyst, Cesare Musatti.

Figure 41. *Postcard of Gradiva (recto and verso) from Emanuel Löwy to Freud.* Sigmund-Freud Privatstiftung, Vienna.

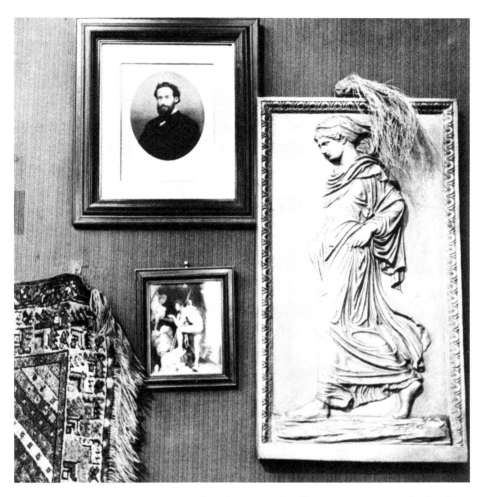

Figure 42. Edmund Engelman, *Copy of Gradiva in Freud's Office at Berggasse 19*, 1938, (detail), Thomas Engelman.

Unlike Michelangelo, who worked in sixteenth-century Rome, Wilhelm Jensen was operating within the same cultural system as Freud, and so his authorship tended to disappear even more rapidly under Freud's interpretive gaze. Although Jensen-as-author—an innocent transcriber of the narrative as manifest content—vanished for Freud, we in historical perspective can see Jensen-as-author as eminently compatible with Freud-as-psychoanalyst insofar as their textual and visual resources were taken from the same material world and received under the same sets of intellectual conventions. In terms established by Michael Baxandall, Jensen and Freud partook of the same cognitive style and "period eye."[11] Cultural anthropologists such as Clifford Geertz have posited theories of local knowledge, namely that an object and the ability to understand it are made in the same shop.[12] According to this formula Freud was an eyewitness interpreter of Jensen's text; his essay was made in the same societal workshop as the text it interprets. Likewise, Jensen's *Pompeiian Fantasy* was composed within the same cultural system as Freud's slightly earlier *Interpretation of Dreams,* even though the novelist denied a direct influence. The process of visualization moved from the *Interpretation of Dreams* to the novel, and to its analysis, without any serious disjunction as Freud took up an investigation of the misadventures of the young archaeologist, Dr. Norbert Hanold. Given these conditions, *Gradiva* becomes a splendid case history, a ghost story spanning antiquity and modernity, life and death, consciousness and oblivion.[13] Moreover, this psychoanalysis takes place under the shadow of Vesuvius at Pompeii, the buried and excavated city of Freud's personal longing and enchantment.[14]

Gradiva, Apollo, Löwy, Freud: The Art of Slaying Lizards

Jensen's *Gradiva* was identified by Freud as a model female practitioner of psychoanalysis.[15] She had no medical training; she occurred fully formed, in the guise

of an ancient sculpture come to life, effectively and ingeniously curing of a case of male hysteria. Gradiva was in fact the perfect analyst to treat an archaeologist, not only because she herself was an ancient marble sculpture, but because she possessed the knowledge that the historical past, which eclipsed Hanold's dream-life, could be replaced by the personal past, or childhood, the memories of which Hanold had apparently forgotten.[16]

In Freud's view, Hanold's cure was brought about by a loving German-speaking analyst, who also happened to be a work of classical sculpture *rediviva*—one of the three Horae (spring, summer, and fall) who personify nature. Gradiva was therefore a creature who embodied and accomplished the impossible, namely the fusion of the irreconcilable conditions of natural instinct with the repressive forces of civilization.

Freud interpreted one of Hanold's dreams: "Somewhere in the sun Gradiva was sitting, making a snare out of a blade of grass to catch the lizard in, and said: 'Please keep quite still. Our lady colleague is right; the method is a really good one and she has made use of it with excellent results.'"[17]

The mid-afternoon setting in the ruins of Pompeii was perfect for lizard-catching, since lizards and butterflies are the silent companions of the sun in remote Mediterranean sites, appearing before tourists like spirits from the past. In fact, in a postcard to his wife from the island of Capri, Freud noted that that "what by day are lizards and butterflies, are by night mosquitoes and fleas."[18] But Freud found the senseless absurdity of the lizard-catching episodes in Jensen's *Gradiva* to be a case of disguised symbolism. He interpreted the female colleague (or "girlfriend" as we might more casually translate *Kollegin* today) as Zoe's honeymooning friend, Gisa, upon whom Hanold had accidentally spied while she was embracing her new husband in the ruins of the House of the Faun, and who later appeared to Hanold and Zoe wearing red Sorrento roses. Snaring a lizard, therefore, stood for "catching" a husband. But, Freud asked, "Why was Zoe's skill in man-catching

represented by the old gentleman's [Zoe's father's] skill in lizard-catching?"[19] It is, of course, as the story evolves, because once the two lizard-catchers are recognized as father and daughter, *Gradiva* becomes Zoe, the daughter of an old acquaintance, namely the zoologist Professor Bertgang.

In the novel and in Freud's commentary, zoology is the study of the instincts of animals, including human animals, and Bertgang father and daughter share an acquired knowledge in this field. The word "zoe" means life, not only life as opposed to the colorless, inanimate conditions of sculpture and death, but also life in its most natural, biological, instinctual forms.

Freud may have unconsciously overlooked one of his own motivations for equating Gradiva-Zoe's facility in snaring lizards with her capabilities as a psychoanalyst, namely his personal identification with Asklepios, the "blameless physician" of Greek antiquity. The archaeology of the Greco-Roman world is what most attracted Freud to analyze Jensen's novel in the first place. In the world of Greek mythology, the lizard-slayer, or Sauroktonos, is a version of the prophetic (seeing) Apollo and the curative, serpent-slaying physician, Asklepios. The lizard symbolizes Apollo's powers of divination as well as his role as a sun god, Helios, both of which are appropriate to the story of Gradiva, where the Mediterranean noonday sun produces foretelling hallucinations, the same circumstances that once brought Jensen to an "almost visionary" state in Pompeii.[20]

Gradiva's other credential, one that Freud does not mention overtly, and may have been an unconscious aspect of his text, is her similarity to another ancient statue, the *Apollo Sauroktonos* of Praxiteles (figure 43).[21] When he wrote *Delusions and Dreams,* Freud had seen two of the extant marble versions of Praxiteles's *Apollo Sauroktonos:* one at the Louvre during his residency in Paris, and the other in the sculpture galleries of the Vatican Museum in Rome on his trips there.[22] It is quite likely that Löwy showed a photograph of the Vatican *Sauroktonos* to Freud

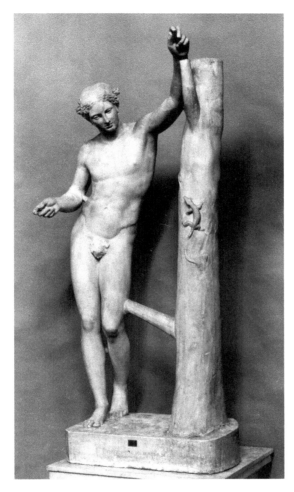

Figure 43. *Apollo Sauroktonos,* Gabinetto delle Maschere,
Vatican Museum, Rome. Photo Felbermeyer, Deutsches
Archäeologisches Institut—Rom, D-DAI-Rom 1-1968-3651.

during a visit from Rome to Vienna in these years. And it is significant that Freud may have discussed the Vatican *Sauroktonos* with Emanuel Löwy and debated its meaning.[23]

In any case Löwy illustrated the Vatican *Apollo Sauroktonos* with a photograph in *Die Griechische Plastik*. Löwy protested against Apollo's lizard-slaying having any mystical or symbolic significance, although he stated that in the past it was believed that Apollo's game had been associated with divination.[24] Whether or not lizard-slaying had a mantic significance in the *Apollo Sauroktonos* had already been debated in the art-historical writings of the nineteenth century.[25] In Löwy's personal experience the most avid proponent of mystical and symbolic meaning in the lizard-slaying activity of the *Apollo* may well have been Freud, who was interested in dream interpretation as it was practiced in ancient Greece and Rome.

In the opening pages of *Delusions and Dreams* Freud declared himself to be "a partisan of antiquity and superstition" when it came to dreams.[26] He stated that dreams were essentially fulfillments of wishes, and therefore prescient of future events, for "who could deny that wishes are predominantly turned toward the future?"[27] In a footnote added to the *Interpretation of Dreams* in 1914 he had referred at length to Apollo and Asklepios, of which Apollo Sauroktonos is a variant, as healers, and provokers of dreams to be interpreted by oracles and priests.

> Apart from the diagnostic value ascribed to dreams (e.g. in the works of Hippocrates), their *therapeutic* importance in antiquity must also be borne in mind. In Greece there were dream oracles, which were regularly visited by patients in search of recovery. A sick man would enter the *Temple of Apollo* or Aesculepius [*sic*], would perform various ceremonies there, would be purified by lustration, massage, and incense, and then, in a state of exaltation, would be stretched on the skin of a ram that had been sacrificed. He would then fall asleep and would dream of the remedies for his illness.

These would be revealed to him either in their natural form or in symbols and pictures, which would afterwards be interpreted by the priests.[28]

Freud's personal interest and identification with Asklepios must have endured, because H.D. dedicated one of her memoirs, "To Sigmund Freud, *blameless physician,*" and she continued the classical allusion throughout her reminiscence, asking, "Was not the 'blameless physician' Asklepios himself, reputed to be Phoebus Apollo's own son?"[29] With regard to Asklepios, she states in another passage that, "The serpent is a symbol of death, as we know, but also of resurrection"; and she characterized Freud as Asklepios, when she stated that even though he did not literally resurrect the dead, he brought children to life from "dead hearts and stricken minds."[30]

Apollo's temple at Pompeii looms large in Jensen's *Gradiva* as the site of a remarkable event that takes place in one of Hanold's dreams (figure 44). Gradiva lies down on the steps of the Temple of Apollo when Vesuvius erupts in AD 79: she is then covered with volcanic ash, and, falling asleep, becomes white and still, like a work of sculpture. Freud quoted this dream, with the metamorphosis of Gradiva from life to death, in *Delusions and Dreams* and interpreted at length as "an ingenious and poetical representation of the real event," namely that Hanold equated a statue with a living girl.[31]

It must also have been particularly meaningful for Freud that Jensen cast Zoe-Gradiva not only as a kind of Sauroktonos or lizard-slayer but also as "the daughter of the lizard-catcher," for Freud affirmed that her technique was his own technique, and that made her one of his pupils, or progeny.

The procedure which the author makes his Zoe adopt for curing her childhood friend's delusion shows a far-reaching similarity—no, a complete agreement in its essence—with a therapeutic method which was introduced into medical practice in

Figure 44. Photographer unknown, Pompeii, *Temple of Apollo,* postcard, 1908. Author's collection.

1895 by Dr. Josef Breuer and myself, and to the perfection of which I have since then devoted myself.[32]

Gradiva's lizard-catching facility was a clue to her identity as a doctor, a seer, and an awakener of the repressed erotic instinct. Her status as the old lizard-catcher's daughter indicated that she was practicing Freudian precepts in her work, precepts that seem unpalatable, even foolish, at first, but were proven remarkably graceful and efficient. It is also meaningful that Gradiva learned her craft of lizard catching (observing and curing) from her father. Bertgang can stand in for Freud, who was

trained as a zoologist by the Darwinian scientist Carl Claus (1835–99), hence his extensive knowledge of the sexual instinct in animals.

During his training in the marine biology laboratory at Trieste, Freud worked with sea eels, snake-like fishes, of which he dissected at least four hundred to determine their sex.[33] It is hardly far-fetched to equate sea eels with the serpent that was the attribute of the ancient bearded Apollonian physician Asklepios. But the lizard slayer had more erotic connotations than did Asklepios, the slayer of serpents. Sauroktonos was represented as a younger, more androgynous sub-type of Asklepios, more like an *erote* or an ephebe than a philosopher. In the mind of Freud, who was well educated in the history of ancient art, and acknowledged bi-sexuality as a universal phenomenon, the figure of an *erote* had a positive charge, as a force of human creativity.[34]

So yes, Gradiva seems to have learned the art of healing from Freud himself. Gradiva is Freud's adopted daughter and disciple, executing a perfect analysis, with precisely the mentality that Freud recommended in his greatest metaphor, that of an archaeologist.[35] Gradiva says:

> My father and I live in the "Sole"; he, too, had a sudden and pleasing idea of bringing me here with him if I would be responsible for my own entertainments, and make no demands upon him. I said to myself that I should certainly dig up something interesting alone here.[36]

The Gradiva of Freud's *Delusions and Dreams,* therefore, in addition to being an ancient sculpture *rediviva,* can be considered one of the earliest female practitio-ners of Freudian psychoanalysis.[37]

Sculpture, Photography, and Dreams

Beyond any other purpose, the scope of Freud's essay on *Gradiva* was to serve as a treatise on the interpretation of dreams. He announced himself on the first page of the essay as the author of *The Interpretation of Dreams*.[38] This announcement in the beginning of the essay is developed in the analytical sections, which distinguish latent from manifest content in Hanold's dream-memories according to psycho-analytic precepts.

We have already established that Freud's *Interpretation of Dreams* allowed for instances of framed images within the context of dream representations, as in the view of Ponte Sant'Angelo seen from a train window in his first Rome dream.[39] And photographs, like views from a stopped or moving train, were understood as living excerpts, "taken" from the flow of reality, from the continuum of time and space, and therefore subject to infinite extendibility and dynamism. Photographs of sculpture and sites, then, are appropriate to the mutable thought systems that define the dream space.[40]

Let us explore some of the ways in which photographs of works of art resemble dream images, both inside and outside of Freudian theory. The genre of documentary photography itself provokes a sense of detachment, like the Freudian concept of the dreamer's "spectatorship" within a dream. Likewise the Freudian "indifference" of a dream is comparable to the "deadpan" quality that is an expected characteristic of documentary photography. These analogies are enhanced by the particular resonance of our unconscious to the photographic medium—a medium that, like cinema, resembles the feigned reality of a dream as representation rather than perception.[41] The differences between *Vorstellung* (representation) and *Wahrnehmung* (perception) or *Empfindung* (sensation) constituted a philosophical

issue concerning the nature of consciousness that was of great interest to Freud and his contemporaries.[42] According to Freudian thought dreams are representations, made by the mind of the dreamer, as opposed to lived experience. Perception and sensation are felt (sensed) as received action in the moment. Photographs and dreams, instead, are constructions: both species of representation are associated particularly closely with direct experience for their truth-telling qualities. Dreams and photographs are representations that potentially reveal the truth in their own vivid forms, and in their naturalistic styles are often mistaken for memories or direct vision. The slippage between memory and remembered dream can be analogous to, and expressed by, the photographic medium.

Like dreams, the photographs of ancient sculpture in use at the beginning of the twentieth century were memorable, yet always intrinsically incomplete—fragments that were simultaneously illuminated and made indistinct by chiaroscuro in two dimensions. Just as the dream-image has been described by Freudians as a positive hallucination surrounded by an empty atemporal void, contemporary photographs of sculpture typically see the figurative image emerge from a dark ground, so that the sculpture, fragment, or architectural ruin seems to float; a moveable symbol, unbound by historical circumstances. Bodies and fragments are envisioned in a state of timelessness as if in the memory bank of the mind's eye. Among many such examples are the head of the *Hermes* from Olympia (figure 45), the Macpherson photograph of the *Laocoön,* and the Alinari photograph of a *Crouching Aphrodite* in the Vatican Museum (figure 46). These photographs are always involved with a melancholic retrieval of the past and therefore display the ghostly, revenant quality of things that are simultaneously present and lost forever.[43]

In Luigi Malerba's essay on the composition of dreams, he defines the mise-en-scène of twentieth-century dreams as kind of an abstract, metaphysical "limbo"

Figure 45. Photographer unknown, *Head of the Statue of Hermes by Praxiteles at Olympia,* plate 21 in Furtwängler and Ulrichs 1904. Author's collection.

that is fluid and without horizon, rather like cinematic space, a space of great mobility and subjectivity, the atmosphere of which is highly *sfumato* and liquid. Malerba observed that for years the black and white material of photography and cinema depended on a subjective application of "color," and that the same is true in the visual material of dreams. According to this reasoning, dream structures are probably inspired by visual models and therefore the ancient Egyptians would

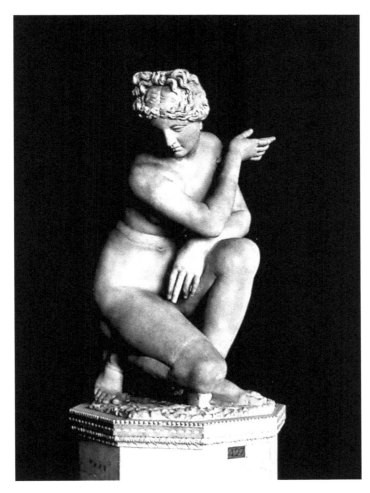

Figure 46. Alinari, *Crouching Aphrodite at the Vatican Museum*. Alinari/
Art Resources.

have dreamed differently from the Renaissance Italians. Plato's dreams would have been coded in his own cultural system versus Federico Fellini, who maintained that his dreams were based on the small gray screen of the television, and that every so often intervals like "advertizing spots" interrupted their flow.[44] The staging of stimuli in dreams corresponds to the stimuli of lived experience (*Wahrnehmung*) as well as those found in representation (*Darstellung*).[45] In fact, recent scientific research indicates that the whole idea of dreaming "in black and white" did not occur until people had black and white photographs and film to compare with the "real" world.[46] Or, perhaps, it took the invention and widespread use of color photography to isolate the phenomenon of dreaming in black and white. It is likely that the dream language between 1860 and 1930 was somehow in tune with the hushed chiaroscuro structure of black and white photography.

The dramatic use of chiaroscuro in photographic observation as well as dream language was part of the legacy of the famous *visuel,* Jean-Martin Charcot. Charcot not only used chiaroscuro in the psychiatric photography he pioneered with Duchenne, Regnard, and Londe. His examination room was painted entirely black, including the furniture, in order to set off the subject of examination to his inquiring gaze. In this setting of visual profundity he would observe and diagnose the patient, as his pupils, including the young Freud, who was particularly impressed with such demonstrations, looked on.[47] This technique of "staging" the physical behavior of a patient parallels photographic practices used in art-historical study, as in the Alinari *Crouching Aphrodite* where the museum setting is blacked out, and the sculpture is observed in dramatic isolation.

In terms of their primary referent objects, these photographs of art and artifacts already contain the qualities of plastic representation, condensation, displacement, symbolization, and dramatization that happen in a dream: a three-dimensional object in a museum setting becomes an essay in *sfumato* black and white. If this

scenography "gives life" to sculptured signifiers, photographic representations of art and archaeological material, in their very substance and structure resembled dreams.[48] Fabricated as they were to present a primary referent object for analysis, they were subject to an interminable inquiry by art historians, who looked into the photograph for truth about an object. This way, the staging techniques of photography as a medium were rarely analyzed in art history books, where the image was nestled in the text or framed with a descriptive caption. The visual qualities of any particular photograph (*sfumato,* chiaroscuro, retouching) remained, as did most photographic strategies and techniques, outside the conscious critique.

Emanuel Löwy: Interpretation and Desire

Freud's copy of Löwy's 1922 book on neo-attic art was inscribed, "Sigmund Freud/ für Gradiva d. vf" ("To Sigmund Freud for Gradiva from the author"), indicating that Löwy had read and appreciated *Delusions and Dreams.*[49] In a mood that was both psychological and photographic, Löwy proposed that early ("archaic," as defined by Winckelmann) Greek sculpture was to be understood according to a system of archaic "memory-pictures."[50] Löwy's *Errinerungsbilden* were not naturalistic but symbolic and subjective images, whose original impulses were "forgotten," left behind in pre-history, just as a child "forgets" the traumas of his infancy. Freud seems to have incorporated these ideas as he went along, because on a trip to Sicily in 1910 Freud wrote to Jung that for him Sicily was the most beautiful part of Italy, and had "preserved pieces of Greek antiquity, infantile reminiscences," and that the journey represented for him on a personal level a necessary wish-fulfillment.[51]

Emancipated as they were from the logic of reality, these archaic sculptural forms were like dream images or memory impressions. The quality of abstract

memory impressions was dramatized in the black and white photographs that Löwy used to illustrate his argument (figure 47). Memory images, of course were central to the psychoanalytic project, and Hanns Sachs coined the term *imago* for the unconscious mental pictures composed of memory traces.[52] In *The Aesthetics of Freud* Jack J. Spector has pointed to Henri Bergson's "Matter and Memory," in which he draws a distinction between pure memory and memory "actualized in an image."[53] The memory of selected photographic images was, and still is, of central importance for the cultural afterlife of classical antiquity.

One of the major accomplishments of Löwy's cathedra at the University of Rome was to outfit the study of ancient sculpture with reproductive technology. He founded a *gipsoteca* (museum of plaster casts) and a *fototeca* (archive of photographs) there in order to facilitate the comparative study of Greek and Roman objects from various chronological periods that were conserved in different parts of the world.[54] Using these tools, Löwy taught not only his own students but also those from Adolfo Venturi's classes on medieval and modern (Renaissance) art history in the 1890s, explaining the influence of ancient sculpture on Renaissance painters such as Raphael with photographs and casts.[55] Venturi was also an enthusiastic proponent of the Morellian method—the "new" art history of the time—that guided Freud's essay on Michelangelo's *Moses*.

The personal photo-archive that Löwy brought back to Vienna with him in 1915 included commercial photographs by Austrian, French, and Italian firms. These commercial prints are accompanied by a collection of unsigned photographs from museums, sites, and collections worldwide. These last consist of uniformly mounted prints in smaller and larger formats, some of which are marked to indicate cropping for publication. The camera operator and printer of this group is unknown, but presumably they were made to order for Löwy's archive in Rome, and were used in instruction as well as publication. In this group of images the

Figure 47. Photographer unknown, side and back views of *Nikandre*. Löwy Nachlass, Institute of Classical Archaeology, Vienna.

sculptured figures appear illuminated in chiaroscuro against a dark ground, which was accomplished by placing a dark curtain behind the work of art in both indoor and outdoor settings.

Among the more striking images commissioned by Löwy was the famous *Oedipus Kylix* (Vatican) so often used as an emblem for Freud's theories and the original logo for the journal *Imago* (figure 48). Photographs of plaster casts of the *Charioteer of Delphi* (figure 49), the *Athena Lemnia* (Bologna) in plaster pastiche (figure 50), and the profile view of *Apoxyomenos* (Vatican) shown with a plaster cast of the bronze Hellenistic *Praying Boy* (Berlin) (figure 51) have a particularly strong graphic impact. The Berlin boy, whose arms are restored, is shown in profile to duplicate the stance of the plaster *Apoxyomenos* in the same psychological picture space. But the two statues reside in the space of time rather than in a logical unified picture space: the originals in Rome and Berlin are neighbors only in this image. Similarly "unreal" is the headless statue of Athena in Dresden, copied in plaster, and completed with a plaster reproduction of the stupendous *Head of Athena* from the archaeological museum in Bologna. On the pages of the *Naturwiedergabe,* for instance, the plaster composite statue of *Athena Lemnia* is thus restored, made whole again for the photographic record, then rendered seamless as glimpsed in a tiny chiaroscuro photograph. Such an image would have been especially meaningful to Freud, who visited the Museo Civico of Bologna on 1 September 1896, where he saw the striking head of Athena.[56]

A stark set of photographs of the archaic style *Nikandre* stresses the necessarily frontal and geometric symbolism of the statue as *Errinerungsbild*. And at the other end of the spectrum in this group of pictures is the Hellenistic (or Roman) *Girl from Anzio,* a naturalistic statue photographed three-quarter length in chiaroscuro according to deliberately naturalistic norms of shades of gray (figure 52). The girl is animated, observed as though she were caught in the moment of pausing in a

Figure 48. Photographer unknown, *Oedipus Kylix*, Vatican Museum,
Rome. Löwy Nachlass, Institute of Classical Archaeology, Vienna.

doorway as she glances down at the salver holding ritual objects. This photograph,
taken at the Museo delle Terme (National Museum) in Rome functions not as an
image of a statue, but as a modern, caught-action photograph of a young woman
in ancient times, as she moves through a domestic interior space. With her slip-
ping draperies and downward glancing gaze, she is a statue brought to life by way
of photographic shadow and light. The individual structures of each photograph—
from the *Nikandre* to the *Girl from Anzio*—serve to prove Löwy's theory that Greek
sculpture evolved over the ages from abstract and symbolic to pictorial and natu-
ralistic. Styles of photography are used, consciously or not, to represent the period
styles of Greek sculpture.

Figure 49. Photographer unknown, *Plaster Cast of the Bronze Charioteer of Delphi*. Löwy Nachlass, Institute of Classical Archaeology, Vienna.

Figure 50. Photographer unknown, *Plaster Pastiche of Athena Lemnia.*
Löwy Nachlass, Institute of Classical Archaeology, Vienna.

Figure 51. Photographer unknown, *Plaster Casts of Apoxyomenos and Praying Boy*. Löwy Nachlass, Institute of Classical Archaeology, Vienna.

Figure 52. Photographer unknown, *The Girl from Anzio*. Löwy
Nachlass, Institute of Classical Archaeology, Vienna.

In his published work Löwy combined the two reproductive mediums of major works of Greek sculpture, creating photographs of plaster copies. From the first still-life photographs of the nineteenth century, plaster copies of classical sculpture were popular and effective subjects.[57] They were venerable, recognizable objects that did not move, and were particularly photogenic in terms of holding and reflecting the ambient light; these objects had a similar effect in the documentary illustrations for art history books.

On the page facing the thrice-removed *Athena Lemnia* stands the *Charioteer of Delphi*—an important bronze original from the early Classical period (ca. 470 BC) of Greek art.[58] Ironically, even though the *Charioteer* at Delphi is one of the very few bronze Greek originals extant (as opposed to Roman marble interpretations of Greek bronze prototypes) it, too, is photographed as a white plaster copy, in order to absorb and reflect the photographic light to a maximum effect in chiaroscuro. In *Die Griechische Plastik* this technique creates somewhat distant, romantic, hushed images of whole, glowing sculptured figures emerging, as if from the shadows of the past, with a soft but dramatic impact. This mode of representation is especially compelling in the photographs of nude Venuses, which have inherently erotic content. For this reason we may step aside for a moment to look at the cultural phenomenon of human beings who have fallen in love with statues.

Lithophilia

Cesare Musatti introduced the term "lithophilia" (fetishized erotic love of statues) in his commentary on Freud's *Delusions and Dreams*.[59] Freud had stated that, "a psychiatrist [of the less imaginative stripe] would perhaps place Norbert Hanold's delusion in the great group of 'paranoia' and possibly describe it as 'fetishistic

erotomania,' because the most striking thing about it was his being in love with the piece of sculpture."[60] But somehow Musatti's sweeter, more Italianate nomenclature of *litofilia* or lithophilia might have pleased Freud, as it has a more profound and positive resonance in cultural history.

Statues and dolls, or any other three-dimensional representations of the human body, call for a particularly empathetic reception by those who would view or touch the object. The human physicality of such an object insists that we converse with statues in a special way, frequently referring to the inanimate objects as "he" or "she." Lithophilia is a condition that is characteristically recognized in the Greek myth of Pygmalion and Galatea, where the sculptor falls in love with an ivory statue of his own creation, lies beside her, and prays to Aphrodite that his statue come to life. The ivory turns to flesh under the sculptor's touch, and according to the Roman poet Ovid bruises of passion can now be inflicted on her living body.[61] But even outside the realm of psychoanalysis or mytho-poetics, lithophilia is a recurrent theme in the history and writing of Western art. Lynda Nead has written about the pan-European phenomenon of what she calls, using a term introduced by Havelock Ellis in 1905, Pygmalionism. Nead maintains that the story of Pygmalion had a renewed popularity in the visual culture of the late nineteenth century, with the advent of mutoscopes, cinema, and other kinds of moving pictures.[62] What is interesting is that just as Freud was analyzing Hanold's personality in Jensen's *Gradiva,* Havelock Ellis wrote about Pygmalionism in male psycho-sexuality in his *Studies in the Psychology of Sex.*[63]

By the nineteenth and early twentieth century the erotic lure of the proverbial "statue-come-to-life" was a major component of the Romantic ideal of the Classical tradition. The simile of a woman as beautiful as a classical (marble) statue was common throughout Europe, from praises of the Princess Torlonia to Parisian actresses and dancers and painters' models. In the softer French erotic photography

that circulated in Freud's Vienna (figure 53) women were often clothed in a kind of "body-stocking" to give them the smooth, marmoreal skin of a statue. Indeed, one of the most defiantly sensational pictures of the century, Manet's *Olympia* (figure 54) disturbed critics precisely in the rendition of female flesh that was all too vulnerably human and lacked the overall luminescent marble glow of classical statuary. On a more reactionary end of the spectrum, a painting such as Gérôme's *Pygmalion* (figure 55), represents the sculptured Galatea as a marble nude who, even come-to-life, will transcend the imperfections of human mortality for the delectation of the lover/beholder.

Pertinent examples of this phenomenon in Freud's ambience can be seen in a photograph of the headless *Aphrodite* at the National Museum in Naples (figure 56), and in the image of the *Aphrodite of Syracuse* that was reproduced in the various editions of Gerhart Rodenwaldt's beautifully printed volume *Die Kunst der Antike* on Greek and Roman art (figure 57). In both cases, the *Aphrodite* statue's decapitation is negated by cropping so that the torso is at "eye-level" in the Löwy photograph, and by a chiaroscuro back view similarly cropped in Rodenwaldt's book. Both images are photographed in tactile *sfumato* bringing the statue to life in an ambiguous but palpable space, so that she is more of "a living statue" than any painting of a living nude model could be, or indeed, any broken statue stumbled across in a museum setting.

Here the medium of photography translates what is durable, breakable, and stationary into the mutable, oneiric language of a daydream or a dream. Illustrated books on art and archaeology were designed for a kind of sustained *Schaulust* or scopophilia, combining the love of looking with the thrill of déjà vu. Such airy, voluptuous surrogates could obviously lead to the anxiety of Freudian derealization when a viewer was confronted with the cold broken stones that resided in museums.

Figure 53. Photographer unknown, *Girl with Hat and Flowers,* postcard, Paris, ca. 1880. Viennese provenance. Author's collection.

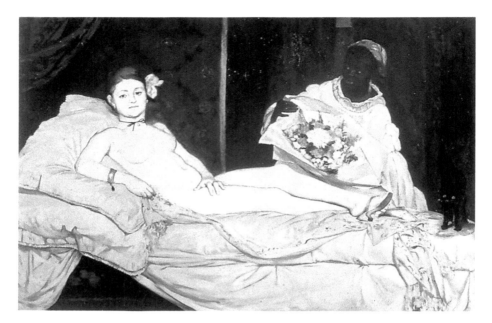

Figure 54. Manet, *Olympia*, 1863. Musée d'Orsay, Paris. Photo by author.

At the same time images such as these are essentially melancholy in that they communicate a sense of loss. Loss is expressed in the injury to the statues, that is, the loss of head and limbs that is so exquisitely repaired in the chiaroscuro weaving of the photograph. The desiring beholder of these photographs feels an acute loss of the past (antiquity), for that is the nature of the archaeologist's work.[64] These nude figures are depicted as Gradiva-like revenants of the absent statue itself. Indeed they speak of the unbearable absence of the goddess Aphrodite in the world of the modern historian.

Printed photographs, with their smooth, sometimes actually varnished, skin of "overallness," were able to "naturalize" any disjunctive or disturbing elements,

Figure 55. Jean-Léon Gérôme, *Pygmalion and Galatea,* oil on canvas. New York, Metropolitan Museum of Art. Gift of Louis C. Raegner, 1927 [27.200]. Metropolitan Museum of Art.

Figure 56. Photographer unknown, *Headless Aphrodite* at
Naples, National Museum. Löwy Nachlass, Institute of Classical
Archaeology, Vienna.

Figure 57. Alinari, *Aphrodite of Syracuse,* in Rodenwaldt, 1927.
Alinari/Art Resource.

from archaeological interventions (restoration of bodies), to pain, fear, or shame, all the while maintaining an appropriately romantic or scientific sense of distance, and finalizing the archaeological record. The act of using such books for historical (scientific) study seems even to have trumped the (at least theoretical) Jewish taboo on gazing at naked statues of anthropomorphic deities. This was true for thinkers like Löwy and Freud as well as others. Similarly, in the Italian world, a published engraving (figure 58) shows Pope Pius IX admiring (or perhaps even blessing) a nude pagan nymph—an event only likely in the nineteenth century when sanctioned by the scientific context of archaeological (scientific) knowledge.[65]

In much the same way as Hanold's archaeological interests turned to lithophilia when provoked by the sight of *Gradiva* in a plaster reproduction, a latent lithophilia, or fetishized attraction to stone sculpture as a love object and surrogate for a living body, was present in some of the most commonly reproduced photographs and text-captions of the time. In Löwy's textbook on Greek sculpture for instance, he accompanied an Alinari photo of the *Capitoline Venus* (figure 59) with the statement, "one can really feel the softness of her flesh." He invites the viewer to imagine the bathwater of the crouching Vatican *Aphrodite* (see figure 46), "the sensation of the waiting bathwater is already lightly perceptible," and her sensory ability to feel it.[66] All of these observations open the realm of classical statuary to the sensorium of tactile pleasures.

The fact that Norbert Hanold's revulsion toward real women was countered by his attraction to classical statue was a common theme in nineteenth-century European culture. For instance the French critic Théophile Gautier, who was thoroughly intrigued with the cast of a woman's breast in the ashes of Pompeii, remembered his shock upon first seeing a nude model in the art academy, and later confessed that he continued to prefer statues to real women.[67] Viewing photographic studies of classically posed naked models, such as Eugène Durieu's nude (figure 60),

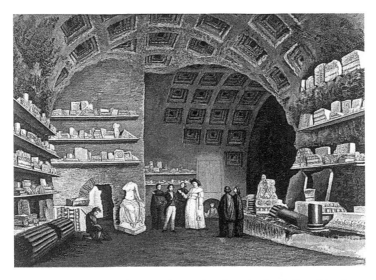

Figure 58. Engraver unknown, *Excavations from the South-East Side of the Palatine with Pope Pius and Fragment of a Goddess,* in Cacchiatelli and Cleter, 1865, vol. 2, plate 1a. Avery Library, Columbia University, New York.

crouching like a bathing Venus beside an urn, raised an awareness of the disjunction between the idealized subject and the physical human reality of the anonymous model. She is a living, mortal woman with body hair, blemishes, dirty feet, a model's prop for her legs, and the capacity to feel fatigue. Embedded in Durieu's photograph is the notion expressed by Camille Lemonnier in 1870 that "Nude is not the same as undressed, and nothing is less nude than a woman emerging from a pair of drawers or one who has just taken off her chemise."[68] Perhaps inadvertently inscribed in Durieu's photograph is the more overarching contempt for women, typified in some of the writings of Baudelaire and the Goncourt brothers, where French nineteenth-century men considered women to be "stupid animals"

Phot. Alinari
198 a

Phot. Anderson
197 b

Phot. Anderson
197 a

Figure 59. (Left and above) James Anderson, *Capitoline Venus,* published in Löwy 1911, Figure. 197a (extreme right of Plate 109). Alinari/Art Resource.

Figure 60. Eugene Durieu, *Nude by Urn,* Salted paper print, ca. 1855. George Eastman House: International Museum of Photography and Film, Rochester.

good only for breeding, and abominable creatures for their most human or "natural" qualities.[69]

Freud was not immune to the guise of respectability provided by classical antiquity. Perhaps in the same way as he dared to speak of the imagined memory of his own mother's nudity only in Latin "matrem...nudam," Freud poured over figures like the female body, and the dead-come-to-life, and even returned the gaze of the castrating Medusa, in terms of photographic representations of ancient sculpture.[70] Bodies clothed in the garb of classical nudity constitute a prime case of the disguising of content (nakedness) with form (nudity *all'antica*), just as it could happen in screen memories or dreams.

In Freud's day the *Aphrodite* from Melos, or *Venus de Milo,* at the Louvre was still a focus of great visual attention and historical controversy. She was the object of tendentious studies by the French art historians Jean-Gaspard-Félix Ravaisson, Salomon Reinach, and the German Adolf Furtwängler.[71] Saved from the lime kilns and brought to the Louvre in fragments in 1821 the statue almost immediately acquired a legendary character. At the turn of the nineteenth century the critic Paul de Saint-Victor claimed that the armless, half-nude figure "reduced all would-be masterpieces to an inferior rank."[72] Although the sacrosanct aesthetic virtue of classical antiquity brought any such statue beyond reproach in the eyes of cultural savants, she was also commonly thought to have an erotic appeal that bordered on damaging the public good.

According to Peter Fuller in his psychoanalytic essay titled "The Venus and 'Internal Objects'," the *Aphrodite* from Melos became a cultural symbol of the female body in a society already obsessed with comparative anatomy, disputed reconstructions, and contentious historical origins.[73] The Hellenistic *Aphrodite* was disinterred, excavated, resurrected, and brought back to life at the Louvre for the delectation of the public in a grand gesture of historical necrophilia.

The statue of Venus was also brought to life in photography, and because for Europeans throughout the nineteenth century classical sculpture was still the absolute *primo mobile* of figurative art, the Louvre *Venus* was represented by photographers like Henri Braun in terms of a romantic, classical mystique. Many of the early Braun photographs are invested with profound art-historical and historiographic insights. In his photograph of the *Venus de Milo* (figure 61) the inanimate female nude looks back, consciously or not, to a prephotographic, even Giorgionesque, mode of representing classical sculpture. Braun's depiction of the *Aphrodite of Melos* engages the beholder's imagination: one restores the image to that of a whole, if ultimately unavailable, woman, like the Syracusan *Aphrodite* in Rodenwaldt's book. The dreamy mood of Braun's photograph and the tonality of enveloping shadow allow the viewer to deny the famous Aphrodite's lack of arms—the reverse of a negative hallucination. In the act of beholding the photograph, then, the spectator transforms into a sort of Pygmalion, and brings her to life.

This is opposed to the previously standard mode of representation used on the pages of the *Gazette des beaux-arts* in 1886 (figure 62)—a linear engraving in which the contours of the statue's body are emphasized and her drapery rendered in crisp cross-hatching, giving the image a diagrammatic "paper-doll" look.[74] In Braun's *Aphrodite*—as, not coincidentally, in Giorgione's *Concert Champêtre* (figure 63) which was also on view at the Louvre—the beholder is implicated in the poetic experience through the deliberate absence of explicit information.[75] On a more explicit, academic note, the French philosopher Félix Ravaisson (1813–1900) had reconstructed the *Venus de Milo* in an interaction with the *Borghese Mars,* creating an interactive ensemble of plaster casts that were photographed together for the archaeological record (figure 64).[76] For Ravaisson, who was curator of antiquities at the Louvre, *Venus* required *Mars* as a partner in the archaeological imagination. Ravaisson's hypothetical restoration was based on intuiting the movement of *Venus*'s

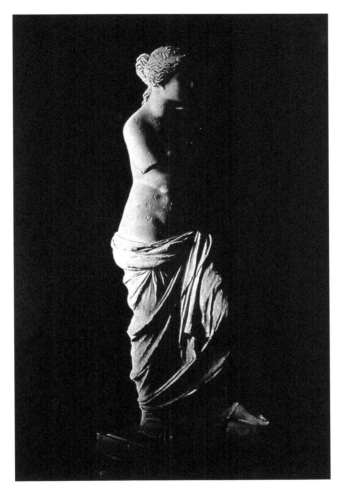

Figure 61. Henri Braun, *Aphrodite from Melos* ("Venus de Milo"), Carbon print, ca. 1871–72. Collections of The New York Public Library, Astor, Lenox and Tilden Foundations.

Figure 62. Hurel, *Venus De Milo. Gazette des beaux arts* 17-1 (1864): 299. Author's collection.

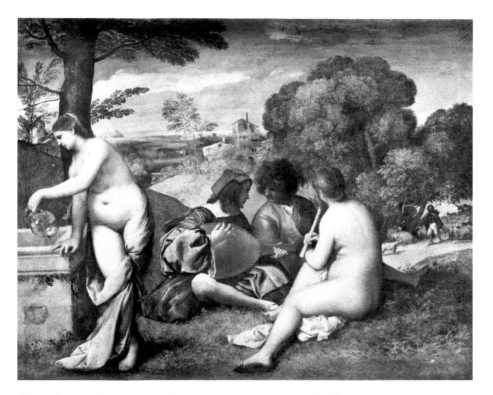

Figure 63. Giorgione, *Concert Champêtre,* ca. 1504. Louvre, Paris. Alinari/Art Resources.

arms from the morphology of her torso. It is no coincidence that Ravaisson advocated the use of artistic photographs of ancient masterpieces in art education.[77]

Freud wrote to his fiancée Martha from his residency in Paris in October 1885 that visiting the antiquities at the Louvre was like experiencing a dreamlike world ("eine Welt wie ein Traum"). He noted that he "saw the famous *Venus de Milo* without arms and paid her the usual compliment."[78] By this time, Freud had probably

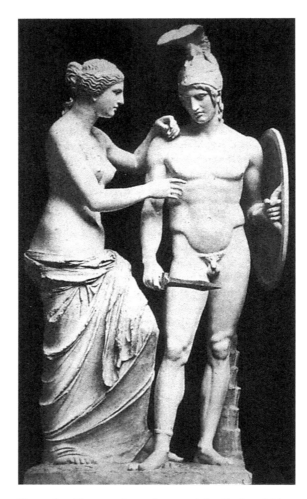

Figure 64. Photographer unknown, *Aphrodite from Melos
with the Borghese Mars,* ensemble created by Jean-Gaspard-
Félix Ravaisson, 1860s, photo from Curtis 2003.

seen numerous photographs of the statue, in which the setting was negated, and the statue emerged from deep soft shadows in a three-quarter view. The pervasive darkness that veils her gaze into the distance makes the figure psychologically unavailable to the viewer and creates a suggestive representation of the past made present. Paradoxically, the same softening shadows that deny the true hardness of the material enhance the viewer's sense of tactile intimacy and simultaneously evoke the goddess's historical and emotional distance. It is as though desiring viewers were forced to pull the image forth from a place in the preconscious mind at the same time that they retrieve the sculpture psychologically from beyond the barrier of time past, thereby creating a world as in a dream.

Even the gaze emanating from a marble head as perceived photographically could engender lithophilic romance. This is nowhere more apparent than in the *Head of Aphrodite* (the so-called *Bartlett Aphrodite*) as photographed around 1900 and published by Maximilian Ahrem (figure 65). The original photograph was probably made by Baldwin Coolidge, a staff photographer, at the Museum of Fine Arts, Boston, around 1900. The photographer interpreted the head, which is believed to be by a younger contemporary of Praxiteles, into a deeply contemplative, warm, absorbing image. His rendering conveys the proverbial *zerschmelzenden* (melting) gaze of the quintessential sculptured Hellenistic Aphrodite, which was derived, in the Bartlett head, from Praxiteles's paradigmatic *Aphrodite of Knidos*. In this photograph, which was present in Freud's library, the melting, softly rendered gaze of the sculpture is returned by the softened gaze of the photographer.

The sensation of romantic mystery exuded by this image is paralleled in an essay about the *Bartlett Aphrodite* written five years later by Henry James. When James visited the United States after a long absence, he wrote, among other observations, a charming essay about the Bartlett head titled "The Lonely Aphrodite," in which

Figure 65. Photographer unknown (Baldwin Coolidge?), *Bartlett Aphrodite,* in Ahrem 1914. Freud Museum, London.

he proclaimed it well worthwhile to cross the Atlantic to see the genius of ancient Greece in the "American light." As he encountered the Bartlett head, James experienced "feelings not to be foretold." He described the disembodied fragment in an ekphrastic reverie on its disjuncture of time and place:

> The little Aphrodite, with her connections, her antecedents, and her references exhibiting the maximum of breakage, is no doubt as lonely a jewel as ever strayed out of its

setting; yet what does one quickly recognize but that the intrinsic luster will have, so far as might be possible, doubled?[79]

The isolation of the fragment that James construed is at the cultural heart of the photograph published by Ahrem. His poetic use of light to create the Leonardesque effect of *sfumato* speaks of a desired but remote and unknowable past in the life of the statue, and communicates the temporal and psychological chasm between *Aphrodite* and her beholder. The "intrinsic luster" of the statue, doubled in its fragmentation, has, in photographic representation, been redoubled.

Sigmund Freud owned a copy of Ahrem's *Das Weib in der antiken Kunst* (*Woman in the Art of Antiquity*), where Ahrem (who may himself have known the fragment better from the photograph than from real experience in Boston) also fell into the lonely *Aphrodite*'s thrall. His text speaks of the softness of the sculptural modeling and the softness of the statue's state of mind, describing the gaze as lovingly dreamy, distant, and indistinct. The eyes, of which the lids are partly closed, beckon the viewer, says Ahrem, with a sweet promise of love. For Maximilian Ahrem, such a dusky gaze exerted great power on "fleshly desire and the life of the emotions" of the beholder.[80]

Freud said of Norbert Hanold's obsessions that "The scientific motivation might be said to serve as a pretext for the unconscious erotic one, and science [in the novel] had put itself completely at the service of the delusion."[81] Much of the same could be said of archaeological photography in general, where although the pretext was one of science in the service of classical Humanism, the image arrived as a sensual and romantic instrument of subjectivity, as in the Naples *Aphrodite* in Löwy's collection. In the world of archaeological photography, disparate, lost fragments of bodies expressed a charm all their own, recalling the dark tenor of Marguerite Yourcenar's essay, "That Mighty Sculptor, Time," where she comments

on a fragmented "torso that no face can prevent us from loving" ("torse que nul visage ne nous defend d'aimer").[82]

Body and Mind

Medicine, psychology, and art history all used photography of the body as a diagnostic tool for the relation of physical to psychic states. In his discussion of Hellenistic sculpture, where the interior psychic state of each fragment is explained in terms of physical morphology, Löwy articulated the various states of pain, anguish, passion, drunkenness, sleep, and death. Photographs by Bruckmann, Anderson, Gargiolli, and Alinari are arranged in striking layouts where cropped details are juxtaposed with views demonstrating relative states of sleep, pain, and drunkenness (figure 66).[83] These works include the *Sleeping Maiden*, the restored *Erinye*, and the *Barberini Faun*. Equally dramatic are the pages that show the pathos of the head of an anguished old woman, the *Old Fisherman*, the *Dying Gaul*, and other specimens of Hellenistic/Roman sculpture.[84] With regard to his emphasis on the affective results of the senses, two Gargiolli photographs of standing satyrs are presented with maximum chiaroscuro dramatization (figure 67). Löwy states that, "Over his face plays a friendly smile; he tastes the rapture of the drink which he presents."[85]

In his characterization of statues of the goddess of love, Löwy's descriptions seem to conform more closely to the photographs—photographs as evanescent shadows and distillations of form—than to the marble sculptures per se. Photography is employed here as a transformative medium through which, in the *Venus Medici,* "the whole form melts into a play of shadows and light."[86] Once the precept that the hallmark of Hellenistic sculpture is the naturalistic representation of

259 b

Phot. Bruckmann

Phot Anderson

260

Phot Gargiolli

261

Figure 66. Emanuel Löwy 1911a, plate 150, with photographs by Bruckmann, Anderson, and Gargiolli. Art and Architecture Collection, Miriam and Ira D. Wallach Division of Art, Prints, and Photographs, The New York Public Library, Astor, Lenox and Tilden Foundations.

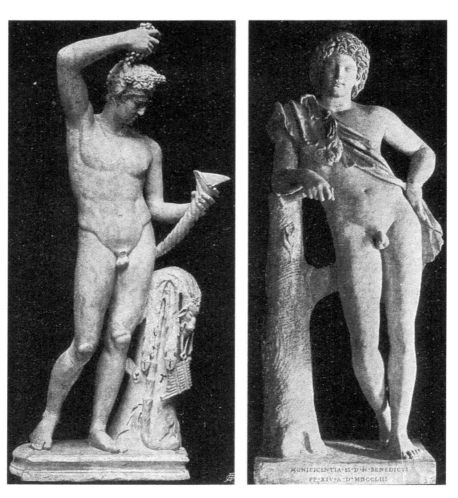

Figure 67. Emanuel Löwy, *Die Griechische Plastik* 1911a, plate 77, with photographs by Gargiolli. Art & Architecture Collection, Miriam and Ira D. Wallach Division of Art, Prints and Photographs, The New York Public Library, Astor, Lenox and Tilden Foundations.

transitory emotional states is firmly established, the statues talk back to modern readers in precisely those terms in representation. (This phenomenon was already observed in the various styles used to represent female statuary in Löwy's own photo archive, from the *Nikandre* glowing in the dark as a static presence to the *Girl from Anzio* captured in a complex transitory state.)

In addition to bringing the nuances of lived experience to the appreciation of ancient art, in art history, the photography of sculpture was called upon to actually explain human nature. For Löwy and his readers, and for many subsequent generations of art history students, photographs of Hellenistic sculpture have served as a guide to the human emotions and affective states. The use of photography in the art of deciphering particular mental states and their causes would have been familiar to Freud from his early studies with Jean-Martin Charcot in Paris and the photographic documents published in sources like the journal *Nouvelle Iconographie.* We recall that Duchenne used photographs of ancient works of art (most saliently the Laocoön) and photographs of psychiatric patients as transparent windows of evidence for the diagnosis of psychic states such as fear, hysteria, or pain. On the other side of the coin, in a parallel manner, hallucinations, dream-images, conscious wishes, or unconscious erotic motivations were also visible in the photographs of ancient sculpture published in this period. And here we see the seductive photographs that Löwy published of the *Apollo Belvedere,* the *Capitoline* and *Medici Venuses,* and the standing *Fauns* from the Capitoline Palace. With every minute detail lovingly described by Löwy in his text, these photographic images were contemplated at length by the reader, for their spiritual and psychological (*geistig*) value as much as for archaeological or historical information.

We have seen in chapter 1 that the psychological literature published by Charcot's group was frequently illustrated with photographs of human subjects and works of figurative art, particularly Greco-Roman sculpture. Eros was depicted in

the medical photography of sculpture and antiquarian objects in Freud's study. An article titled, "Deux Cas d'Ermaphrodisme Antique," by Henry Meige in the *Nouvelle Iconographie* of 1895 was illustrated with photographs of the *Sleeping Hermaphrodites* at the Uffizi and Borghese collections (figure 68), and a plaster-cast of the Berlin (Staatliche Museen) "*Hermaphrodite*" in its unrestored state.[87] The same article featured pages of ancient *Erote* figurines from the Necropolis at Myrina (figure 69). These small Hellenistic terracotta *Erotes* (ca. 150–100 BC) illustrated in the *Nouvelle Iconographie* were partly from the collections of Salomon Reinach (1858–1932), archaeologist and director of the museum at Saint-Germain-en-Laye. Freud knew Reinach's five-volume *Cultes, Mythes, et Religions* (1905–23) citing it in his own *Totem and Taboo*.[88] The photographs were utilized here to illustrate human developmental aberrations that Meige designated as "Infantilisme" and "Feminisme."[89] Freud was familiar with this article, and with Charcot's retrospective medical diagnoses of modern conditions in works of art from the past.[90] But Freud's response to these sculptured figures, and their appearance in photography (flying and pirouetting in the air without visible props) was less literal-minded than that of Meige, who compared them didactically with photographs of living humans afflicted with what he called "Hermaphrodisme Antique" (figures 70 and 71).

In the mind of Freud, who was educated in the history of ancient art, the *Erotes* seem to have had a more positive charge. In Freud's own consulting rooms a terracotta *Erote* figure from Myrina stood in a central position in a glass case at the foot of the couch where patients could gaze on it during analytic sessions.[91] In Freud's view the *Erote* represented the most vital of life forces, a personification of libido, the "Lebenstrieb" of *Beyond the Pleasure Principle*. Freud expressed the idea in *Civilization and Its Discontents,* and elsewhere that eros was the motor of human creativity.[92]

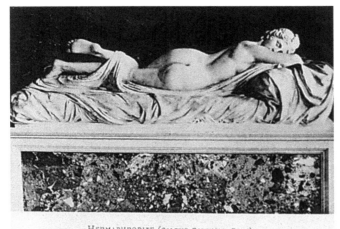

HERMAPHRODITE (GALERIE BORGHÈSE, ROME)

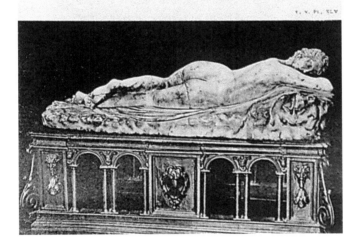

Figure 68. Albert Londe, reproduction of photographs of *Sleeping Hermaphrodites* from Rome, Borghese, and Florence, Meige 1895. Archives and Special Collections, Columbia University Health Sciences Library, New York.

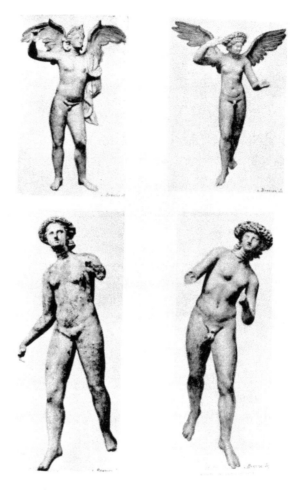

Figure 69. Albert Londe, *Ancient Hermaphrodites,*
Terracotta sculptures from Myrina from the Pottier and
Reinach Collections, in Meige 1895. Archives and Special
Collections, Columbia University Health Sciences Library,
New York.

Figure 70. Albert Londe, *Case of "Hermaphrodisme Antique,"* in Meige 1895. Archives and Special Collections, Columbia University Health Sciences Library, New York.

Figure 71. Henry Meige, *Case of Infantilism in a Nineteen-Year-Old Boy,* in Meige 1895. Archives and Special Collections, Columbia University Health Sciences Library, New York.

The Visual Imagination

At the risk of some redundancy, it is important to remember that through photographic illustrations, Freud's knowledge and visualization of mythical forms was far more varied, and memorized in a more graphic form, than the examples he would have known directly from his personal collection, the Vienna museums, or other collections he visited. In the pages of books he owned by Ahrem, Löwy, Furtwängler, and others, were an abundance of sphinxes, *eroi,* and even a gorgeous *Medusa,* swimming in the chiaroscuro of a dreamlike reality. Adolf Furtwängler and H. L. Ulrichs's *Denkmäler Griechischer und Römischer Skulptur* (*Monuments of Greek and Roman Sculpture*), with its richly printed photographs was a key image-bank in Freud's library. The photograph of the *Rondanini Medusa* (Munich, Glyptothek) they published is an arresting image of a beautiful object in which the head of Medusa fills the page in a horizontal format (figure 72). When Freud wrote his essay on *Medusa's Head* in 1922 he was familiar with a plaster copy of the *Rondanini Medusa* from the Academy of Fine Arts in Vienna.[93] But the photograph is a more expressive and dramatic than the cast, and was present in his visual field, accompanied by a vivid text, whether it remained in his optical consciousness or slipped in through the optically unconscious means.[94] According to Freud, a decapitated Medusa's head represented castration, and not only that, but: "If Medusa's head takes the place of a representation of the female genitals, or rather if it isolates their horrifying effects from their pleasure-giving ones, it may be recalled that displaying the genitals is familiar in other connections as an apotropaic act." Indeed, the male viewer's reaction to a Medusa head results in just that: "The sight of Medusa's head makes the spectator stiff with terror, turns him to stone. Observe that we have here once again the same origin from the castration complex and the same transformation of affect! For becoming stiff means an erection."[95]

Figure 72. Friedrich Bruckmann, *Medusa Rondanini,* plate 13 in Furtwängler and Ulrichs 1904. Author's collection.

Sarah Kofman has argued that, "the inseparable blend of horror and pleasure," the thrill that the sight of Medusa brings to a male is based, in Freud's thought, on the fact that the power of a woman's genital organs always has its apotropaic counterpart in the erection of the male.[96] Adolf Furtwängler's text, which accompanied and described the photograph of the *Rondanini Medusa,* emphasized precisely those issues that would concern Freud, namely the congealing of blood in the mortal viewer of any Medusa and the terrible dentilated mouth (*vagina dentata*) of the sculpture in Munich.[97]

Furtwängler and Ulrichs state that the *Rondanini Medusa* represented not Goethe's "stare of death" but rather "a demonic creature at whose aspect the blood of mortals congealed in their veins and turned them to stone." But even if the final affect was an apotropaic erection, it was the threatening, slightly open, mouth of the decapitated head of *Medusa* that was pointed out to the readers of the *Denkmäler* in a gripping reference to the photograph:

> The strictly symmetrical design also increases the demoniacal effect. The evenly balanced overspread wings form a horizontal mass, which has a gloomy, oppressive effect on the whole. The lines converge in the manner of an isosceles triangle and meet where the terrible expression of the whole is concentrated in the half-open mouth.[98]

Indeed, Furtwängler directed the reader's attention to the illustration from the very beginning, with the idea that "Most of the expression is in the mouth, which is unusually large and slightly open, the upper teeth being visible."[99] The photograph and its textual ekphrasis in *Denkmäler* had both agency and reflective power in the cultural systems that supported and received Freud's theories. Without reducing Freud's reading and viewing of Furtwängler's *Denkmäler* to a simple formula of cause and effect, we can appreciate the way in which published photographs and their art-historical texts entered the visual imagination—both individual and collective, both conscious and unconscious—of psychoanalytic modernity.

Let us attempt to reimagine, for a moment, the visual imagination of Sigmund Freud—Freud not necessarily as a theorizing psychologist, but as a typical reader of Jensen's *Gradiva*—and of Jensen himself, together with their contemporary readers. As Sander L. Gilman has pointed out, Jensen employed a concept of memory that was mimetic, representational, and real, like the condensed

composite photographs published by Francis Galton.[100] Gilman states that for Freud, "Galton's photographs became the central model for visualizing how the unseen processes of the psyche work."[101] In Freud's "R-is-my-uncle" dream, the face of his uncle Josef, superimposed on that of a friend ("R.") was "like one of Galton's composite photographs."[102] Similarly the photographic material as it appeared in books like those by Löwy, Ahrem, Mau, Lanciani, and Furtwängler, can be brought to bear and implicated in the process of imagining the fantastic and novelistic text by Jensen, as well as single mythological beings like Apollo or Medusa.

In Furtwängler's widely read *Denkmäler* the *Medusa* from the Munich Glyptothek and the Praxitelean *Hermes* from Olympia (see figure 45, p. 132) are rendered in close views where the coldness of *Medusa*'s gaze and the warmth of that of *Hermes* are available for close contemplation. They are presented with the visual subtlety and emotional specificity of human memory and they enter the reader's mind as already remembered images. As in the tender embrace of the *Orestes and Elektra* group from the National Museum in Rome (now Palazzo Altemps), and the activated *Apollo del Belvedere* (Vatican) (figure 73) these sculptures are represented as animate beings.

On the pages of Ahrem's book about women in ancient art, the *Capitoline* and *Medici Venuses* are animated on facing pages in sequential views that mimic movement of a figure in space (figure 74). In each case three views of the statue are printed against a unified ground, as though the statue, rather than the viewer, were moving around in space. The temptation of a twenty-first century viewer is to imagine them completely and literally enlivened as in the effect of computerized animation. But the animation of inanimate objects is already achieved in the vivifying photographic strategy and accompanying text; digital animation would be just another technological step in the attempt to reproduce the flexible capacities of the human mind.

Figure 73. Löwy, 1911a, plates 98 and 99, Photographs by Vasari: Head of *Niobe* and Three views of *Apollo del Belvedere*. Art & Architecture Collection, Miriam and Ira D. Wallach Division of Art, Prints, and Photographs, The New York Public Library, Astor, Lenox, and Tilden Foundations.

These multiple views of the nude goddesses correspond with the idea advanced by Löwy in his *Naturwiedergabe* that plurifacial sculpture, which can communicate the "moment of motion seized," is absolutely lifelike, and that this distinction belonged to the period of Hellenistic art:

> It was in the work of Lysippos that sculpture truly fulfilled all the conditions. In
> the natural rendering of his forms there flow in and out of one another endlessly

Figure 74. Photographer unknown, multiple views of *Capitoline and Medici Venuses*, plates 205–6, in Ahrem 1914. Freud Museum, London.

different views; there is no reserve, no perceptible division between one view and another.[103]

For art historians like Löwy and Ahrem, Hellenistic figurative sculpture possessed the light, shade, modeling and depth, and also the subtlety of emotional gradation, and instantaneous movement in space and time, that imitated nature. Taking Löwy's photograph of the *Girl from Anzio* as an example, we see that when these sculptured figures were served by what was supposed to have been the most naturalistic and instantaneous medium, namely photography, Lypsippean naturalism could be redoubled. In the method of illustration used by Ahrem, instantaneous movement is seized in sculpture as if in photography or film, and the *Capitoline Venus* comes to life as in Hanold's dream.

Furtwängler's *Denkmäler* brings the Paionios *Nike* from a ruined fragmentary state to a deity caught in the dynamics of flight (figure 75). A plaster model of the assembled original fragments faces a photograph of the restored original in Berlin. The restored *Nike* was sculpted by Richard Grüttner, who added limbs and wings, and completed the figure with a plaster copy of a suitable head that had been found in Rome.[104] The didactic photographic ensemble here brings to mind Löwy's 1911 discourse on this object. Six years later, with knowledge of the photo layout in the *Denkmäler,* Löwy rhapsodized about the figure in terms of its highly evolved, "naturalistic" rendition of human flight, where the winged Nike is interrupted (or stopped in action, as in a photograph) in the act of landing.[105] Löwy visualizes the figure in situ at Olympia on a high pedestal against the blue sky, where "she seems to have landed from heaven."[106] In his typical fashion of drawing on sense impressions to animate sculpture, he asks the reader to close his eyes and try to imagine a flying figure, concluding that he would envision a still torso with animated limbs, head, wings, and draperies.[107]

Figure 75. Friedrich Bruckmann, *Paionios Nike at Olympia and Plaster Reconstruction in Berlin,* figure 7 and plate 10 in Furtwängler and Ulrichs 1904. Author's collection.

Freud's *Gradiva*

Having looked at the representation of Greco-Roman sculpture in the photography of Freud's time and place, we return to his psychoanalytic interpretation of Jensen's *Gradiva*. How can a manipulation of photographic material in the imagination be brought to bear on Freud's reading of Jensen's *Gradiva*? One of Norbert Hanold's most frightening dream-images has to do with the eruption of the volcano Vesuvius. Among the protagonists endangered are the *Capitoline Venus* and

the *Apollo del Belvedere* (a somewhat unlikely couple) who flee the volcano together, behaving like a pair of the honeymooners that Hanold seemed to encounter everywhere in Rome and Pompeii. Murmuring sweet nothings in German, *Apollo del Belvedere* takes the *Capitoline Venus* in his arms and carries her out to a dark and ambivalent space. Thus develops a romance between two ancient statues, which are necessarily animated and imagined outside their physical-temporal contexts. Hard, fractured stones become soft, spectral, and whole in the arena of the conscious or preconscious mind.

It has been established that the archaeological photograph in Freud's time was frequently a stimulus to erotic feeling as well as a desire to see and possess (or at least to imagine) the past. Published photographs of ancient statuary served as surrogates for the real statues and could be more easily animated, or brought to life, in the imagination because of their isolation and completion in a chiaroscuro setting that resembled the ambience of a dream. This way the past was made present and the stones were loosened from their physical settings, such as the Belvedere Courtyard at the Vatican, the Capitoline Palace, the Louvre, and museums such as those at Berlin, Boston, Munich, Rome, or Olympia. Photographs of the *Apollo Belvedere,* the *Vatican Venus, Capitoline Venus, Venus Medici, Venus de Milo, Bartlett Aphrodite,* the *Nike from Olympia, Capitoline Fauns, Rondanini Medusa,* and *Hermes and the Baby Dionysos,* tended to model the inanimate objects with softening light against a darkened ground. This way, the figures looked like dream material pulled forth from the unconscious, on the threshold from the past to the preconscious mind of the beholder. In photographs of the *Apollo Belvedere* and the *Capitoline Venus,* published by Löwy and Furtwängler, all specificity of time or place is muffled by chiaroscuro so that the marble figures seem pressed forth from the past to the threshold of consciousness as if a delusion, or dream. Frequently several different views or photographic details are presented to the effect that the statue is

mobile in space, and details are isolated like the significantly individual features in a dream. The statues "come to life" in photography as they did in Hanold's delusions and dreams.

Forgotten Pompeii

When it came to the realm of the ancient and forgotten, to ruins, fragments, and traces, Freud's theorizing was sublime. Destroyed by Vesuvius in AD 79, Pompeii was the site par excellence for the great Freudian archaeological metaphor of burial and excavation. The phenomenon of Pompeii quickly became a paradigm of forgetfulness and retrieval that has shaped much of modern thought. Freud stated in *Delusions and Dreams* that, "There is, in fact, no better analogy for repression, by which something in the mind is at once made inaccessible and preserved, than burial of the sort to which Pompeii fell a victim and from which it could emerge once more through the work of spades."[108] He followed Jensen's suggestion that from Pompeii, "there stirred a feeling that death was beginning to talk."[109] As early as 1896 and 1897 Freud told Fliess that he longed to meet for discussions in Pompeii, and that he spent his spare time studying the streets of Pompeii in the maps found in archaeology books.[110] In a letter of 8 May 1901 he told Fliess that he had pulled himself together and made peace with his circumstances, but that his daydreams were still transporting him to Pompeii: "A basket of orchids gives me the illusion of splendor and glowing sunshine; a fragment of a Pompeiian wall with a centaur and faun transports me to my longed-for Italy."[111] He described his only visit to Pompeii (1902), Naples (National Museum of Antiquities), and a hike on Vesuvius, as a spellbinding (*bezaubernde*) experience.[112] There is little surprise then, that Freud was so attracted to Jensen's *Gradiva* as a subject for psychoanalysis. Nor

is it surprising that, once again, the images in Freud's extensive archaeological library furnished his visual imagination, just as these materials entered the collective visual imagination of hundreds of thinkers around the turn of the twentieth century in Europe and the Americas, and allowed them to fantasize works of art and thereby the gods and goddesses.

The pleasure of visiting Pompeii was not really discovery, but recognition; the burden of appreciation fell upon the visual memory, and places like Pompeii were "landscapes of memory" to be revived by the traveler's photographic imagination.[113] Memories were more important to the sightseeing process than were perceptions, and the thrilling nostalgia of recognition, or déjà vu, contributed to a mood of the uncanny. It is interesting to note that a similar sense of "having been there in the past" occurs in E. M. Forster's *Albergo Empedocle* (1903), when a character falls asleep among the ruins of the Temple of Zeus at Agrigento, and upon awakening announces that he had lived there before. In Forster's novel, however, the episode leads to insanity rather than to the curing of a delusion.[114]

Peter L. Rudnytsky recognized that the "intertwined problems of distinguishing what is alive from what is dead and what is real from what is fictional" made Gradiva a prelude to Freud's famous paper "The 'Uncanny'" (1919).[115] Rudnytsky observed that Freud's description of the confusion between fantasy and reality in "The 'Uncanny'" likewise glossed the situation of delusions and dreams in *Gradiva*. Freud's paper was motivated by a reading of E. Jentsch's "Zur Psychologie des Unheimlichen" (On the Psychology of the Uncanny), published in a journal of psychiatry and neurology at the same time Freud was writing *Delusions and Dreams*. As an example of the uncanny Freud referred to Jentsch's example as to "doubts whether an apparently animate being is really alive; or conversely whether a lifeless object might not be in fact animate."[116] This is the problem that disturbs and deludes Hanold in his courtship of Gradiva. In his afternoon walks around

Pompeii, Hanold the archaeologist suffers from an intoxicating overdose of his own professional activity, that of bringing the dead to life. Not only the protagonist but even the reader of Jensen's novel is prompted to wonder: "Is she a 'real' ghost? Or a living person?"[117] The photography of statues and archaeological sites in published sources owned by Freud emphasized the spectral, or uncanny nature of a dead city like Pompeii and its inhabitants, animate and inanimate, past and present.

A book titled *Pompeii Before the Destruction* by C. F. W. Weichardt (1898) serves as a paradigm of the way in which people from Freud's social group perceived the ruined, forgotten city of Pompeii and its visual representations. This volume, which Freud purchased in Naples in 1902, provided specific photographic settings for imagining the past. Weichardt began his book by stating that at the beginning of the twentieth century Pompeii was only a "shadow" or a "trace" of the culture that thrived there in antiquity.[118] Nothing seems to express this shadow-world better than the medium of photography; and the author juxtaposed photographs of ruins with his own reconstructions, which he used to "give body to this shadowy representation of the past."[119] Weichardt's facing-page strategy paired the romantic photographs of deserted ruins with his own reconstruction drawings of the sites (figure 76). These reconstructions of the past are rendered in a prosaic, reifying manner, complete with narrative vignettes of everyday life. The friendly, busy quality of the reconstructions emphasizes the romantic oblivion that is so poignantly expressed by the corresponding photographs. The drawings presented ancient Pompeii as *heimlich* or cozy and familiar, whereas the photographs of modern Pompeii emphasized that which was *unheimlich,* or secret and strange.[120]

Friendly, pleasurable, complete, explained by inscription, and populated with human life—*heimlich* to the point of being *kitschik*—the modern illustrations underscore the disturbing silence of the photographs. In Weichhardt's view of the

Figure 76. Weichardt, *Photograph of Ruins and Hand-Drawn Reconstruction of the Temple of Isis at Pompeii,* illus. 34–35 in Weichardt 1898. Author's collection.

Temple of Isis for example, the old Romans are configured in a Freudian nuclear family, where a little boy presents an offering as his parents look on. This opposes a Brogi photograph of the ruins of the *Temple of Isis,* which in its long exposure expresses exactly what Jensen called "the noonday ghost hour" at Pompeii.[121] And here (as in most Romantic landscapes) the *lack* of population is what counts, implying enchantment, antiquity, human absence, and spiritual presence. In early photography the depiction of ruins is charged with romantic awe, or to borrow a term from ancient Roman landscape painting, such images are sacro-idyllic to an

extraordinary degree. It is no coincidence that Freud, as a tourist of archaeological ruins, experienced the uncanny ghostliness of the calm preceding *scirocco* winds from Africa. On 18 September 1910 he described the deadly, immobilizing calm in a letter to his family from Syracuse, having just visited the *Temple of Apollo:* "it is something of a paralyzing atmosphere and oppressive in the air, the sky is not clear, everything is silent, a little bit *unheimlich*. I have slept badly and I am tired."[122]

Here we may recall the belief that feelings of melancholic torpor that clouded the mind, but intensified Romantic perceptions of loneliness and the past, were brought on by the meteorological phenomenon of *scirocco*. Moreover, this psychological state had a medical literature of its own, as exemplified by Jacopo Finzi's *Fluctuations of the Well-Being of the Soul (Schwankungen der Seelenthärtigkeiten)*.[123]

In Weichardt's *Pompeii before the Destruction*, the uncanny is invoked in a series of comparisons between the romantic silence, isolation, darkness, and fragmentation described in Jensen's novel as petrifaction "in dead immobility."[124] It was in this weird, lonely setting of empty Mediterranean afternoons that a sixth sense was awakened in Hanold, who was then, in Jensen's words "transported into a strangely dreamy condition, about halfway between a waking state and a loss of senses."

In his definition of the phenomenon Freud remembered that "an uncanny feeling, which, furthermore, recalls the sense of helplessness experienced in some dream-states" was something that he himself had experienced on a solitary Mediterranean day. One hot summer afternoon while walking through the streets of an (un-named) Italian town, Freud said that he repeatedly found himself in the quarter frequented by "painted women" despite his efforts to find his way out of that particular neighborhood.[125] I have speculated that the town in question may have been Pisa, which Freud described to Martha in a postcard with an uncharacteristic contempt: "Pisa is a dead, deserted city, full of Italian *Schweinerei*."[126]

In this memory of lived experience, which was nevertheless as weird as a dream, Freud seems to have been drawn back to the prostitutes' quarter by purely unconscious forces. He was relieved to find himself back at the central piazza, "without any further voyages of discovery."[127] Voyages of discovery in foreign cities, be they modern or ancient, could lead to uncanny and even frightening circumstances. An immersion in the strange silence, suggestive shadows, and disembodied wall paintings of Pompeii could bring forth at least an illusion of ghosts of the ancients to any nineteenth-century tourist with an imagination prepared by documentary photography.[128]

In Jensen's novel Hanold observes strange sights as he wanders among the buildings of the dead city. Characteristic nineteenth-century photographs of Pompeii come to mind as Hanold accidentally spies on a pair of lovers in the *House of the Faun* and meets Gradiva at the *Temple of Apollo* and the *House of Meleager* (figure 77). Photographs like the *House of Meleager* formed a visual stage set for the dreamed story of Gradiva. These sites were memorably formed in the mind of people like Jensen and Freud in the widely circulated photographs by Giorgio Sommer, another German-language protagonist with an overwhelming attraction to the ruins and excavations of the classical world. Sommer is best known for his Neapolitan street scenes and his photographs of Pompeiian casts of human bodies (figure 78). His images were published and dispersed throughout Europe (figure 79). In a consideration of the history of photography it is worthwhile to bring the ideas of Freud and Sommer together, at least as historical parallels.[129]

Sommer maintained photographic studios in Naples and Rome, working primarily for a Grand Tour clientele. He began as a sculptor, making bronze and plaster cast copies of Pompeiian originals.[130] His photographs are the predominant illustrations in the 1904 volume of the *Land und Leute* series by Hippolyt Haas dedicated to Naples, Pompeii, Capri, Paestum, and Sicily. Because Freud owned

Figure 77. Photographer unknown, *House of Meleager, Pompeii*, ca. 1870. Author's collection.

the volume of *Land und Leute* dedicated to Rome and the Campagna we may assume he knew the Naples and Sicily volume as well. Here Sommer's photographs represent folkloristic types, peasants, Neapolitan street types, antiquities, and scenic views of monumental ruins in the environs of Naples, Capri, Paestum, Segesta, and Agrigento. The text and images, like those in Otto Kaemmel's *Rom und die Campagna* (1902) were meant to prime the imagination of the grand tourist a priori, or to create an armchair tour for the culturally curious. The photographic

Figure 78. Giorgio Sommer, *Cast of a Woman at Pompeii*, ca. 1875, private collection, New York.

illustrations resonate deeply with Freud's travel letters from the same period, and allow us to visualize his mental landscape in southern Italy. Single figures engulfed by remote grandiose ruins, as in Sommer's photographs of *Necropolis and Temple of Hercules at Selinunte* and *Agrigento seen from the Temple of Zeus* (figure 80) set the tone for the total immersion of a visitor to the past. In September 1902 Freud wrote to Martha that the views and scenery in the south were stupendous even though the crowded Naples had been virtually a medieval spectacle of hell.[131] He wrote to Fliess that the Temple of Neptune at Paestum was the highpoint of

Figure 79. Giorgio Sommer (?), *"Donna trovata in Pompeii nel 1875" and Other Casts.*, Collection Armand, vol. 21, c. 47. Bibliothèque nationale de France, Paris.

Figure 80. Giorgio Sommer, *View of Agrigento from the Temple of Zeus,* in Haas 1904, illus. 126. General Research Division, The New York Public Library, Astor, Lenox and Tilden Foundations.

his journey.[132] In keeping with this Romantic view of the past, Freud pondered his exquisite sense of overwhelming solitude at Segesta."[133]

Giorgio Sommer's photographic scenes of Pompeii and his photographs of ancient sculpture are among the richest and most romantic of the scientific/art-historical records. Many of Sommer's Pompeiian photographs include remnants of Roman wall painting among the ruins, images that seem to float as weightless surprises in a condensed depth of field. Erwin Panofsky observed in *Perspective*

as Symbolic Form (1927) that in Roman painting the perspective system is such that space begins to "consume" the depicted objects, and that in landscape and sacro-idyllic painting, "the world becomes curiously unreal and inconsistent, like a dream or a mirage."[134] The ruined paintings at Pompeii had already been made inconsistent and fragmentary by the ravages of time. And the "mirage" effect of the partly consumed pictures is redoubled in monochromatic photography where the images float toward the picture surface like ghosts.

Tourists purchased Sommer's photographs to be pasted into travel albums, or into the blank pages of novels like Jensen's *Gradiva,* just as anglophone tourists to Rome bought photographs to paste into their copies of Nathaniel Hawthorne's *Marble Faun* (figure 81), making them de facto illustrations. Photographs of landscapes, ruins, local people, and sculpture were as definitive as fiction or art-historical prose in creating a visual imagination, part remembered, part constructed, of the Italian world.[135]

Freud's reception of archaeological photographs may have contributed to the formulation of the concept of the uncanny, and the images typified by those of Giorgio Sommer loomed large. Such photographs therefore deserve to be interpreted in psychological terms. The Roman documentary photographer Romuoldo Moscioni, who worked at the excavation of Lanuvium also made oneiric images that created "the world as in a dream" from sculptural fragments that were ostensibly arranged arbitrarily in an indifferent and factual manner for the documentarian's lens.[136] His 1885 *Lanuvium* (figure 82) expresses a splendid, dreamlike sense of isolation, where the body inanimate and mutilated communicates the sense of anonymity, estrangement, and displacement that can be characterized as "uncanny" or even "surreal"—this despite and even because of the painfully familiar, deadpan manner in which the objects are lined up for photographic documentation. Indeed the French surrealists would adopt Freud's ideas about the uncanny, and play with the

Figure 81. Photographer unknown, *Transformation: Or, The Romance of Monte Beni*, 1860. Illustrated book with fifty-six photographs, Museum of Fine Arts, Boston. Gift of Mr. and Mrs. David Lampert 1978.129. Photograph © 2010 Museum of Fine Arts, Boston.

aesthetic of deadpan documentary photography in their art, transforming familiar objects and bodies into ensembles that were strange and haunting.

Pompeii and the Uncanny in Involuntary Sculpture

Two of the problems Freud found most intriguing in Jensen's *Gradiva* were "the problem of the bodily nature of Gradiva" and "the conscious insistence on Gradiva's

Figure 82. Romuoldo Moscioni *Lanuvium,* ca. 1888. Photographic Archive—American Academy in Rome.

peculiar oscillation between death and life," which he interpreted as, "a young man's erotic curiosity about a woman's body."[137] Gradiva is envisioned in Hanold's dream as having been buried in the rain of ashes and asphyxiated by sulfur fumes. Freud repeats Jensen's description of the way in which she took her seat on the steps of the *Temple of Apollo* and slowly laid her head down, while her face grew paler and paler, as though she were turning into white marble, until she had become like a piece of sculpture. We have seen that ideas of this kind (metamorphoses from life to sculpture and vice versa) were salient characteristics of lithophilia and its myths.

A classic precedent for Gradiva's metamorphosis was the thrilling story of the intact body of an ancient Roman girl discovered in a tomb on the Appian Way in 1485.[138] At the time of this Renaissance discovery a visiting cleric from the north of Italy wrote a letter about the pleasure of viewing a woman caught in an inexplicable oscillation between (youthful) life and death: "I am sure that if you had the privilege of beholding that lovely young face, the pleasure would have equaled your astonishment." The writer then went on to praise such delicious details as the tongue that was visible through her lips.[139] Here the collapsing of time between the fifteenth century and Roman antiquity was in the service of desire. An ancient woman's body, preserved in youth as if she had not died, is available for the delectation of a Renaissance beholder, thus fulfilling historical as well as erotic aims.

The life-to-statue phenomenon was thematized in contemporary photographs and guidebooks from Pompeii, where the Barthesian sense of "having been there" in the solidified traces of absent bodies is dramatized in photography.[140] Nicola Pagano's guidebook to Pompeii (1898), for example, echoes the mind-set of the fifteenth-century tourist on the Appian Way. Pagano urged that the cast of a girl exhibited under glass at the museum at Pompeii be inspected and admired from several distinct points of view. He praised the spontaneous way her head rested on her arm, and her lovely shoulders were partly denuded from the clothes she was wearing. According to Pagano's guide a viewer could best admire the girl's face when descending the staircase into the second room of the antiquarium. She was made of the finest ash, he added, which was a most suitable material to describe the refinement of her destroyed body.[141] Such figures are the object of Norbert Hanold's attention in Jensen's *Gradiva,* where "in the museum of Naples there is under glass, the exact impression of the neck, shoulders, and beautiful bosom of a young girl clothed in a fine gauzy garment."[142] She stands for a kind of classicism found in nature—the imprint of real body parts—as well as an involuntary

fragment come to life. This was the same cast that had moved Théophile Gautier (in the mid-nineteenth century) to write a romantic tale set in Pompeii, where the breast impressed in the fragment of ash is transformed into a living girl, Arria Marcella, who appears to the protagonist during a fantastic night visit to the ruins.[143]

The archaeological romance of finding women's bodies in the ruins resonates with Sabine Hake's interpretation of Freud's archaeological metaphor, namely that the site is gendered female to the male archaeologist.[144] Ancient women had reverted to becoming part of nature to the contemporary male cultural scientist.

The white counter-imprints (casts) made by the disappearance of a burned-out body in solidified ashes seem to be among the unnamed and perhaps unconscious models for Hanold's ghosts in Jensen's *Gradiva* and in Freud's psychoanalytic interpretation of the story. Retrieved memories brought forth and from the remote past and then glimpsed in the fugitive, chiaroscuro medium of photography, they are extremely powerful *mementi mori,* which also evoke a language of shock, sleep, and dreams. The body is buried (suppressed and repressed) under the ashes of Pompeii and later uncovered, brought to life, reanimated, assuming the uncanny power associated with automata, dolls, "living sculptures," or sculptured bodies—like that of the exhausted Gradiva)—which had once been alive.

Freud was primed to pay particular attention to dreams, texts, and images featuring those who have been "buried alive" or "buried too soon," having read Havelock Ellis's 1895 article, "On Dreaming of the Dead," in *The Psychological Review.* Ellis devoted his essay to a certain type of dream (like those that would be experienced in *Gradiva* by Hanold) where the dead person, "is not really dead."[145] Such dreams, or apparitions, says Havelock Ellis, were factors in the widespread (if primitive) beliefs that "death is only a transitory and apparent phenomenon."[146]

Pairs of embracing "lovers" excavated near the Pompeiian Forum and elsewhere appear in photographs by Giacomo Brogi, Giorgio Sommer, and the Alinari

throughout the archaeological and touristic literature (figure 83). One such couple, cast in plaster for perpetuity, has a strong impact on Hanold in Jensen's novel, where, in his delusion, Hanold identified the female figure of this couple with Gradiva, fearing that in escaping the ashes of Vesuvius she had met another man and died with him.[147]

> Then it was no fairy tale that a couple of young lovers had been excavated near the Forum in such an embrace, and there at the Apollo temple he had seen Gradiva lie down to sleep, but only in a dream; that he knew now quite definitely; in reality she might have gone on still farther from the Forum, met someone and died with him.[148]

Photographs of Pompeiian casts were considered evidentiary documents of the ancient dead *redivivus*. As such they were disturbing and even shocking in their impact. These ostensibly scientific images, sculptured figures belonging more to the realm of natural history than to that of art, prompt the release of feelings: fear of death, wishing for death, and longing for immortality. What disturbs the beholder is the involuntary or unconscious nature of the sculptural forms, and the shock of discovery in viewing photographs of the simultaneously absent and present bodies, seen in isolation against an ambiguous ground. The idea of memory, of course, is inherent in the medium of photography as well as in the casting from volcanic material. Michel Frizot has observed that the impressions of bodies from Pompeii are themselves like photographs, as well as being works of "sculpture." Like photographs, they are rapidly captured impressions, memories, as well as being remembrances of the dead, or memorials.[149] It can also be said that these figures, like photographs and other light impressions, are ephemeral and fugitive; they are literally fugitives, struck down and frozen in their flight.

Figure 83. Alinari, *Cast Figures in the House of the Criptoportico, Pompeii.*
Alinari/Art Resources.

The topic of apparent death and reanimation of the dead is terrifying, and this sense of anxiety was heightened in the language of photography, where the chiaroscuro language of the medium makes condensation and displacement more isolating and profound. Johannes Overbeck's book on Pompeii shows a cast figure in "eternal sleep" (figure 84), a phrase also used by Nicola Pagano, like Havelock Ellis's "dead person who has never really died."[150] And the question asked by the spectator ("Is it real? Or is it 'only an image?'") is comparable to "Was it real? Or was it only a dream?"

In *Delusions and Dreams* Freud claimed that Hanold's archaeological interests acted at the service of a complex delusion, serving as an intellectual pretext for unconscious erotic desires. We have now observed that much the same could be said of archaeological photography in general, where the pretext was one of science in the service of humanism. The actual images, however, as seen in the illustrations

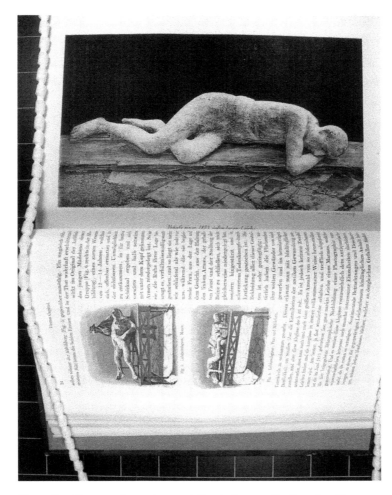

Figure 84. Photographer unknown (Giorgio Sommer?), 1873, *Cast Figure, Pompeii*, in Overbeck 1884, 24–45. Freud Museum, London.

presented here, were captivating and sensuous sites of subjectivity and precon-
scious associations. Freud and his disciples were particularly sensitized to the fas-
cination and anxiety produced by beholding fragmented body parts, suggestive
ruins, sphinxes, Medusas, Aphrodites, and ephebes. In the world of Freud's visual
resources, these images were available for viewing in photography, where the me-
dium itself made condensation and displacement more isolating and profound.
These photographs were also jumping-off points for the composition of elaborate
caption-texts in literature, psychology, and art history.

Freud believed that ideas were repressed because remembering could prompt
the release of unbearable feelings. In the cast photographs what prompts the re-
lease of feelings (fear and longing of death and immortality) is the total absence
of intention in the sculptural forms, and the instant sense of discovery in viewing
photographs of isolated absent bodies, as if in the memory-theater of the mind's
eye.[151] Out of Pompeii stirred a feeling that "death was beginning to talk."[152] The
sensation of "having been there" in the solidified traces of bodies is oddly quick-
ened and reanimated in photography. The photography of involuntary sculpture
serves as a photography of memories of living bodies involuntarily called forth
from the past.

Postscript: Gradiva and Surrealism

In France, the scientific and medical establishments were slow to accept psycho-
analysis as a valid discipline; rather it was the avant-garde artistic community that
introduced Freud's ideas into French society.[153] This is certainly not as Freud would
have desired it, but cultural history is seldom controlled by the wishes of individual
thinkers. *Delusions and Dreams* was translated into French by Marie Bonaparte in

1931, and had a visible trajectory in the art and thought of the French surrealists.[154] Whereas Freud and his fellow psychoanalysts put a genuinely high premium on classical culture (history, literature, art) and maintained a reverent view to the material of classical archaeology, the surrealists held classical culture in a kind of ironic contempt, and for them a kind of anti-art, nonsensical ethos held sway.[155] Despite Freud's serious life-long devotion to neo-classical and Romantic aesthetics, and his nearly total rejection of Dada and Surrealism, André Breton and the French surrealists seem to have grasped the ideas of fragmentation and classicism-made-strange, and the lure of the supernatural, somnambulism, and occultism in *Delusions and Dreams* and its relationship to *The Uncanny*. Indeed, Breton (who had also been trained as a physician) was interested in Freud's writings from the early years of psychoanalysis. While working as a medic in a wartime psychiatric center in 1916 Breton began to read Freud, and became convinced that dreams were an important expression of reality. And he encouraged the study of dream-memories that had been collected by various surrealist artists.[156] Freud was notoriously cool to Breton when he visited Vienna in 1921; nevertheless he kept a copy of Breton's *Surrealist Manifesto* (probably a gift from the author) in his personal library.[157]

By the late 1930s, the French surrealists had adopted Freud's Gradiva as their talismanic mascot. Breton opened the "Galerie Gradiva" in Paris in 1937. Salvador Dalí (the only Surrealist artist to have really interested Freud) made a series of drawings called *Gradiva*. In 1939 André Masson painted the *Metamorphosis of Gradiva* (figure 85), which conflates several moments of Jensen's story including her metamorphosis at the *Temple of Apollo*. Masson's *Gradiva* is a grotesque figure, made of equal, contrasting parts of marble statue and flesh, with a central passage of her body depicted as raw meat and fragments of bone. Styled in the colors and compositional devices of a Roman wall painting, the image gives several simultaneous views—Vesuvius erupts at the right, and a lizard slithers among poppies at

Figure 85. André Masson, *Gradiva,* 1939, oil on canvas. Private collection, Paris.

the lower left near the fissure in the wall through which Gradiva's spirit passed. These are the wild poppies of forgetfulness that grew in the ruins of the House of Meleager; the configurations of house flies that disturbingly reminded Norbert Hanold of honeymooning couples are also comically prominent in Masson's colorful image. Here Gradiva has materialized as a bizarre, hideous, femme fatale of the unconscious realm.[158]

Luis Bunuel's classic surrealist film *L'Âge d'or* (1930) presents the lithophilia complex with an absurdist lesbian twist, as a woman makes love to a nude classical statue

in a garden. The uncanny nature of automata, "living sculptures," and dolls had a strong tradition in surrealist photographic representation. It took a violent turn, for instance, in the photographs of mutilated dolls made by Hans Bellmer in the 1930s. And in the late twentieth century Cindy Sherman's insistent substitution of her own self with mutilated prostheses and sculptured parts communicated a maximum anxiety and perplexity about the female body—animate, inanimate, or dead.

One of the most psychologically charged surrealist artists was the photographer Brassaï, whose images have come to bear on practically every strand of twentieth-century photography. The haunted mentality of *Delusions and Dreams* is present in Brassaï's photograph *L'Atelier de sculpture de Picasso la nuit* (*Picasso's Sculpture Studio by Night,* 1932), where sculptured objects are transformed into ghosts, and in his *Sculptures Involontaires,* a series of texts and photographs realized with Dalì's collaboration for the magazine *Minotaure.*[159] But Brassaï's entire oeuvre is a Pandora's box of conscious and unconscious attitudes, and the topic of Gradiva as the surrealists' muse goes far beyond the limits of this chapter. Surrealist production in France occurred in the aftermath of Freud's *Delusions and Dreams* and "The Uncanny," essays that were informed by the visual material (the photography of ancient art) in his library.

In his essay on Jensen's *Gradiva,* Freud claimed that Hanold's scholarly interest in archeology acted at the service of a complex delusion, and that ancient relief sculpture served as an intellectual pretext for unconscious erotic desires. I have tried to demonstrate that much the same could be said of archaeological photography, where the pretext was one of science in the service of the humanities. We have seen that the actual images, however, also served as visual fields of subjective, unconscious, and preconscious associations. The elaborate and imaginative captions and texts these photos have stimulated in literature, psychology, and the history of art testify to the extent of their power.

4 | Uncanny Egypt and Roman Fever
Freud's Ethnographic Quest

> The cats are beautiful and friendly, but the women are
> especially distinctive.
>
> —Freud to Silberstein, Trieste, 5 April 1876

Throughout the nineteenth and early twentieth centuries the photography of art
was intimately connected to the phenomenon of tourism and the Grand Tour
mentality. Traveling photographers made little distinction between what we would
now classify as "works of art" and other subjects such as monuments, sites, tradi-
tional customs, landscapes, and ethnic types.[1] Photographs documenting the vol-
canic casts of humans at Pompeii, the smoking Vesuvius, ruined architecture, and
fragments of sculpture inhabit an area of knowledge about the world unbounded
by distinctions in history, geography, or artistic culture (figure 86). Photography
typically documents and romanticizes this knowledge. Like many other tourists

206

IL VESUVIO - Piccolo cono nel grande Cratere

Figure 86. E. Ragozino, Naples, *Vesuvius, Small Cone in the Great Crater,* postcard. ca. 1900. Author's collection.

Figure 87. Photographer unknown, *Pompeii—Temple of Jupiter with Vesuvius. From a Viennese Travel Album,* postcard, ca. 1900. Author's collection.

Freud and his brother Alexander climbed Vesuvius during their last day in Naples in 1902 after having visited Pompeii and the National Museum of Antiquities.[2] The volcano had a strong presence in Neapolitan tourist photography, where its eruptions were caught in serial and individual views, and where smoke and steam could be added to the pictures by the retoucher's swabs (figure 87). The viewing clientele's expectations endowed such pictures with a scientific accuracy and evidentiary seriousness.

An analogous situation prevailed in the documentary photography of Egypt from the 1850s forward, where sculpture, views of temples, tomb objects, local people, and mummies in various states of exposure were grouped together (at least for European consumers) under a single geographic rubric. This anthropological interface of culture and nature long characterized photographic practice and the publication of photographic material for documentation, even throughout the

twentieth century. The semiotic structure of nineteenth-century photographic al-
bums was determined by loose patterns of collected miscellanea; and this absence
of categorical boundary prevailed, too, in Freud's social and historical researches,
where antiquity and ethnography interfaced.

Freud's Uncanny Egypt

Freud never traveled to Egypt, but a photographic postcard (dated 11 October 1913)
from Sandor Ferenczi in Budapest, of an Egyptian relief of Alexander the Great
with the god Amun-Ra, indicates that such a journey was at least fantasized by
Freud (figures 88a and b).[3] The relief, from a wall of a barque shrine set up by
Alexander within the ancient Luxor Temple on the east bank of Thebes, depicts
Alexander as a pharaoh in the Blue Crown making offerings to Amun-Ra in ithy-
phallic form.[4] Although Freud probably understood the content of this image, it
was captioned only as the "Interieur d'un Temple." Ferenczi had in fact acquired
the postcard from a friend who had been to Egypt that September, and proposed
in his note that he and Freud also travel there together in the bearable September
whether: "Maybe we'll do it next year!"[5]

 Meanwhile, Freud fed his curiosity about Egyptian art and archaeology with the
many books on the topic in his personal library, and hours spent in museum col-
lections. On a visit to London, Freud wrote to his family that he spent from ten
in the morning to noontime in the Egyptian collections of the British Museum,
and "not yet completely cured" went back in the afternoon at about three.[6] Ernest
Jones reported that during that week Freud spent his evenings reading up for his
next day's museum visit.[7] As mentioned earlier, ancient art objects from Egypt,
Greece, and Rome provoked a longing for his own Jewish ancestral heritage in the

Figure 88a. Photographer unknown, *Relief of Alexander the Great as an Egyptian Pharaoh Making Offerings to the God Amun-Ra,* Luxor, postcard from Ferenczi to Freud, 11 October 1913. Austrian National Library, NB 800 335 A/B, Vienna.

Figure 88b. Verso of postcard in fig. 88a.

Mediterranean. For Freud this association was visible in phylogenic mental "memory traces" and physical ethnic traits. He was probably speaking only partly in jest when he described one of his own possessions, a mummy-portrait painting from the Faiyum (Roman Egypt, ca. AD 250–300), as having "a nice Jewish face."[8]

Theories of Jewish physiology were much in the air during Freud's lifetime: they were used to support ideas as disparate as Zionism and anti-Semitism, leading up to the highly organized anti-Semitism of the 1930s and to the systematic extermination of European Jews. European Jews, especially immigrants from the East who lived in the cramped ghettos of large northern cities, such as Vienna or Berlin, were also believed to have been constitutionally sick, to have had had a particular tendency toward nervous weaknesses, hysteria, and psychosis. Eastern

Jews in particular were considered an unhealthy people whose long phylogenic exposure to superstition, mysticism, and cumulative persecution, as well as marriages within the close social group, made them prone to diseases both physical and mental. The delicate question among physicians and historians working around 1900 was whether this tendency was a kind of endogenous racial degeneracy or a cumulative social effect caused by the terribly insecure existence in which literally running for their lives was a given for European Jews.[9] Before the turn of the twentieth century, Henry Meige characterized and illustrated these suffering Jews in terms of physical appearance: thin, creased faces, sunken eyes, and long, unkempt beards at the Salpêtrière in Paris.[10] Zionists responded to the concept of the sick and suffering Jew by inventing the idea of "muscle Jews"—European Jews who would leave the confinement and miasmas of the ghetto for sunny Palestine to develop strong bodies and healthy minds.[11]

From a psychiatric standpoint, Freud was familiar with the photographic studies made by physiologists Alphonse Bertillon, Cesare Lombroso, and Francis Galton. Their projects were tangentially related to the work of Duchenne, Charcot, Londe, Meige, and others at the Salpêtrière, whose photographs of human subjects Freud had at his disposal in books and journals.

Interpretive physiognomy had a long history in modern Europe, beginning with the prephotographic work of Goethe's neo-classicist contemporary Johann Kaspar Lavater. Lavater was steeped in an ethos of classicism, and for him the physiognomic (and ethnographic) norm was to be found in Greco-Roman sculpture. Specifically, the head of the *Apollo del Belvedere* served Lavater as the normative ideal man.[12] For Winckelmann, the "divine grandeur" of the *Apollo del Belvedere* had an immensely powerful agency: "In the presence of this miracle of art I forget the whole universe and my soul acquires a loftiness appropriate to its dignity. From admiration I pass to ecstasy."[13] This ideal continued into the twentieth century,

into the consciousness of Freud and his contemporaries. In Jensen's *Gradiva,* for example, the archaeologist Norbert Hanold is irritated when he overhears a vulgar German bourgeoise bride, Gretchen, telling her new husband that to her he is even more handsome than *Apollo Belvedere.*[14]

Bertillon, Lombroso, and Galton were heirs to Lavater's classicism in their attempts to identify physical and moral difference, or to separate the abnormal from the norm in terms of the measurement and proportion of physiognomic features.[15] Bertillon made synoptic tables of physiognomic traits in the service of detective work (for the Paris police), and extended his technique to physiognomic typing according to ethnicity and occupation (figure 89). The Milanese physician Cesare Lombroso attempted to illustrate with photographs that certain physical traits of human faces contained distinctive signs of criminality, whether it was actual or potential. The overarching scope of Lombroso's project was to inspect photographic evidence for proof positive of a relationship between physiognomy and insanity, and its ultimate result in criminal behavior.[16]

The photographic documentation of data that was collected by Bertillon and Lombroso endowed their findings with overtones of unblinking realism. A sort of predestined social schema with given occupational and moral categories (aristocratic versus criminal, for instance) provided a teleological substructure for photographic classification of the human face. Ethnic and moral "norms" together with visible qualities of social class such as inherited "nobility," rarely strayed far from Lavater's scale of classical versus anticlassical as an equation for good versus bad in the natural composition of the human head.

The use of photography or physical measurement to identify *potential* criminality in physiognomic types (as in the work of Bertillon and Lombroso) presaged the most dangerous kinds of racialism, including the Nazi propaganda against homosexuals, the Roma (gypsies), and Jews. But the anthropological work of Bertillon

Figure 89. Bertillon teaching his system at the Paris Prefecture of Police "*Service de l'Identité judicaire: Cours de Signalement descriptif (Portrait Parle)*." Prefécture de Police, Paris.

and Lombroso was also related to more overarching concepts, such as the belief that the camera was an instrument that provided access to visual truth, and more specifically that portrait photography could reveal the innermost nature of the individual portrayed. These last ideas, as philosophically flawed as they may be, have deep roots in the West, and still inform cultural expectations operative in the twenty-first century.

Francis Galton, the British eugenicist, also set out to categorize that which was typical in the faces of individuals who belonged to the same family, ethnicity,

occupation, or those who suffered from the same physical or mental affliction. Galton made full-face and profile portrait photographs, superimposing several portrait images, and arrived at typological composites. Notwithstanding the dreadful theories of racialism and eugenics inherent in his work, Galton's physiognomic belonged to the greater nineteenth-century trend of classifying and typifying human beings through supposedly objective, truth-telling portraiture.

In his *Hereditary Genius* Galton favored the ancient Greeks, asserting that, "The average ability of the Athenian race is, on the lowest possible estimate, very nearly two grades higher than our own—that is, about as much as our race is above that of the African Negro."[17] For Galton the blended composite was the most effective way to visualize hereditary traits in physical anthropology. He sought to discover the "Athenian" physiognomy in composite photographs of ancient Greek and Roman portrait coins and medals. Physiognomically speaking, the photography of sculpture was never distant from the photography of human types: in the 1880s Galton had produced a definitive "portrait" of Alexander the Great, made of a composite of photographs from six different relief sculptures on ancient coins.[18] One of his most influential composites was the "Jewish type" (1883) based on contemporary photographs of Jewish boys from the Jews' Free School or the Jewish Working Men's Club in London (figure 90). The discovery of a purely distilled racial type was therefore vetted by historical photographic evidence, and photographs of racial types in modernity (from photographs of human subjects) versus the same types in antiquity (from historical sculpture) allowed comparison of moderns with their ancient ancestors.[19]

Galton's strategies were not altogether separate from certain cultural expectations experienced by Sigmund Freud. Freud looked for physiognomic clues to the most interior psychology of portrait sitters by type when he visited the National Portrait Gallery (London).[20] In notes to himself, recently translated and published by Michael Molnar, Freud accepted and employed the classical ideal: "The truly heroic expressions in the tradition of the *Zeus* of Phidias belong to artists, Lord

Figure 90. Francis Galton, *Components and Composites of the Jewish Type,* in *The Photographic News* (1885). Art & Architecture Collection, Miriam and Ira D. Wallach Division of Art, Prints and Photographs, The New York Public Library, Astor Lenox and Tilden Foundations.

Leighton, Tennyson, Bulwer.... [And] nobles have the best faces."[21] He wrote that, "Face is race, family and constitutional predisposition, of which only the last factor is interesting, actually mostly raw material, there is too little in it of experience, least of all of choice of career."[22] Freud's amateur brand of physical anthropology was at times rashly impressionistic, as in his statement written from Orvieto that the ancient Etruscans were "as black as gypsies."[23]

Freud also searched for the concrete visibility of his Jewish heritage in ancient Mediterranean art, such as the "nice Jewish face," of the Faiyum portrait. Above all, Freud's analysis of Moses from photographs of Michelangelo's *Moses* paralleled

the work of the racialist photographers in a striking way. In the art-historical literature that Freud used as preparatory material for his study of the *Moses,* writers such as Eugene Guillaume had perceived the future of the entire Jewish race in the features of Michelangelo's statue.[24] Experimental methods used by Galton and other photographers were present in Freud's visual imagination. We have seen that Freud even likened an image in his dream to Galton's composite exposures, where the face of his uncle Josef, who had been sent to prison for the possession of counterfeit money, was superimposed on that of another man.[25] The emphasis on determining types, racial or social, and the proofs of symptoms of illness, as represented in photography, seems to have imprinted Freud's overarching strategy for historical interpretation, allowing his historical theories to develop in a candid, somewhat naive, but visually rich, manner.

Documentary photographs of "Jewish types" as well as photographs of Egyptian sculpture, mummies, and men, may well have fueled the concept that Freud proposed in "Moses and Monotheism" that Moses was an Egyptian. The purpose of Freud's pseudo-historical study was, in his own words, "directed to the single aim of introducing the figure of an Egyptian Moses into the nexus of Jewish history."[26] In this essay, which he referred to as his "historical novel," as well as in his earlier, equally obsessive, investigation of Michelangelo's *Moses* (1914), Freud tried to make sense of his own life in history, and to ask: Who is a Jew? What is the relation of a Jew to classical culture? How is a Jew to visualize and be visualized?

Moses and Monotheism was written in a period of great stress just before the end of Freud's life, and it recapitulated Jewish and Mosaic themes that had haunted him for many years. Edward Said has called the essay a *Spätwerk* or a composition in Freud's late style, comparable to Beethoven's final string quartets or Monet's *Waterlilies.* These are open-ended works, highly expressionistic, with little interest in the satisfaction of closure or conclusion.[27] The ethnological premise

that "Moses was an Egyptian" was as insecure as related issues of biography, history, and archaeology that Freud shaped into an essentially psychological study of the ancient protagonist, Moses.

According to Freud, Moses was an Egyptian aristocrat who gave his "chosen people," a Semitic tribe called the Levites, the monotheism that had been discovered in Egypt by the Pharaoh Ahmenhotep IV (known as Akhenaten). Jewish monotheism, which rejected magic, sorcery, and anthropomorphic representation of the deity, had come about after a period of somewhat complicated historical latency, from Akhenaten's "Aten" religion.[28] Freud claimed that, "In an astonishing presentiment of later scientific discovery [Akhenaten] recognized in the energy of solar radiation the source of all life on earth and worshiped it as a symbol of the power of his god."[29] As a scientist, Freud obviously saw this as historical progress, as an enormous step forward in Egyptian culture and in the civilization of humankind. For Freud the story of Moses, particularly with regard to Michelangelo's statue, was a dramatic historical saga of filiation and parricide. It is pertinent to *Moses and Monotheism* that in the sixth year of his reign Akhenaten destroyed all the cartouches of his father, Ahmenhotep III, in an Oedipal gesture necessitated by intellectual progress at the founding of his new, more abstract, religion.[30] Akhenaten's view of the cosmos presaged Freud's age of scientific discovery. The Oedipus complex remains fixed in Freud's world historiography: in much the same way that Michelangelo had to "kill" his fathers, biological and papal, Amenhotep IV had to become Akhenaten and reject his patronymic as successor to Amenhotep III.

Freud's thesis that Moses was an Egyptian aristocrat from the circle of Akhenaten gave him the opportunity to characterize the modern Jews in terms of a revised historical ethnology. According to him, the Jews were not fundamentally different from Europeans, but rather they were the heirs to the Mediterranean civilizations from which they were descended and from whom they had retained phylogenic memory traces. Freud's anxiety that the Jews not be considered "Asiatics" but

rather "civilized" Mediterraneans, is a racialist absurdity that can be understood not only in terms of his education at a classical gymnasium, but also as a conscious or unconscious response to Nazi racial policies and the Anschluss of 1938.[31]

In *Moses and Monotheism* Freud devised an ethnological profile of the Jews based on their acceptance of the monotheistic, abstract religion of Akhenaten. The prohibition against making images of a single, abstract God, created an advance in intellectuality for the Jews, as well as a set back to sensuality and physical strength.

> The pre-eminence given to intellectual labors throughout some 2,000 years in the life of the Jewish people has, of course, had its effect. It has helped to check the brutality and the tendency to violence, which are apt to appear where the development of muscular strength is the popular ideal. Harmony in the cultivation of intellectual and physical activity, such as was achieved by the Greek people, was denied to the Jews.[32]

The Jews, therefore, not unlike some other peoples of advanced societies, were a people who lacked harmony in the cultivation of physical activity with that of the intellect, a people who had endured, like the modern condition itself, "an advance in intellectuality" as "a setback to sensuality."[33] According to this historical rationale, if the Jews were congenitally sick or neurotic, as Rathenau, Meige and the anti-Semites would have had it, their condition was a result of ontogeny recapitulating phylogeny. Perhaps only the "natural," athletic, individual of the Zionist ideal could ever correct the congenital sickness of the Jews.

Pictures of contemporary Semitic types were present in Freud's collection of miscellaneous photographs, which included a commercially produced portrait of an elderly bearded Egyptian in ethnic costume marked "Réis de Dahabiéh" (the captain of a *dahabia,* or small sailing boat on the Nile) (figure 91). We know from notices posted in Joseph Maria Eder's journal *Photographische Correspondenz,* that there was a market for photographs like this, because firms such as Steglitz of

Figure 91. Photographer unknown, *Réis de Dahabiéh,* ca. 1890. Freud Museum, London.

Figure 92. "Rotations—Photographie," *Photographische Correspondenz* 1898, Beilage. Array of photos and cabinet cards with Sarah Bernhardt, an Egyptian, a Jew, a Woman in Tracht, and some portraits from Neue Photogr. Gesellschaft, Steglitz, Berlin. Albertina, Vienna.

Berlin advertised them for sale. In the 1898 "Beilage" to *Photographische Correspondenz* Steglitz published an array of photos and cabinet cards featuring portraits. We see Sarah Bernhardt (who was greatly admired by Freud) in costume as *La Princesse lointaine,* an Egyptian dignitary, a Jew, a woman in folkloric costume, and various other portraits (figure 92).

A posed photographic portrait of Freud's brother-in-law, Moritz Freud, who was a dealer in oriental rugs, dressed in Middle Eastern costume was also in Freud's collection (figure 93). Moritz was a distant Romanian cousin who had married Sigmund Freud's sister Marie, and acquired carpets in the Ottoman Turkish port

Figure 93. Photographer unknown, *Moritz Freud in Arab Garb*.
Freud Museum, London.

cities of Izmir and Salonica. It was probably from him that Sigmund received the Qashqa'i carpet for the analytic couch as well as other rugs in his office.[34] In a letter to Wilhelm Fliess Freud referred to Moritz in Orientalist terms as a half-Asian from Bucharest who suffered from mythomania "pseudologica fantastica."[35] The studio portrait of Moritz belongs to the tradition of Europeans depicted in "Turkish" or "Arab" garb when they visited the East. Moritz's distant, upward, gaze accords with this Romantic formula. Romantic Orientalism was common practice in photography and painting; indeed, Jean-Léon Gérôme's *Rug Merchant at Cairo* (1887) provides a pictorial context for Moritz Freud "going native" in photographic portraiture (figure 94). These photographs of the elderly Egyptian sailor and the young Jewish carpet merchant may have meant little to Freud, ending up in his papers almost by accident. But in the spirit of psychoanalysis, it is possible that Freud searched for a Jewish ethnicity, including his own phylogenic Mediterranean roots, in Egypt. Photographs such as the one of the elderly sailor or that of Moritz Freud in Middle Eastern garb may have functioned as investigative visual material. Or the photographs may have been "discovered" by Freud as evidence of anthropological theories. Certainly a kind of Jewish Orientalism was present in Vienna around the turn of the century among Jews. Stefan Zweig, for instance, remembered his first impressions of "the King of Zion," Theodor Herzl, as a person of "natural majesty," describing the encounter as follows:

> Even at this old desk, covered with papers, in this narrow editorial office, with its one window, he appeared like a Bedouin sheik of the desert, and a flowing white burnoose would have been as fitting as his carefully tailored black cutaway, obviously fashioned along Parisian lines.[36]

Ancient Egypt was represented well in Freud's library. Many of the books and images familiar to Freud contained what may be described as an "ethnographic"

Figure 94. Jean-Léon Gérôme, *Carpet Merchants in Cairo,* oil on canvas, ca. 1887. Minneapolis Institute of Arts, The William Dunwoody Fund.

photography of antiquity, including mummified remains and the contents of the tombs of Egyptian kings. In James H. Breasted's *History of Egypt,* which Freud owned, photographs of human remains are intermixed with those of sculptural artifacts, and are given equal value as historical evidence.[37] First published in 1905, *A History of Egypt* retained the same sets of photographic illustrations in its later editions, through the middle of the twentieth century, where maps, scenographic landscape photographs, sculpture, architecture, epigraphy, and photographs of skulls and mummified remains illustrate the condition of long ago and far away. Mummies, like the volcanic casts at Pompeii, were archaeological objects that occupied an ontological status somewhere between cadavers and sculptured portraits. In an Orientalist mode that collapsed time between ancient and modern, they communicated a maximum degree of ethnicity and human expression. At the same time, they stood as reminders of mortality and its uncanny opposite.[38]

If picturesque Orientalism was a prominent cultural system in nineteenth-century Europe, then Egyptian mummies were exotic in terms of time and space. Théophile Gautier called "the taste for the exotic in time" a "more supreme seduction" than that of geographic distance and societal strangeness. When Gautier stated that "nothing excites me like a mummy," he was referring to the lure of deep temporal distance brought shockingly close to human observation.[39] Freud knew mummies from the Hapsburg Egyptian collection in the Belvedere Palace: an 1889 watercolor by Carl Goebel shows that at that time the bandaged mummies were shown in vitrines in front of their wooden sarcophagi, surely a great point of attraction for the public.[40] This material was reinstalled in the Kunsthistorisches Museum after 1891.

Georg Steindorff's *Die Blütezeit des Pharaoenenreichs* (*The Golden Age of the Pharaonic Kingdoms;* 1900) was one of the illustrated books on Egyptian archaeology on Freud's shelves. Its genealogy of the Pharaohs as photographed in sculptured portraiture and mummies is of a piece with the medical and archaeological

photography that was most familiar to Freud. In Steindorff, mummified bodies and sculptured portraits were brought together within a common format of photographic illustrations. On the one hand, the mummified head of Thutmosis II in the Cairo museum is photographed according to the same norms as isolated sculptural fragments, as if it were a work of art, and evidence of an elevated ancient culture (figure 95): the portrait resides in the body itself. On the other hand, it is accompanied by a medical diagnosis, concluding that Thutmosis had probably suffered at length from a severe disease, which caused him to lose his hair before death.[41] This explanatory text brings us back to the Salpêtrière and its particularly apposite uses of photography of the human body for medical and cultural interpretation.

In 1896 the journal *Nouvelle Iconographie* had published an article by Joseph Grasset titled "Un 'homme momie'" about a living "mummy man" who had a case of hereditary syphilis.[42] A photograph of the boy called "mummy man" shows his congenital condition of atrophied skin, muscles, and bones, to be identified and studied as a medical curiosity (figure 96). I would stress here that the captioned photograph of Thutmosis II in Steindorff's book, and the "mummy man" in *Nouvelle Iconographie* belong to the same family of images. Thutmosis II and "mummy man" are part of a single integral cultural system, which saw no rigid distinction between cultural artifact and natural history.

Carl Jung identified mummies as powerful images of death in Freud's mind. In Bremen, directly before sailing for the United States in 1909, Jung chatted with Freud about the natural mummification of humans in the peat bogs of northern Europe and in the *Bleikeller* (lead cellar) of the Bremen Cathedral. Jung maintained that Freud resisted the topic, and that in one discussion of these cadavers over dinner Freud suddenly fainted, evidently because of the intensity of his own fantasies about these natural objects. Freud apparently interpreted all Jung's talk about mummies as a "death wish" against him.[43] During his brief visit to New York, Freud

Figure 95. Photographer unknown, *Mummy of Thutmosis II in the Cairo Museum,* Steindorff 1900, illus. 22. Author's collection.

Figure 96. L. Biermann, "*Homme Momie*," in Grasset 1896. Archives and Special Collections, Columbia University Health Sciences Library, New York.

visited Chinatown and, in a burst of exoticism, commented that he was struck by the similarity of older Chinese men to "the mummies of Egyptian kings."[44] Inappropriate as this simile would be in twenty-first-century intellectual circles, the mummies of Egyptian kings loomed large in the visual imaginations of turn-of-the-century Europeans, and photography was a primary agent of this visualization.

Egyptologists of the later nineteenth century were driven to examine the ancient dead, as mummies were unwrapped for study and duly photographed.[45] Mummies were unwrapped before spellbound audiences who witnessed the release of human figures from thick pads of wrapped cloth.[46] An anonymous photograph from the 1880s of the "*Mummy of Mahinpra*" (figure 97), for example, represents the unwrapped figure propped up, standing erect on a pedestal against a light neutral ground, looking just slightly more dead than Dr. Grasset's "mummy man" patient of the same decade. The installation of the preserved body of Mahinpra on a pedestal for this photograph reinforced the ambiguity between statue and cadaver that so perplexed and enriched archaeological thinking of the time, whether at Cairo or Pompeii.[47]

Archaeologist-photographer Emile Brugsch was one of the first to make romantic photographic "portraits" of mummies. The photograph of Thutmosis II in Steindorff's *Blütezeit* belongs to the same family of images as a photographic "portrait" of Pinudjem II—Upper-Egypt Military Commander and Theban high priest of Amun—made by Brugsch in 1881 (figure 98). The French Egyptologist Gaston Maspero labeled this photograph a *portrait* taken from the mummy.[48]

In the nineteenth century mummies were considered a kind of ultimate portraiture, preserving the actual face of the dead for posterity. Archaeologists believed the role of the ancient embalmer was to make the representation of the dead man so life-like that he should remain alive, just as the modern painter, sculptor, or photographer attempted to do according to the ideals of Western portraiture. Another mummified head photographed by Brugsch, that of Ramses II, was received as no

Figure 97. Photographer unknown, *Mummy of Mahinpra*, 1890s. Wilson Centre for Photography, London.

Figure 98. Émile Brugsch, "*Portrait of Pinudjem II, taken from the mummy,*" in Maspero 1881. Art & Architecture Collection, Miriam and Ira D. Wallach Division of Art, Prints and Photographs, The New York Public Library, Astor, Lenox and Tilden Foundations.

less than a telling portrait by Maspero, who discerned in the king's remains a, "somewhat unintelligent expression, slightly brutish perhaps, but haughty and firm of purpose."[49] Maspero and Brugsch's excavations of the Theban pharaohs was considered one of the most romantic of all excavations in ancient Egypt. Freud had at least two of Maspero's books in his personal library, and Brugsch's sensational work in the unwrapping and photographing of mummies was very famous. These photographed mummies constituted a kind of involuntary sculpture (*sculptures involontaires*) before Brassaï and the surrealists—a portraiture less contaminated with intentionality and therefore ostensibly more valid than its human-made counterparts in stone.

The exposure of mummified bodies was an art of finding, rather than making, producing an image that was free from intention and therefore endowed with a special quality of the real. In this sense the revelation of mummies paralleled the art of photography. Like the cast bodies from Pompeii, photographs of mummies still seem to evoke a sharp primal thrill, an adventure of sensing the remote historical past together with the suggestion of physical immortality.[50] As involuntary portrait sculpture of the dead who live on, their condition as objects resembled that of the volcanic casts of the dead at Pompeii. The interpretive reception of these involuntary portraits fitted seamlessly into the tradition that governed the interpretation of all portraiture including statuary, painting, and posed studio photographs of living people.

The head of another important Pharaoh from the Cairo Museum appears in *Die Blütezeit:* a stone portrait of Amenhotep IV (Akhenaten), found at El Amarna, is presented in a photographic composition that mirrors that of the mummified Thutmosis II (figure 99). Steindorff's accompanying text praises Akhenaten for having introduced the single supreme deity, Aten. Because most Europeans of the time were at least nominally monotheists, Akhenaten's innovation was probably considered a precocious "discovery" of the single deity (the God of Judaism and

Figure 99. Photographer unknown, *Portrait of Amenhotep IV (Akhenaten)
from El Amarna in the Cairo Museum,* In Steindorff 1900, illus. 126.
Author's collection.

Christianity) as opposed to merely an alteration in the style of ancient Egyptian worship practices. Although there is evidence of monotheism in Egypt long before Akhenaten's reign, the West regarded Akhenaten as the first Western-style monotheist.[51] Freud's eulogy (1939) of Akhenaten as a personality who was responsible for the spiritual and philosophical advancement of humankind and the foundation of Judaism followed in the stream of arguments put forth by Egyptologists. For Steindorff, the "portrait" of Akhenaten—a chiaroscuro photograph of a fragment of stone sculpture—revealed the enlightened historical personage who first proclaimed "a single God, creator of all life, the lord of the entire world."[52] Freud's attachment to Akhenaten as a knowable historical figure was such that at the 1912 Psychoanalytic Congress in Munich he slipped off his chair in a dead faint when Carl Jung noted that Akhenaten's destruction of Amenhotep III's cartouches was probably not motivated by Oedipal resistance.[53]

Here it is pertinent to remember that for Sigmund Freud, statues, especially those isolated in photographic representation, contained, figuratively and metaphorically if not literally, a kind of inner consciousness or volition. To an even greater extent than the portrait-format photographs of Michelangelo's *Moses,* Steindorff's illustration of Akhenaten was presented as if it were an absolutely authentic likeness of the historical personage.[54] A fragmentary sculptured head that was juxtaposed so closely to the mummified head of a real human being, could be analyzed—or even psychoanalyzed—as a historical individual, as though the cranial forms had enclosed the workings of a real mind. A photograph of sculpture, which could be searched in the same way as a biological specimen for evidentiary proof about the past, was, in all of its anthropomorphic objectness, apprehended as far more revealing in scientific terms than, for example, a painted portrait of a contemporary personality. This condensation of past and present was always a salient feature of Orientalism: time was stopped and historical progress denied

Figure 100. Photographer unknown, Stereocard by Underwood & Underwood, 1896, *Upper Egypt, "Princes of the Blood," Ancient and Modern.* The Metropolitan Museum of Art, Gift in Memory of Kathleen W. Naef and Weston J. Naef, Sr., 1982 [1982.1182.1657].

in the exotic east.[55] The format of Steindorff's archaeological study and its photographic material testifies to the mentality described here and its internalization and application by thinkers such as Freud.

The Orientalist condensation of time prevailed on a popular, and even humorous, level. An 1896 stereoscopic view card by Underwood & Underwood spells out, for Westerners, the atavistic relation of living Egyptians to their remote sculptured ancestors (figure 100). Two Egyptian peasant children lounge against the fragmentary sculptured ruins of statues of Amenhotep III and the god Thoth at the Temple of Ramses III at Medinet Habu. The smiling boy and girl take on the roles of king and consort, with the caption reading, "Princes of the Blood, Ancient and Modern." In this photograph, the idleness of the Egyptian children languishing at the temple statuary of their ancient ancestors suggests a picturesque collapsing of history and

the absence of any struggle or work in the lives of nineteenth-century Egyptians, who are presented as being as idle as "princes" and as static and "unchanging" as their sculptured ancestors. Although this particular stereo card is not from Freud's personal collection, James H. Breasted (whose *History of Egypt* Freud owned) published many of the Underwood & Underwood stereo photographs from the Egyptian series in various books.[56]

The photography of art may have caused a particular effect on Freud's historical biography of Moses or on his own version of the historical origins and history of the Egyptians and Jews. It would be more accurate to recognize integrated visual systems as agents in the ongoing historical process; that is, to characterize the relationship in terms of prevailing mentalities and cognitive styles. Above all, photographs and their internal visual language were at least as effective as written texts in the formation of cultural beliefs. In the nineteenth century photographs of skeletons, mummies, and ancient art were frequently related to the study of the origins of racial difference.[57] When paired with salient texts in widely disseminated publications, subjects such as ethnographic Egyptian "types," documents of bizarre medical conditions, mummies, and sculptured portraits, the power of such photographs is deepened and quickened.

What I have shown is that the photography of "art" (sculpture, archaeological fragments) was hardly separable from the new anthropological photography that was so closely aligned with (psychiatric) medical practice. All of these images belong to a common body of knowledge, where sculptural facture (representation) is not necessarily distinguished from nature (biology), and where the facture (aesthetics, techniques, and strategies) of photography and its graphic reproduction was beautiful and mute, and therefore immune to critique. In diagnostic disciplines such as archaeology and medicine where morphology was everything, documentary photography inspired great credence. Constellations of photographs and their accompanying didactic materials (captions, texts) contributed to the

visual imagination and to a richly photographic cognitive style among turn-of-the-century thinkers, including scientists and art historians.

Roman Fever

In Freud's later years this style of thinking gave rise to morphological assumptions and historical rationalizations. If, beginning with Moses, the Jews were really originally Egyptians, and later Greco-Roman Egyptians then they had an entitlement to an immense visual culture. A culture that extended in an unbroken stream from the Hellenized Jews of Alexandria throughout the Roman-Egyptian Faiyum period (which directly preceded the Christian middle ages) and on to the Renaissance Jews who admired Michelangelo's *Moses* in San Pietro in Vincoli, and finally to Sigmund Freud as a classically educated tourist in Athens and Rome. This sequence parallels the supposed emigrations and peregrinations of Freud's ancestors (Palestine, Rome, Cologne, Lithuania, Galicia, Moravia, Leipzig, and Vienna). Conversely, if modern Jews were physically attenuated ghetto-dwellers, prone to neurotic diseases and certain physical ailments, this, too, was a condition that stemmed from their early Mediterranean history, their precociously abstract religion and its attendant strain of aniconism. For Freud, Jewish city-dwellers were out of touch with the Greco-Roman sensuality that had so animated the Western visual arts and rendered the human body the most important and beautiful subject in life and art. But modern Jews, who dwelt in the slums of Leopoldstadt and other populous cities, were no different from other people in industrialized northern Europe. On the contrary, Mediterranean peoples of anthropomorphic religions (pagans and Roman Catholics), the ancient Greeks and Romans, and the modern Italians had achieved a balance between intellect and sensuality that was truly classical, a sensuality that was also subject to ethnographic research in the photography of art.

Trieste

Freud may have protested too much when he stated late in life, "I am not an eth-
nologist but a psychoanalyst."[58] Like many Europeans educated in the nineteenth
century, Freud was always an amateur anthropologist. His quest for ethnographic
observation and description had begun in the 1870s, when he was a student of zool-
ogy in Trieste. His anecdotal letters to Eduard Silberstein from Trieste, then part of
the Austro-Hungarian empire, described not only what he spent hours looking at
through the lens of the microscope, the testes of dissected sea eels, but the people
he saw on the streets, and the relative beauty and ethnicity of the population, with
special attention to the local women. An initial impression was that "The cats are
beautiful and friendly, but the women are especially distinctive."[59] Oddly, Freud's
first protracted stay on the Italian peninsula presaged that of Norbert Hanold in
Jensen's *Gradiva* and Freud's psychoanalysis of that novel in several ways.

On his first day in Trieste, Freud had the impression the city was inhabited by
"none but Italian goddesses," but he was eventually disillusioned and disappointed
to find the women as ordinary, even "*brutte*" (ugly) as those in any other city.[60] One
spring day, however, he went on an outing to Trieste's seaport of Muggia. There,
Freud's powers of observation were in full force, and among other demographic
curiosities, he noted a Latin inscription to the effect that a community of Jews
had been exiled there by the Venetian Senate in 1532.[61] But more important, it
was on the excursion to Muggia that he found the most graceful and feminine
girls and women. The women of Muggia were, "more attractive, mostly blonde,
oddly enough, which accords with neither Italian or Jewish descent," but the local
blondes were "not Slavs either, and do not even speak that tongue."[62] Freud sud-
denly became aware of a great number of pregnant women and young mothers
with small children, and wrote of them in lyrical terms: "the girls and children

in the ancient ruins were *assai belle* [quite beautiful]," and describes a scene at a local inn where a beautiful pregnant landlady presided over a company of assorted local types.[63] Freud told Silberstein that later that day, "the local beauties were out promenading on the *molo,* inspecting and laughing at the strangers."[64] We see from his letters to Silberstein that Freud's experiences in Trieste anticipated those of Norbert Hanold in Rome in an eerie, almost uncanny manner. The unmarried Freud, occupied as he was by looking at life through a microscope, was haunted on his day off by human fertility in the romantic guise of the ethnic "other," an ethnically perplexing race of beautiful women neither Italian, nor Jewish, nor Slavic, but something else. The gap between looking at life through a microscope and conducting research on foreign women in their natural habitat would also find a clear echo in Freud's views that civilized sexual morality could lead to neurotic illness. In the study of modern neurosis, *"Civilized" Sexual Morality and Modern Nervous Illness,* he stated that, "the young intellectual can by [sexual] abstinence enhance his powers of concentration."[65] But he had already shown in *Delusions and Dreams* that suppression of the instincts in favor of scientific study could come back to haunt a young scholar (Hanold in this case) in the dissonant and disturbing forms of newlyweds, house flies, volcanoes, and ghosts.

Freud's published writings and personal letters demonstrate that the study of classical and Renaissance sculpture fused intellect and sensuality in a manner that was particularly invigorating to his work. Like an art historian, he wrote about these works under the spell of memories retrieved from the south and reconstructed in his study in Vienna.[66] Throughout the nineteenth century the journey to Italy was as much a mental as physical process; tourism of the mind generated a set of feelings and beliefs that were as important as any real fresh experience of the geographical place.[67] The Grand Tour ethos, with its souvenir photographs of Rome (and photographic pictures of the vestiges of Rome throughout geographical Italy)

furthered the antiquarian and psychological research that fueled Freud's theories and interpretations in *Delusions and Dreams* and *"Civilized" Sexual Morality and Modern Nervous Illness.*

Rome and Sicily

Roman photography had a specific set of thematic concerns that stood in marked contrast to those of contemporary photographers in industrialized Europe. In the Paris inhabited by Freud in 1885, photographic subjects included city life, nudes, and psychological portraits, like those by Nadar. Scientific and medical photography, with cameras connected to microscopes and telescopes, and the psychiatric photography we have seen by photographers such as Albert Londe was also prominent in the cultural life of Paris. Vienna was a center for courtly and bourgeois portraiture and photochemical research and scientific imaging. Meanwhile, in Rome (as well as Naples and Pompeii) local and foreign photographers sought to represent that which was ancient, dormant, or vanishing. Preferred subjects in Rome, as in Egypt, included venerable monuments, scenic ruins, and folkloric people (figure 101). Unlike industrialized Paris, with Baron Georges-Eugène Haussmann's massively rebuilt boulevards streaming with life, Rome was perceived and pictured as an exhausted city where urban reality consisted of naturalistic ruins, pastoral animals, and solitary figures. Hippolyte Taine formulated the rhetorical question in his *Italy, Rome, and Naples:* "Is there in Rome any degree of moral energy?"[68] Nature and culture were inseparably intertwined, and scenic views, such as those by Robert Macpherson, Giacomo Caneva, Frédéric Flacheron, and Ignazio Cugnone, were produced for tourists who romanticized the Eternal City as a place not dead and restituted like Pompeii, but rather suspended in time,

Figure 101. Photographer unknown, *ROMA—Gruppo di Ciociari,* postcard. Author's collection.

Figure 102. Robert Macpherson, *Rome: Via Appia,* 1858. Glasgow
University Library, Special Collections.

in a condition of stasis and silence.[69] From the mid-nineteenth century on, ruins
that were shaped or engulfed by nature were popular photographic subjects; views
like Robert Macpherson's *Rome, Via Appia Antica* (1858) were sold to tourists for
souvenir albums (figure 102).

German-speaking tourists were primed in advance with "memory-pictures" of
various *topoi* that conformed to prevailing romantic formulae. In Rome, external
objects and people became an incarnation of previous mental (photographic) struc-
tures. This was true of sculpture, architecture, and painting, where in tourism, the
published photograph almost always anticipated the experience of the object itself.
It is no wonder, then, that when Freud finally visited Rome in September 1901 he
wrote to Fliess that it was an overwhelming experience, but at the same time disap-
pointing, as are so many such long-held wishes when they are finally granted.[70]

On 29 September 1896, Freud wrote to Fliess, "Hehn's *Italy* was a delight for the
women and for me," referring to Victor Hehn's *Italien: Ansichten und Streiflichter,*

mit Lebensnachrichten über der Verfasser (*Italy: Views and Side-Lights, with Information from the Author's Experiences*). According to Hehn, the most characteristic views in Rome consisted of a composite of culture and nature, where columns and cypresses, walls and ruins, architecture and landscape, intersected. Rome was more beautiful than Paris, in Hehn's view, because there were always antiquities around the corner instead of factories.[71] Idyllic photographic representations coalesced easily in an ancient city where orchards, vineyards, and pastures were contained within the city walls and shepherds tended their flocks at public fountains.

Photographs of shepherds, like a carte-de-visite image of a shepherd boy from the Roman Campagna (figure 103) were produced for collectors as nostalgic mementos of this fugitive Arcadian past. In the eyes of northern ethnographers, people were all the more elegant, "classical," and alive for being ancient, pagan, and natural. In an illustration in *Rom und die Campagna* titled *Römischer Landmann* (*Roman Peasant*) a shepherd is posed in contrapposto in a studio, languishing on the remnants of classical columns, which are fabricated studio props (figure 104). Otto Kaemmel uses the same vocabulary that Emanuel Löwy used to describe ancient sculpture when he refers to Roman models and rustics from the Campagna as *Typen* or "types."

Shepherds stood for the primeval intermingling of culture and nature that artists, archaeologists, and historians wished to locate in Rome. Images of shepherds in Western art are laden with diverse (but continuous) layers of meaning. Shepherding, of course, was also the occupation of the Biblical Jews, and in Freud's Philippson Bible, shepherds are depicted in Romantic engravings among classical ruins in natural settings, such as the landscape vignette *View of the Ruins of Ancient Ephesus*, which accompanies a verse from *Lamentations* (figure 105). Freud owned Kaemmel's *Rom und die Campagna* (1902), which was published as

Figure 103. Photographer unknown, *Shepherd from the Roman Campagna,* Carte-de-visite, ca. 1860. Boston, Boston Athenaeum.

die Eukalyptuspflanzungen von Tre Fontane, die mit 120 000 Stämmen einen Raum von 12 ha bedecken und eine verrufene, kaum bewohnbare Fiebergegend so weit gesund gemacht haben, daß jetzt nur noch einzelne Erkrankungen an Malaria vorkommen. Das ist das Verdienst der als Nachfolger der Cistercienser und Franziskaner seit 1868 hier angesiedelten französischen Trappisten. Von hohen, zimtbraunen oder aschgrauen Eukalyptusbäumen überragt, die sich gegen Weihnachten mit üppigen, gelblich-weißen Blütenbüscheln schmücken, liegen das Kloster und seine drei in ihrem Ursprunge sehr alten Kirchen um einen Hof. Hinten, geradeaus von dem hohen Eingangsbogen, dem Reste einer Johanniskirche, steht San Paolo alle tre Fontane (Abb.148), in seiner jetzigen Gestalt ein Bau von 1599 mit den klaren

Abb. 147. Römischer Landmann. (Zu Seite 156.)

Honorius I. (625 — 638) gegründete, jetzt restaurierte Pfeilerbasilika San Vincenzo und Athanasio mit dem malerischen, wohlerhaltenen Kreuzgange aus der Mitte des zwölften Jahrhunderts.

Auch die zweite der großen Basiliken „vor den Mauern", San Sebastiano, hat einem antiken Thore, der Porta Appia, den mittelalterlichen und modernen Namen gegeben. Hinter dem sogenannten Drususbogen erhebt sich die mächtige Thorburg mit zwei braunen runden Zinnentürmen von 28 m Höhe; dann senkt sich die Via Appia in die flache, breite Valle Caffarella hinab, die der Almo (Marrana) durchfließt. Geht man sie ein Stück hinauf, so sieht man an der südlichen Thalwand ein Nymphäum, das erst die Humanisten irrtümlicherweise die Quelle der Egeria getauft haben, selbst beim heißen Mit-

Quellen in Altarnischen, die hervorsprangen, wo das abgeschlagene Haupt des Paulus dreimal aufschlug, ehe das Leben ganz entfloh, rechts Santa Maria della Scala Coeli, eine kleine schmucklose, innen weiß getünchte Rundkirche von 1590 auf einer Grundlage aus dem neunten Jahrhundert, nach einem Gesicht des heil. Bernhard von Clairveaux so benannt, weil er hier einen Sünder, für den er in der unterirdischen Kapelle gebetet hatte, auf goldener Leiter gen Himmel steigen sah, endlich links die große, von Papst

tag ein lauschiges, kühles Plätzchen zwischen moos- und epheubewachsenen, feuchtglänzenden Felswänden und Gewölben, wo unter der liegenden verwitterten Gestalt der Quellnymphe aus drei Röhren klares, frisches Wasser in ein bemoostes Marmorbecken sprudelt. Hoch über der Grotte, mitten in der blumenbestickten Grassteppe, breitet eine Gruppe prächtiger, dunkler Steineichen ihre knorrigen Äste aus, der sogen. Hain der Egeria, der ursprünglich bis zu der Quelle reichte, weit und breit die einzige Baum-

Figure 104. Rommler, *Römischer Landmann,* in Kaemmel 1902, illus 147. General Research Division, The New York Public Library, Astor, Lenox and Tilden Foundations.

Figure 105. Artist/engraver unknown, *Ansicht von den Ruinen des alten Ephesus,* Philippson Bible 3:684, 1858. Photo by author.

part of a "National-Geographic" style series "Land und Leute, Monographien zur Erdfunde." Geography, anthropology, and art are addressed in the selected photographic illustrations, where panoramic views of Rome and the Campagna (such as an Alinari view of the Via Appia Nuova with Ruins of the Aqueducts of Claudius) are intermixed with reproductions of romantic paintings and prints of local people in idyllic landscapes. A painting by Franz von Lenbach (1836–1904), for example, titled *The Arch of Titus* (Budapest) depicts shepherds and peasants relaxing at the foot of the arch while a group of shepherds passes majestically through the arch as if in an ancient triumphal procession (figure 106). Lenbach was the most fashionable German painter of his time. Beloved by monarchs, aristocrats, and industrial magnates, his works commanded astronomical prices.[72] In 1937 Bernard Berenson reflected that, "Lenbach represented the ideal between sentimental pomposity and banal aestheticism of those good mothers of the pure German race."[73] In *Rom und die Campagna, The Arch of Titus* is photographically reproduced and presented as uncritically as the evocative photographs of ruined monuments and folkloric local types in the same book.

Classical sculpture provided a constant simile of idealization for all that was typically Italian in the nineteenth and early twentieth centuries. The people of Rome's Trastevere district and nearby Albano were idealized as "the last of the Romans" and characterized as works of ancient sculpture.[74] Significantly for Freud, when Wilhelm Jensen's Norbert Hanold takes the train from Rome to Naples he "goes native" traveling in a third-class carriage, in hopes of avoiding German honeymooners and finding, "an interesting and scientifically useful company of Italian folk-types, the former models of antique works of art."[75] Although Roman models posed for photographers in local folkloric costumes they were consistently described in terms of ancient statuary. When Nicolai Gogol was in Rome writing *Dead Souls,* he described a model from Albano named Annunziata: "Everything

Figure 106. Photographer unknown, *Der Titusbogen* (The Arch
of Titus) oil painting by Franz von Lenbach, Budapest Museum,
in Kaemmel 1902, illus 79. General Research Division, The New
York Public Library, Astor, Lenox, and Tilden Foundations.

about her recalls Roman antiquity, the moment when the chisel first made the marble sparkle and come to life. [She] is a masterwork of creation, from her shoulders to the toe of her foot she is of an ancient elegance throbbing with life." In a tour-de-force of what we have now defined as lithophilia, Gogol continued that Annunziata's legs were so beautiful that "only the sculptors of antiquity could have anticipated their perfection."[76] By the nineteenth and early twentieth centuries the erotic lure of the proverbial "statue-come-to-life" was a major component of the Romantic ideal of the classical tradition, and in Rome the *topos* extended from beggars and occasional models to the aristocracy. Thus the princess Torlonia, who was descended from the ancient house of Colonna, was praised as "an ancient statue on a golden pedestal."[77]

In a similar vein, the personification of the Italian spirit in Nathaniel Hawthorne's eponymous *Marble Faun,* is figured as an ancient statue (the *Capitoline Faun*) come to life, "a beautiful creature, standing betwixt man and animal."[78] Hawthorne's language here suggests a flip-book overlay or a Galtonesque simultaneous composite. It brings to mind the photographs of the standing marble fauns suggestively photographed by Gargiolli and the souvenir photographs of shepherd boys. Clearly the shepherd in such photographic images is also a faun, standing in contrapposto, dressed in animal skins, and wearing the hat of a typical *pifferaro* or player of pan's pipes. Were these images superimposed in the visual imagination (as in Freud's Galton dream where his uncle and a friend formed the composite image of an unknown character) a Roman faun with both classical and folkloric qualities would emerge. We may imagine alternating photographs flipping to blend the living folkloric shepherd with the *Capitoline Faun.* A psychological "flicker effect" between shepherd and faun, between culture and nature, and between past and present, characterizes the way in which foreigners perceived Rome and its Campagna in the Grand Tour epoch.

Until now, we have looked at the actual printed text captions belonging to specific medical, art-historical, and ethnographic photographs. On a more conceptual level, the idea of the photographic caption need not be taken literally, for the captions that bind photographic material to its meaning can be supplied by the audience or individual beholders as well as an author, photographer, or publisher. Absent or moveable captions for photographs are interwoven throughout the fiction, scientific, or art-historical writings of turn-of-the-century Europe. They were applied to and recombined with visual images in kaleidoscopic sets of culturally appropriate possibilities. A pertinent example of this practice is seen in novels published by firms such as Tauchnitz of Leipzig, where pages of the published narrative are left blank in order to receive photographic images after the fashion of a personal scrapbook or Grand Tour album.[79]

By the time Freud read and interpreted Jensen's *Pompeiian Fantasy,* he had internalized various sets of images, captions, and texts. Chapter 8 of Victor Hehn's *Views and Sidelights of Italy* is titled, "Pro populo Italico," an essay that was originally composed by the author in 1864, and devoted to a kind of philo-Italic racial tourism, the tenor of which was as romantic and reactionary as the illustrative plates of Kaemmel's *Rom und die Campagna.* When considered in combination with the ethnographic and archeological photography known to Freud, we can see how Hehn's anthropological observations contributed to the fertile humus for ideas expressed in *Delusions and Dreams* as well as Freudian theories of modern civilized sexuality and neurotic illnesses.

Photographic representations of ethnic traits and classical beauty came into play in Freud's fascination with the oscillation of Jensen's *Gradiva* between sculpture and living flesh, and with her bodily transformations from death in antiquity to life in modernity and back again. Jensen and Freud were working within a com-

mon cultural system, with visual imaginations that were fed by sets and subsets of photographic images and rafts of corresponding identifying captions.

Among the miscellaneous photographs in Freud's collection were some that portrayed the vestiges of ancient Rome in terms of a picturesque grandeur. The photographic print of the *Temple of Castor and Pollux at Agrigento* (figure 15, p. 61), which Freud purchased in Sicily in September 1910, is painterly and grandiose. Photographs like the one of the temple at Agrigento evoke the lyrical blend of Classicism and Romanticism that characterized the most conservative aspect of nineteenth-century aesthetics. In Freud's experience, sites with great ruined Greek temples standing in wild Mediterranean landscapes, were among the highpoints of his travels, evoking transcendental feelings of being alone in the world—of being alone in a moment where past and present were fused. In Sicily the Greek temple at Segesta provided him with "a magnificent view into the deepest sense of abandonment and solitude."[80] The photographs spoke of an immersion in Arcadia. Löwy's personal *fototeca* was devoted to photographs of ancient sculpture and plaster casts, but he had also collected "Arcadian" scenes and characteristic Italian views.

Löwy's "Arcadian" photographs, now conserved at the Institute for Classical Archaeology of the University of Vienna, are germane to the romantic cultural biases common to Hehn, Jensen, and Freud. Hehn contended that the Italians were a more robust and beautiful race than the northern Europeans, and he compared the Italians to the "majestic heroes of ancient art" as seen in classical sculpture.[81] Roman men stood around the market like Roman senators at the forum, and the body of a girl who was seated on a broken column was arranged in terms of "pure sculptural forms."[82] This description of a girl in modernity resembling an ancient sculpture is paralleled visually in Arcadian photographs from Löwy's collection, where local young people are dressed in classical looking tunics in classical

poses among broken ruins and gardens (figures 107 and 108). They function as living classical sculpture wrought from the contemporary indigenous population of the Italian world. Such photographs belong not only to the predominant lyricism of the statue-come-to-life theme, but also to a special genre of ethnographic photography.

This category of photography is typified by the homoerotic pseudo-classical images of male nudes produced by Wilhelm von Gloeden (1856–1931) in Sicily and Vincenzo Galdi in Rome. Nude studies by von Gloeden and Galdi were produced for foreign consumers as erotica with a classical and ethnographic premise (figure 109).[83] A precedent for such images existed in French romantic painting, as in Hippolyte-Jean Flandarin's *Seated Nude Young Man by the Seashore* (1837, Louvre). Gloeden's photographs of boys in Taormina (Sicily)—nude fishermen, apprentice mechanics, and laborers, dancing and playing pan's pipes *all'antica*—were respected as ethnological studies and poetic evocations of classical antiquity and as reincarnations of Greek deities.[84] As in Hehn's view of the Italians, Gloeden's nudes were received as unself-conscious, naturally aristocratic, instinctually graceful creatures, at one with their environment, and naturally sexual. They were received as such as recently as 1979 by the German-born art historian Gert Schiff, who wrote about Gloeden's photographs in the *Print Collector's Newsletter*.[85] As far as Gloeden's models were concerned, Schiff stated that, "the Italian male, apart from being unabashedly narcissistic, also has the inborn theatricality of his race." And that, "Every young Italian male is more or less overtly in love with his own body, its beauty and virility." Apropos the homosexuality and pederasty alluded to in Gloeden's photographs of teenage boys, Schiff saw the pictures as transparent windows to ethnographic observations: "[homosexuality] is due to this people's instinctually knowing attitude toward all matters pertaining to a man's physical nature."[86]

Figure 107. Photographer unknown, *Arcadian Landscape: Boys with a Bocca della Verità*. Löwy Nachlass, Institute of Classical Archaeology, Vienna.

Figure 108. Wilhelm von Gloeden, *Costumed Youths in a Garden*.
The Metropolitan Museum of Art, Gift of Martha Birnbaum, 1957,
[57.562.9].

Figure 109. Wilhelm von Gloeden, *Reclining Male Nude*. The Metropolitan Museum of Art, Museum Accession, 1952 [52.658.2].

After Freud and Sandor Ferenczi returned from a trip to Sicily in 1910, Ferenczi said he was still in a lingering mood of *dolce far niente*, and that he spent his time, among other things, dealing "with the appropriate framing of the Sicilian photographs with a serious expression on my face."[87] Although the content of the photographs acquired by Freud and Ferenczi in Sicily is not known, they probably consisted of landscape views, works of art, and ethnographic themes.

In Hehn's view, the Italian was always more lively, and hot-blooded, a fuller, more complete, more natural, and therefore more instinctively sexual human

being than the repressed "lymphatic" German. It comes as no surprise that Gradiva, the Mediterranean alter-ego of Zoe Bertgang, who would reawaken and restore Norbert Hanold's sex instinct, was visualized by Jensen in the same manner as Löwy's Arcadian scene.

Sander L. Gilman has noticed that if Jensen's *Gradiva* is considered independently of Freud, it can be read as the "family romance" of people of the northern German race—Jensen, we remember, was from Kiel—who find themselves in the classical world, which itself becomes German, in an almost magical transformation.[88] For Freud, then, the Gradiva phenomenon was a fulfilled wish about the curing of neurotic illness—the repressed German becomes as naturally instinctual as the Italian, but manages to remain German, and to remain a scientist.

In Hehn's experience young girls danced on dusty roads under clear skies, with a grace, proportion, and vitality unknown in the industrialized north.[89] The implication is that these Italian girls were descended from less benign ancestors, namely the delirious bacchantes and voluptuous maenads seen in classical gems and reliefs, whose ecstasy is so frequently inspired by nearby satyrs or sculptured herms. In the Francophone world, the stereotype of Mediterranean women was recorded by the Goncourt brothers on a journey to Rome in spring of 1867: "The woman of the South speaks only to the senses: the impression she makes goes no deeper. She addresses herself exclusively to the masculine appetite." They go on to contrast the sensual Italian woman with the northern European woman who is, instead, capable of inspiring tenderness and genuine affection.

> In the evening, after having passed in review all the types of brilliant or savage beauty to be seen in the streets of Rome, in the Pincio, on the Corso, it seems to me that only an Englishwoman or a German woman can give a man the feeling of affection, the stir of tenderness.[90]

Figure 110. Bartolomeo Pinelli, *Saltarello,* etching, in Haas 1904,
illus. 140. General Research Division, The New York Public Library, Astor,
Lenox and Tilden Foundations.

The etching titled *Saltarello* by Bartolomeo Pinelli in Kaemmel's *Rom und die
Campagna* encapsulates just this attitude: beautiful Roman peasants dance with
an aqueduct in the distance and an onlooker seated on an ancient column capital
(figure 110). Similarly, Hehn's description of Roman girls feeds directly into the
Freudian image of *Gradiva:* they dance like nymphs and bacchantes; and what
is more significant, they look to Hehn as though they were figures taken directly
from ancient bas-reliefs and transferred to reality.[91] We may assume that Wilhelm
Jensen composed his Pompeiian novel under the influence of books like Hehn's
Italien, where girls from ancient relief sculptures came to life in the contemporary
population in a metaphorical if not fantastic manner. Jensen's *Gradiva* was from
a relief of a row of the three *Horae,* dancing girls as natural and inevitable as the
seasons themselves.

If the Italian girls described in Hehn's ethnographic research tend to predict the *all'antica* qualities of Jensen's "Zoe-Gradiva," Hehn's typical German tourist corresponds with the condition of Freud's repressed and deluded archaeologist, Hanold. The following passage by Hehn seems a prescient diagnosis of Hanold and his misadventures, together with Freud's own "deeply neurotic" longing for Italy as a source of youth and pleasure.

> The German, if he goes to Italy, whether it be for recreation or business, receives from the Italian the impression of a total and direct existence, whose expression is performed in a natural flow, necessary and light, in spirit as well as body. The German himself, son of the North, is a faltering broken creature: a gray twilight dominates the consciousness of the German, even deep inside, where feelings and resolve are born, and endows him with an injuring pallor and uncertainty. In the German a surplus of spirit arises with no outlet in the organic functions, so that the movements of the soul are not followed through in the muscles or limbs. And the body, thus separated from the soul, is angular, raw, podgy, mechanical, and clumsy. The whole sluggish physical apparatus reacts against the sensory fascination of the world to obey only the cerebral part of the brain. On the other hand the appearance of the Italian expresses a spiritual and perceptive feeling, which is not arrested in its effusion from the formation of the organic body, but rather takes a fully sensuous existence in bodily form.[92]

For Freud—who developed the theme of the separation of the body from fundamental desires and urges such as sex and aggression, and the resulting neurotic illnesses—Hehn's praise of the Italian race, whose intellect and sensuality were melded together in a bodily grace that echoed that of the ancient Greeks (a combination of intellect and sensuality, which according to Freud was denied to the Jews) must have struck a meaningful note.

Indeed, received knowledge had it that contrary to the ancient Greeks, nineteenth-century Jews had very little balance between body and soul. Leroy-Beaulieu stressed that the unhappy psychological state of the Jews with the statement, "No other race has so often proved the fallacy of the *mens sana in corpore sano*" as the Jews. The plight of the Jew was to have a lucid, hyper-vigilant mind in a feeble body: "No race is so little carnal."[93]

Carl Schorske has observed that the opposite notions of *Geistigkeit* (intellect; spirituality) and *Sinnlichkeit* (the realm of the senses) drove Freud's conflicted view of civilization until in *Moses and Monotheism,* he personified *Geistigkeit* in the historical Moses as the most fundamental characteristic of Jewish culture.[94] Freud already posited the triumph of intellectual wisdom over feeling in his *The Moses of Michelangelo* (1914). We have established that a prevailing contemporary view of Jewish monotheism, with which Freud grappled in his study of Michelangelo's *Moses,* held Jewish aniconism up against the lure of Hellenic and Roman Catholic anthropomorphism. According to Jewish writers like Solomon J. Solomon and Heinrich Graetz, the so-called Latin races enjoyed a multiplicity of gods (or saints) whose configuration as humans necessarily divided them into two sexes, thereby endowing the belief system with passions, divisiveness, and "all the frailties of sex."[95] These writers emphasized the likeness of the Jews to the northern Europeans (Protestants), not racially, but temperamentally, casting the society of "Hellenic Southerners" as a source of license and excessive passion. It is not surprising that Freud believed that Hellenic Southerners were temperamentally at one with their sunny and volcanic climate: in a letter to his wife from Sorrento he wrote,

> Vesuvius was smoking competently by day, and yesterday evening it showed some fire. The radiance is indescribable today, and the temperature is startling too. I grasp everything now that I've ever heard about the effect of the south on character and energy. The sun is simply stronger.[96]

Löwy's Arcadian views, ethnographic photographs of shepherds and peasants, and archaeological photographs of inanimate sculpture, "flickered" to create a vocabulary of *Gradiva*-like figures. The *materia photographica* of Löwy's archive was meant to be studied in a library, thus trumping the Jewish taboo on figuration and the Hellenic veneration of the nude—a way of seeing that was a source of fascination and cultural transcendence for assimilated Jews like Freud, Ludwig Pollok, and Emanuel Löwy.

The "surplus of spirit" that Hehn considered blocked in the northern European led to pallor, uncertainty, and nervous illness. Conversely, the Italians—past and present, in life as in art—expressed life in a "natural flow," where spiritual, psychological feeling is not arrested, but rather, "takes a fully sensuous existence in the body." The suppression of instinct, then, finds its cure not only in ancient sculpture but also in "ancient" Mediterranean peoples.

Freud's ethnographic research in sculpture and photography took place in a universe of moveable captions, where photographic overlay-effects formed recombinant composites of Jews and Egyptians, mummies and Parisian syphilitics, and where ancient marble statues shared an identity with living shepherds. In a cultural system where morphological observation and visual description were of primary importance, photography played an essential role, and a photographic manner of seeing could easily aid in the imaginative transformation of a German bride into a dancing bacchante or an animated Aphrodite.

Sympathetic Magic and Conclusion

I am but a symbol, a shadow cast on paper, the real person is
going to return and then you may neglect me again.

—Freud to Martha Bernays, speaking as her portrait

Scientific modernism inspired Freud's life and work. But premodern religion and superstition intrigued him from his position in modernity—a position that we have seen to be as precarious as it was adventurous. The new project of dream interpretation on the cusp of the twentieth century was intimately connected with ancient superstition. We recall that in *Delusions and Dreams in Jensen's* Gradiva Freud introduced himself as the author of *The Interpretation of Dreams,* thus claiming to be "a partisan of antiquity and superstition." In the same text he stated that dreams were, by their very nature as fulfillments of wishes, prescient of future states and events.[1] This delicate balance between superstition and science, between

primitivism and sophistication, between objectivity and subjectivity, hinges on the all-important concept of *interpretation*. A quest for interpretation, and a premium placed on the value of interpretation, lies at the heart of the psychoanalytic project. Freud interpreted everyday life as a field in which whimsical or absurd coincidence could represent deep unconscious conflict.

In *The Psychopathology of Everyday Life,* Freud declared that he, as a modern, scientific man, differed from a primitive, superstitious person in that he did not believe that an external omen in which his mental life had played no part could possibly determine truths or events. His unconscious mind, however, could disclose truths about the past and the future, because in psychic internal life there were no mere accidents. Chance, instead, belonged to the chaos and flux of external reality. For a superstitious individual the chance events of external reality begged for interpretation and were potent indications of underlying mystical truths and future events the causes of which floated beyond the realm of apparent reality. "But," Freud declares, "what is hidden from [the superstitious man] corresponds to what is unconscious [and therefore discoverable in analysis] for me, and the compulsion not to let chance count as chance, but to interpret it is common to both of us."[2]

In his study of everyday life Freud stated that superstition was the stuff of the pre-scientific, pre-modern world:

> It is only in our modern scientific but as yet no means perfected Weltanschauung that superstition seems so very much out of place; in the Weltanschauung of pre-scientific times and peoples it was justified and consistent.[3]

It is generally recognized that modern technology enhanced objective scientific investigation, especially in fields such as medicine, biology, and astronomy. But technology also produced a kind of talismanic thinking of its own.

Photography stands in the foreground of the phenomenon of modernist superstition, even for Freud and his social group. Photographs provided the material for the simplest to the most arcane forms of fetishism and magical thinking. This is particularly true of portrait photographs, in which the camera worked as a proverbial "insight machine" revealing deep character traits, such as the masculine wisdom and authority expressed in the waist-length "portraits" of Freud and Michelangelo's *Moses*. Photographic portraits also functioned as ghostly surrogates for the person portrayed, and as such were charged with mysterious efficacy in the realm of everyday life.

The idea of surrogacy is deeply embedded in the Western idea of portraiture. A classic example of the portrait as surrogate occurs in the sonnet that Baldassare Castiglione wrote about his own portrait painted by Raphael. This poem takes the form of a letter from Castiglione's wife, where the "living portrait" by Raphael substitutes his own presence to console her when he was away from home. Raphael's skillful mimesis, his conquest of nature, Castiglione states, makes the absent present: "Assensu, nutuque mihi saepe illa videtur."[4] If we needed scientific proof of this abiding cultural phenomenon, in 2004 the British cognitive neuroscientist Keith M. Kendrick came to the rather anodyne conclusion (via his work with face-recognition in sheep) that keeping a photo of a loved one nearby, "should be a fairly effective method for reducing separation anxiety in humans."[5] Photographic portraits can provide consolation, but in the imagination of humans they can be uncannily disturbing.

Around the turn of the twentieth century portrait photographs had come to acquire talismanic value, as though the photograph were a sort of blood sample, a relic in which the most salient qualities of the individual were condensed. In Europe photographic portraits also served as amulets, talismans, effigies, and vehicles for sympathetic magic. The indexical relationship between a photograph

and its portrait sitter made this quality of surrogacy even more vivid. Throughout the twentieth century in Europe and the Americas portrait photographs have served as powerful fetishes: they were destroyed, for instance, in order to mark (or even cause) the termination of an affective relationship with the subject. Photographs of loved ones were traditionally burned by Europeans rather than mutilated or thrown away: thus the ghostly double dissolves back into the ether rather than suffering pain or abandonment. Portrait photographs received human kisses and other attentions that were directed at the subject's indexical referent. In late twentieth-century New York, photographs of enemies were placed in the freezer compartment of refrigerators, in order to disable the nefarious thoughts or actions of the subjects.

Such superstitious practices of "like affects like," which James George Frazer wrote about in his investigation of religion and folklore, held sway in Europe and the United States when it came to photographs. Frazer defined this principle as "sympathetic magic."[6] Photographic likeness both substituted and acted on behalf of the referent subject. In Freud's personal life the reverse also held true, that is, the portrait subject could determine the behavior of her corresponding framed photograph.

Animism: The Talismanic Qualities of Photos

There is no question that photographs made the absent present and brought the dead to life in Freud's circle of medical mentors and friends. Official portrait photos, which were widely replicated in publication and thus instantly recognizable, served a symbolic role as emblems of schools of thought. They also functioned as amulets and talismans of inspiration and protection. Such portrait representations,

placed in propitiously visible spots in the workplace, offered a component of sympathetic animism. Freud kept a formal portrait photograph of Jean-Martin Charcot in his office at Berggasse 19 (figure 111).[7] This was the man who led the young Freud through what he called the "wilderness of paralyses, spasms, and convulsions" at the Salpêtrière; who installed there not only a museum but also a special photographic studio.[8] The photograph accompanied the famous photo-lithograph of André Brouillet's painting of Charcot teaching (figure 112).[9] For Freud a "magic emanated from [Charcot's] looks and his voice," and the posed portrait photograph made him an absent presence in Freud's study.[10] At the same time that it was a symbol of respect, Charcot's presence functioned as a propitious charm for Freud's work. The great *visuel* cast his gaze on Freud's work, auguring well, as it were, for psychoanalysis.

When he visited A. A. Brill in his apartment in New York, Freud remarked, "My photograph, of course, hangs in his study."[11] The portrait photograph in Brill's study functioned as a badge of allegiance and an espousal of a certain set of intellectual beliefs rather than a visual investigation of the sitter's presence at a given moment in time. Freud did not want to search the photo for clues or for unconscious material, he was just relieved to see that it was there, presiding over Brill's work in the new world. Sighting his own photograph in Brill's study was one of the few consolations during of Freud's trip to the United States, which was otherwise fraught with doubts, resentments, and anxieties.

By 1882 Freud had a display of the "severe faces of the men I revere" above his desk. But among these faces he dared not display the "delicate face of the girl I have to hide and lock away" in a little box. This was the recently acquired photographic portrait of Martha Bernays (figure 113) charged with memory, agency, and attraction. It was conserved, like an efficacious object, inside its own protective reliquary. "In fact," he tells his fiancée, "I hardly dare confess how often during the past

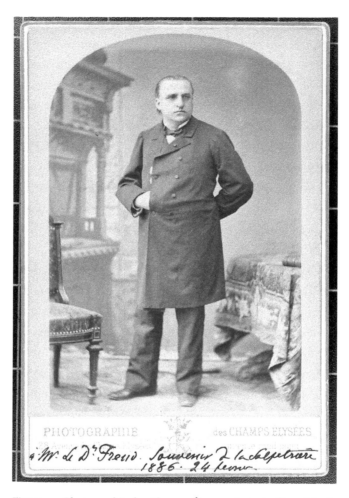

Figure 111. Photographie des Champs Élysees, *Portrait of Jean-Martin Charcot*, Cabinet Card, inscribed 1886. Freud Museum, London.

Figure 112. Louis-Eugène Pirodon, Detail of a photo-lithograph, 1888.
Reproduction of painting by Pierre-André Brouillet, *Une leçon clinique à la
Salpêtrière*, 1887. Photo by author.

twenty-four hours I have locked my door, and taken it out to refresh my memory."[12]
Freud in love refused to squander the erotic agency of his beloved's photograph by
displaying it among the severe portraits of intellectual father-figures; the thrill of
desire and possession was best enjoyed at intervals behind a locked door.

If Kendrick concluded that face-recognition could provide emotional solace,
Freud arrived at the same conclusion from the personal experience of his long
separation from his fiancée. During that time Freud wrote to his beloved, in a po-
etic *ekphrasis* before the image, about the importance of her photograph:

> [Y]our lovely photograph. At first, when I had it in front of me I did not think so much
> of it; but now, the more I stare at it the more it resembles the beloved object; I expect

Figure 113. *Portrait of Martha Bernays*. Freud Museum,
London.

the pale cheeks to flush the color our roses were, the delicate arms to detach them-
selves from the surface and seize my hand; but the precious picture does not move, it
just seems to say: Patience! Patience! I am but a symbol, a shadow cast on paper, the
real person is going to return and then you may neglect me again.[13]

The more Freud gazed with desire at the photograph of his adored fiancée the
more he saw a potential for the surrogate-image to magically come to life, like Pyg-
malion's *Galatea* or Norbert Hanold's *Gradiva*. But the photograph itself speaks to
Freud, telling him that she is just a ghostly symbol, a "shadow cast on paper," an
uncanny double for "the real person," who will eventually return. Freud's desiring
gaze was answered by the sympathetic magic that linked the young woman with
her picture. In Freud's imagination Martha spoke to him by way of her photo-
graph, admonishing her lover that patience would have its rewards.

Vexed with himself that he had not held onto an old photo that was owned by
her mother, Freud then begged Martha to "steal from your fond relations all the
photographs of you as a child."[14] Several of these did indeed enter his collection
(figure 114). To travel back in time, to possess the beloved as she was before he
knew her, to hold in his hands her embodiment as a child through the surrogacy
of a mere "shadow cast on paper"—these were wishes that lovers could enact with
printed photographs.

Freud wrote to Martha later in their courtship (1886) that he was analyzing an
American physician on behalf of whose particularly "beautiful and interesting"
wife he was consulting the gynecologist Rudolf Chrobak. This gynecological con-
sultation was apropos some of the more "delicate aspects" of the husband's case.
Freud states that: "It seemed weird to me that on both the occasions she was here
your photograph, which has otherwise never budged, fell off the writing table.
I don't like such hints, and if a warning were needed—but none is needed."[15]

Figure 114. *Portrait of Martha Bernays*. Freud Museum, London.

Telepathic thought and sympathetic magic allowed Martha's discomfort to determine the behavior of her framed image. Martha's photo portrait was apparently capable of seeing and intuiting as well as being loved—the effigy was a truly uncanny *Doppelgänger* who edged her way off the table to communicate as in the context of a spiritual séance. Freud's use of Martha's photographic portrait as a surrogate for her physical presence was about desire, possession, and its terrible corollary, jealousy. This time it was Freud who advocated patience and trust. No visible portent was needed, he reassured his beloved: the photo could stop its disturbing behavior, for all was well and constant despite the presence of a desirable, "beautiful and interesting," woman in Freud's office.

Freud's tongue-in-cheek tone in these letters emphasizes his understanding of the deep ambivalence that haunted the turn-of-the-century mentality toward magic and superstition. The following statement also speaks to this condition:

> Our patient was to a high degree superstitious, and this although he was a highly educated and enlightened man of considerable acumen, and although he was able at times to assure me that he did not believe a word of all this rubbish. Thus he was superstitious and not superstitious; and there was a clear distinction between his attitude and the superstition of uneducated people who feel themselves at one with their belief.[16]

Here Freud might as well have been describing himself when faced with the animated, speaking, and protesting photographs of his beloved. A "highly educated and enlightened man," he did not always feel himself at one with his intellectual beliefs; there was always room for what Freud would later define as "the uncanny." The "patient" in question, however, was not Freud himself, but rather Ernst Lanzer, the so-called Rat Man.[17] The Rat Man was of special interest to Freud

because (rather than in spite) of his belief in premonitions and prophetic dreams, and because of the unconscious mental processes that played against his everyday experiences of coincidence and chance.

Freud's experiences in the culture of portrait photography admitted the strange, the subversive, and the uncanny. In this sense he was a typical member of his own educated social class, living in the thrall of a modernity that was haunted by superstition. But these anecdotes of "magical" photographic surrogacy in Freud's letters to Martha are based on the keen, and somewhat mildly humorous observation of his own mind from an arm's length, in almost the same way he would observe a deluded patient.

In his work as a scientist and philosopher, the occult had little interest for Freud. It is interesting to note that in July 1921, Freud responded to Hereward Carrington, a British-born American psychologist living in New York who experimented with occult phenomena, by insisting that his name *not* be used in connection with Carrington's ventures. In an exaggerated gesture of *politesse* Freud added:

> I cannot rid myself of certain skeptical materialistic prejudices which I would bring with me into the study of the occult. Thus I am utterly incapable of considering the "survival of the personality" after death even as a scientific possibility, and I feel no different about the "idroplasma" [the slimy or bubbly plasma produced by ghosts]. In consequence I believe it is better if I continue to confine myself to psychoanalysis.[18]

Freud had no literal belief in magic, religion, or ghosts, and the "speaking" photographs on his desk did not alter his fundamental beliefs. However, photographic presence and surrogacy was deeply embedded in Freud's visual imagination.

The underlying premise of my argument has been that photographs, like memories, are always subjective constructions with unconscious as well as conscious

content. The inherent paradox in turn-of-the-century photography is that the images are not transparent windows to an objective reality; and yet they were frequently used as if they were endowed with the ability to present the visual truth. In their very subjectivity, photographic images (ostensibly "documents" or "reproductions") are part and parcel of the history of modern thinking—in particular of the historiography of art and the history of psychoanalysis. To the extent that the phenomenon of photography resembled memory and dream-memory, it interfaced easily with Freud's psychoanalytic project.

Freud said little about photography in his published work. Yet most of his photographic thinking (and envisioning) was so deeply embedded in the culture as to be involuntary, or unconscious, on the part of the founder of psychoanalysis, and, by extension, his contemporaries.

In this book I have analyzed specific photographic images, and instances of photographic beholding and thinking, as well as the interaction of published photographs with text, in the context of various aspects of Freud's life and work. We have seen that Freud's art-historical theories about Michelangelo's *Moses* were fed by varieties of photographic phenomena. Freud's photographic thinking about Michelangelo's sculpture incorporated: documentary photographs of sculpture, contemporary conventions of portrait photography, sequential chronometric photography, psychiatric photography (some of which was sequential), popular postcard photography (with a charged interaction of image and text), ethnographic photographs, Orientalist photographs, photographic reproductions of paintings, and enlarged photographic details of works of art. These enlarged details, in their isolated intensity, resembled Freudian screen memories, just as photographs generally "looked like" memories and dreams.

If photographs resembled dreams, then the reverse also held true: dreams looked like photographs. The fugitive view of Rome through a train window that slipped

away from Freud in the first of his famous "Rome dreams" was eminently photographic, and we have seen that its photographic prototypes were found to be ubiquitous in the landscape of Freud's expanded environment and personal library.

Archaeological photographs spoke a language of their own—a visual language rich with sadness, fragmentation, the historical past, and oblivion, or time forgotten. These images were plentiful in Freud's extensive library, published by art historians such as Maximilian Ahrem, Adolf Furtwängler, Emanuel Löwy, C. F. W. Weichardt, August Mau, and other mainstream scholars of antiquity. For people like Freud who read illustrated art-history books, these highly subjective photographs eclipsed the physical forms (fragments and pastiches) of ancient sculpture almost entirely.

When Emanuel Löwy stated that "The whole form [of the *Venus Medici*] melts into a play of shadows and light," he was addressing a photograph rather than the statue at the Uffizi. This phenomenon of photographic surrogacy, with room for the imagination of the beholder to play in the melting chiaroscuro passages of the photograph, allowed statues to "come to life" in the unconscious fantasy of the beholder. Jensen's Gradiva's oscillation between life and death was an echo of the greater archaeological metaphor for psychoanalysis, and for the forgotten past, both historical and personal. Photographs were latent (negatives) and manifest (prints) just as buried objects were latent, and excavated material manifest, in archaeology and the psychoanalytic process.

Around 1900 Pompeii itself was an uncanny site where the dead came back to life after an interval of eighteen centuries of burial. The images of archaeological photography—nude bodies and fragments of bodies floating in a darkened space—served as intellectual pretexts for erotic desires. Archaeological photographs resembled dreams, and in particular dreams of the dead *redivivus* or of sculpture come to life. Such pictorial language was, like dream imagery, simultaneously condensed and visually open to interpretation.

Rome and Italy were sacred to Freud in intellectual, mythological, and erotic terms. Ethnography, natural history, and classicism merge in the Italian tourist photographs of Freud's time. Italy is fantasized as fully classical in its aesthetic and naturally authentic in its social life. This trait is reified in the Italian people, who are represented in literature and photography as "naturally" elegant and at ease in their bodies. Ancient statues of fauns, for example, are visually interfaced with living shepherds in the photographic repertoire to form the "naturally" sexual Italian. The equation ROMA = AMOR dominated Italian photography of the nineteenth and early twentieth centuries. Similarly, Vesuvius and the Roman Campagna provide a romantic photographic habitat for fauns, nymphs, and shepherds.

Although Freud did not reach Egypt, he was steeped in Egyptian history and archaeology throughout most of his career. His last great work, *Moses and Monotheism,* fantasizes Jewish and Egyptian antiquity based on tendentious historical and ethnographic assumptions, many of which resonate with the photographic images in Freud's library.

Contemporary ethnographic photographs of living Egyptians positioned Egypt as the static, unchanging, society proposed by nineteenth-century archaeologists. In an uncanny sense of simultaneous stasis and continuity, living Bedouins belonged to the Pyramids. Orientalism continued, closer to home in both time and place, to define the Jews of Europe. Touristic and medical photography, among other vehicles demonstrated that Jews from Eastern Europe were "others," contaminated, as much by their "Asiatic" racial origins, as by their chronic physical and psychic illnesses. Such images prevailed in nineteenth-century Paris and Vienna, finding place in Freud's library, his consciousness, and most probably his unconscious fantasy-life.

I have proposed that photography played a significant role in the process of visualization for the great archaeologist of the human mind. At the same time, I have

used Freud and his ideas as a paradigm for a synthesis of the history of visual culture and the historiography of art. The subjectivity of this language defied the ostensibly documentary (objective) principles according to which it was produced.

The thickness and flexibility of Freud's visual imagination was in many ways the key to the great modern project of psychoanalysis. Principles of archaeology, ethnology, art history, medicine, and psychoanalysis spoke a common language in photography. It is my hope that through examining some of the photographically motivated styles of thinking that went into the making of Freudian interpretations, readers have gained insight into the historical apparatuses and the visual imaginations—both collective and personal—that prevailed during the early years of psychoanalysis.

I conclude by asking: Is it not something of a relief to recognize that those of us who read and write about psychoanalysis, history, and the history of art, are also driven by unconscious conflicts and wishes? We, too, are captive to the long-remembered and long-forgotten images in our conscious and unconscious minds. We in the twenty-first century are still enthralled by photographs, old ones and new ones. And we are still motivated by assumptions, biases, and screens, which we—like the founder of psychoanalysis himself—may furtively hide from ourselves without knowing it.

Notes

Introduction

1. Gilman et al. 1994.
2. Bergstein 1992.
3. Wharton 2001, 2: 749–62.

Chapter 1. Memories and Dreams

1. Freud 1901, 47.
2. Rizzuto 1998, 104.
3. The French philosopher Ernest Hello (1872, 172–74) was the first to establish the metaphor of photographs as mirrors of memory.
4. Goethe [1789] 1982, 116.

5. Freud 1900, 194; the "Rome Dreams" are presumed to have occurred around December 1896–January 1897.

6. Laurence Simmons (2006, 133) cites its frequency in drawings, watercolors, and prints throughout the eighteenth and nineteenth centuries.

7. Brogi's photograph was present as an illustration in Edward Hutton's *Rome* (1909), which Ernest Jones sent to Freud from Rome in 1912.

8. Danius 2002, 112–13.

9. Freud 1913a *SE* 12: 121–44, 135.

10. 3 September 1902, Freud to his family from Sorrento (Tögel 2002, 159–12).

11. See Roskill and Carrier 1983, among many other writings on photography and representation.

12. Valéry 2005, 36–40.

13. Ibid., 32.

14. Crary 2001, 146.

15. Armstrong 1998, 3.

16. See Benjamin 1999, 510–12; Krauss 1993, 178–80; Buse 1996, 136.

17. Barthes 1981, 47.

18. Bergstein 1992.

19. Described in a letter from Freud to his children, Tögel 2002, 224–25; see also Crary 2001, 361–70.

20. Freud 1899, 305–7.

21. Freud 1900, 536.

22. Ginzburg 1980.

23. Freud 1936, 239–50.

24. Ibid., 240, 244.

25. Ibid., 241–43.

26. See Kristeva 1996, 326–27 for the concept of "Freudian Time."

27. Freud 1900, 611.

28. Barthes 1981, 93–94.

29. Kaufman 1982, 198.

30. See, e.g., Brassaï 2001, 82.

31. Duve 2007, 109–11 passim.

32. Freud 1939, 126.

33. See Eder, vols. 1895–1914, passim.

34. Rose 2001, 26; idem, 2003, 116.

35. Bordieu 1984, 13.

36. See Bergstein 1992 on the photography of sculpture.

37. See Bergstein 1999, 123–24; Bann 2006, 126–27.

38. Trosman 1973, 66–70.

39. Tögel 1989, 31–32.

40. Ibid., 31–32.

41. Freud to Fliess 5 November 1897 (Masson 1985, 277–78).

42. Freud to Martin Freud, 16 August 1937 (Ernst Freud 1992, 437–38, no. 291).

43. Löwy 1900.

44. Wolf 1998a, 22–23, citing Spector 1972.

45. Löwy 1909, 1911a, 1911b.

46. Fothergill 1907, v.

47. O'Donoghue, 2004, 21–24.

48. Fothergill 1907, vi.

49. Gombrich 1966, 30.

50. Ricoeur 1970, 159–60; Ferguson 1996, 2–3.

51. Panofsky 1953, 140–44.

52. Ibid., 144.

53. See Podro 1996, 16–17. For a theoretical discussion of Panofsky and Freud, see Holly 1984, esp. 167, 177. Art historians have now revised the idea of "disguised" symbolism in Netherlandish painting. But, as with Freudian dream interpretation, one might argue that this search for indirect symbolism in images is still a primary *modus* in the apprehension of figurative and abstract art on a popular level. Thus the *Interpretation of Dreams* changed the paradigm for interpretation of visual material, including historical art.

54. See Baxandall 1972 for the concept of a "cognitive style" pertaining to a given culture and its habits.

55. Gombrich 1966, 30–31; Tögel 1998, 131–33.

56. As quoted by Romm 1983, 44.

57. Tögel 2002, 141, 146–47, 233–35; Romm 1983, 44.

Chapter 2. Freud's Michelangelo

1. Freud 1914, 211.

2. Ibid., 211–38.

3. Falzeder et al. 1993–2000, 3:78–79, no. 899.

4. Magherini 1995, 129.

5. Bernfeld 1951, 112.

6. Freud 1939, 91; for Rathenau's comment (1897) see Vital 1999, 258–59; see also Gilman 1995, 162.

7. Freud 1939, 98–100.

8. H.D. 1974, 97.

9. Gay 1988, 171.

10. Flem 2003, 31.

11. Freud to Martha Bernays, 20 January 1886 (Ernst Freud 1992, 194).

12. H.D. 1974, 116; Handler Spitz 1989 for Freud's antiquities.

13. Ibid., 42.

14. See Bernstein 1998, 21.

15. See Davies 1998, 95–98.

16. Gronberg 2001, 67–88; Gronberg 2007, 37–67.

17. Berkeley 1988, 47–57, 85–92; Decker 1991, 14–40.

18. See Yerushalmi 1991, 16; Berkeley 1988, 57–99; Schorske 1980, 185–93; Beller 1989, 205–6. Strangely enough, when on vacation in the spring of 1898 Freud toured the caves of Saint Canzian at the same moment as Lueger, an irony that did not escape his attention, as he alluded to the mayor as "The Lord of Vienna" in a letter to Wilhelm Fliess about the natural marvels of the caves (Tögel 2002, 96).

19. See Davies 1998, 98 and Gronberg 2007, 63 n. 22.

20. Molnar 2007, 119–27.

21. Leonardo 1980, 207.

22. Ballerini 1996.

23. Masson 1985, 214; see also Anzieu 1986, 182–83.

24. Bonfante 1989, 545–46, 563.

25. Poliakoff 1987, 146.

26. Solomon 1901, 553–66; Graetz 2002, 88, 177. For the origins of Jewish monotheism as a counter-religion to Egyptian idolatry see Assmann 1997, 208–11.

27. Hibbard 1974, 152.

28. Trincia 2000, 3–40. Whereas Trincia and others find that Freud's intensity of observation is legible in the photographic portraits made throughout his life, Stefan Zweig (quoted in Robert 1966, 227) maintained that beside a certain *gravitas*, Freud's photographic portraits revealed little. "At a loss, one closely examines the photographs without ever discovering anything except a typical doctor's face framed by a well-trimmed, ideally masculine beard, such as Lenbach and Makart liked to paint; a gentle, somber, grave face but not really very revealing."

29. Quoted in Thode 1908, 211.

30. Ibid., 210–12.

31. Hammond 1892; De Sanctis 1889; Hall 1904.

32. Hall 1904, 2: 262–58.

33. Ibid., 262–63.

34. Saslow 1991, 419.

35. Paskauskas 1995, 169–70.

36. H.D. 1974, 64–65, 101.

37. Thode 1908, 195–203

38. Ibid., 203.

39. Freud used Thode (1908) as a working bibliography, underlining and highlighting the observations of various authors whose works on Michelangelo's *Moses* he thought important. In the standard English edition of Freud's works James Strachey added full citations for the works quoted by Thode, whereas in the original German paper, these

details were not included. Therefore it is not exactly clear as to which of these earlier sources Freud actually went back to in preparation of his *The Moses of Michelangelo* (see Macmillan and Swales 2003, 43–44). But Thode's monograph was thick enough with quotes and citations for Freud's purposes.

40. 27 August 1933, Morra 1965, 158.

41. Panofsky 1939, 193–94, Hibbard 1974, 157–58; Tolnay 1975, 85. Cf. Grubrich-Simitis 2004, 69–78.

42. Hibbard 1974, 158.

43. Panofsky 1939, 193.

44. Wilde 1954, 22–23; Hibbard 1974, 202–8. Despite its ahistorical assumptions and other peculiarities, Freud's interpretation has adhered to the *Moses* like a patina in the psychoanalytic community. Scholars of psychoanalysis Malcolm Macmillan and Peter Swales (2003) have presented an eloquent restaging of Freud's original argument on the pages of *American Imago*. They set out to gauge the correctness of Freud's interpretation, concluding that the determinate moment represented by Michelangelo is not the one from Exodus 32, but rather after Moses's *second* ascent of Mount Sinai (Exodus 34). This shift in textual interpretation could account for the fact that the tablets under *Moses*'s arm are uninscribed, for the figure's horns of light, its facial expression, and for Michelangelo's pairing of Moses with Saint Paul (in theophany). But the scrupulous evaluation offered by Macmillan and Swales prioritizes the same methodologies and issues as Freud had; and since Freud's reception of the sculpture was specific to his time and place, their parallel argument betrays a certain historiographic archaism. (This interpretation was actually first suggested by Blum 1991, 521.) For a beautifully nuanced and imaginative psychoanalytic-rabbinic-Midrashic reading of this second (uninscribed) set of tablets, see Spero 2001, 402–23 passim. Faced with Spero's elegant thinking, one can only say, "Se non è vero, è ben trovato."

45. Beck 1999, 173.

46. Jones 1953, 1:346.

47. Schorn and Förster 1832–49: 292–93 and n. 59; the story was reiterated in Steinmann 1899, a copy of which was in Freud's library.

48. Gsell Fels 1912, 754, marked by Freud.

49. Paskauskas 1995, 15 November 1912, no. 103, 177.

50. Flem 2003, 51–52.

51. Quoted in Robert 1966, 372.

52. Flem 2003, 52–54.

53. Freud 1936, 239.

54. Postcards from Athens to Martha, dated 3 and 4 September 1904 (Tögel 2002, 190).

55. Anzieu 1986, 184; Haddad 1995, 13.

56. Masson 1985, 284–85.

57. Anzieu 1986, 194; Haddad 1995, 40.

58. Paskauskas 1995, 179–84; Hutton 1909, 4, 6.

59. Magherini 1995, 154–55.

60. Thode 1908, 200.

61. Ginzburg 1980.

62. Morelli 1897; Tögel 2002, 117.

63. Freud 1914, 222.

64. Bergstein 1999, 125.

65. For an extensive analysis of Engelman's photographic documentation see Fuss 2004, 71–105.

66. I have chosen not to discuss Freud's great failed psychoanalysis of Leonardo da Vinci (Freud 1910a), which hinged upon the identification of a repressed memory that determined the painter's personal psychology. Freud searched Leonardo's paintings for fragments of unconscious childhood memories, and found in the *Madonna and Child with Saint Anne* (Louvre) a disguised scene of Leonardo's relationships with his "two mothers"—his birth mother and his stepmother. It is pertinent to the theme of the Jewish father, however, that whereas Freud had psychoanalyzed Leonardo's painting as an aspect of the artist's personality, and therefore a representation (as in the representative medium of a fantasy or a dream), in the case of Michelangelo's *Moses* he suspended disbelief, and saw the statue come to life as a historical individual.

67. Jones 1955, 2:365.

68. Falzeder et al. 1993–2000, 1:417–19, no. 332; 424, no. 338. For the historical role of the cast collection at the Academy of Fine Arts see Hagen 2002.

69. 23 December 1912 (Paskauskas 1995, no. 109, 184): "I enclose two photographs of Moses. Will you tell me if they are what you wanted? You will notice that the projecting pediment interferes inevitably with the view of the tables. I examined the latter carefully, and one cannot say there are fingerprints on them." In response Freud wrote on 26 December 1912 (no. 111, 186–87), "Thanks for your two photographs of Moses. They show as much as may reasonably be expected. If I may trouble you for something more—it is more than indiscrete—let me say I want a reproduction—even by drawing—of the remarkable lower contour of the tables, running thus in a note of mine [drawing]."

70. Freud 1914, 138, n. 1.

71. Ibid., 223.

72. Letter from Freud to Silberstein 5 April 1876 (Boehlich 1990, 146).

73. Gaskell 2000, 155.

74. Freud 1899, 305–7.

75. Wharton 2001, 749–62.

76. Postcard from Rome to Martha Freud, 5 September 1901 (Tögel 2002, 138).

77. Finzi 1900, 149. Again in September 1913, in a postcard to Sandor Ferenczi, he wrote as though another catharsis was in the air: "Today hot, very hot, sciroccal; but things will soon change since it has been this way for three days already. It will disappear and make way for normal brightness and beauty" (Falzeder et al. 1993–2000, 1:506).

78. A mistranscription of this text led Ernest Jones to believe that Freud claimed to understand the *Moses* at first sight; Michael Molnar and Christfried Tögel have since published a copy of the correct transcription (Tögel 2002, 142).

79. Freud 1914, 212.

80. Magherini 1995, 65–66, 128.

81. Tögel 2002, 370.

82. Freud 1914, 213.

83. For Freud's attitude of avoidance in looking at Michelangelo's *Moses,* see Barker 1996, 96–97.

84. See Lalvani 1996, 50.

85. Weinke 2003, 110–51.

86. Reik 1914.

87. See Ponstingl 2003, 200–223.

88. For Freud and the Philippson Bible, see Blum 1991, 514.

89. For the Philippson frontispiece *Moses* in the continuum of Freud's father figures, see Barker 1996, 92–96.

90. Steinmann 1899, figure 140.

91. Gombrich 1966, 31.

92. Ernst Freud 1992, 82.

93. Gombrich 1966, 31.

94. Thode 1912, 3:258.

95. 30 October 1912 (Paskauskas 1995, no. 97, 165). Cf. Macmillan and Swales (2003, 67) who suggest Bernardo Ciuffagni's *Isaiah*.

96. Jones 1955 2:365. See Paskauskas 1995, no. 99, 172. Freud to Jones 8 November 1912: "Your photographs have shaken much of the confidence in my interpretation, I am studying a copy [of Michelangelo's *Moses*] at the Academy here." Jones answered 13 November 1912: "In what way did the photographs shake your confidence? The other statues could only have served for the theme and form, not for the inspiration that constructed the *Moses*" (no. 100, 173).

97. Falzeder et al. 1993–2000, 1:424, no. 338.

98. 21 September 1913 (Paskauskas 1995, no. 142, 227).

99. Hibbard 1974, 158.

100. Molnar in Tögel 2002, 256.

101. Tögel 2002, 41–50.

102. Löwy 1911a; Kendl 1998, 95.

103. Musatti 1980, 68; Rosenthal 1964, 549; Bowie 1993, 55–85; Buse 1996, 136; to this point we may note that during his trip to New York in 1909, Freud saw a variety show with "moving pictures" (Tögel 2002, 304–5).

104. Doane 2002, 33–68.

105. Fuller 1980, 46–47; Frizot 1998, 243–57.

106. Fuller 1980, 46–47.

107. For Charcot's work and its influence on Freud, see "Hypnotism and Hysteria," in Webster 1995, 52–70.

108. See Spero 2001, 394–99.

109. Grubrich-Simitis 1996, 153–55, found two other (unpublished) drawings of the *Moses* among Freud's papers, both of which contain the entire figure, and are less "sketchy" and insecure than the four published in *Imago;* see also Spero 2001, 386–89.

110. Falzeder et al. 1993–2000, 1:537–38, no. 453.

111. Ibid., no. 454.

112. Ibid., 1:539–40, no. 456; 543, no. 459.

113. Grubrich-Simitis 1997, 153–55.

114. Ibid., 73, 76; Grubrich-Simitis 2004, 15–18.

115. In the twenty-first century Michelangelo's *Moses* is still extremely susceptible to dramatic lighting effects in photography, and after a recent restoration (2002) a series of souvenir photographs for sale at San Pietro in Vincoli showed the statue floating free of the tomb setting and surrounded by a photographically manipulated halo of light. Part of the extended caption, printed in six languages on the verso, reads, "According to the original text, the prophet descended from the mountain with a ring of light encircling his head after he had a divine vision." Consciously or not, the fabrication of this image followed in the tradition of Alinari, Anderson, and the German art historians who emphasized "the original text" as an iconographic source for the statue.

116. See Bergstein 1992 passim.

117. Musatti 1980, 68–69.

118. See also Blum 1991, 520.

119. 5 December 1912 (Paskauskas 1995, no. 107, 179).

120. Trincia 2000, 29, 49.

121. Quoted by Didi-Huberman from Charcot's *Oeuvres completes* (Didi-Huberman 2003, 281).

122. See the cultural study of Charcot's photographic iconography by Didi-Huberman 2003.

123. Hertl 1968, 42–47.

124. Luxenberg 2001, 206.

125. Ibid., 202–5 passim.

126. Ibid., 206.

127. Ibid., 201.

128. Rouille and Marbot 1986, 56–57.

129. Charcot and Paul Richier sought to identify cases of hysteria and hysterical paralysis in various old-master paintings that dealt with religious subjects of demonical possession or mystical trance in a kind of retrospective diagnostic practice (Goldstein 2001, 370–72). Examples published by Charcot and Richer in their *Les Démoniaques dans l'Art* (1887) included figures in frescos by Andrea da Firenze in the Spanish Chapel at Santa Maria Novella in Florence, the sculptural dioramas of the *Sacro Monte* at Varallo, and paintings by Rubens, Rembrandt, and Raphael. These cases were all illustrated with photographic reproductions of the works of art as evidence. His diagnosis of fictive figures as hysterics, as in the possessed boy in Raphael's Vatican *Transfiguration,* hinged on the reliability of painting as a more or less documentary medium (in spite of its own conventions), through which subjects could be examined for symptoms. Just as some historians such as Rudolph Bell (1985) have retrospectively diagnosed medieval saints as victims of anorexia nervosa, Charcot believed his photographic system to have proved that the religious trances and possessions of earlier centuries in Europe had actually been cases of hysteria (male and female) and hysterical paralysis. In Charcot's case, the evidence was sought and discovered in physical morphology and visual representation; he used photographs of modern subjects at the Salpêtrière to prove, by comparing them with photographs of old master paintings, that human hysteria was universal and timeless. Georges Didi-Huberman (2003) has investigated and extensively illustrated this aspect of Charcot's "invention of hysteria."

130. Londe 1893, 95.

131. See Didi-Huberman 2003, 129.

132. Thode 1908, 205; Freud 1914b, 176, 184 passim.

133. Gombrich 1966, 33.

134. From a letter to the editor of the *Vossiche Zeitung,* quoted in Robert 1966, 368.

135. Lessing 1984, 17.

136. See Blum 1991, 521, 530.

137. Lessing 1984, 19.

138. Ibid., 78.

139. Rose 2001, 19–25.

140. Ibid., 19, 22, 28.

141. Schade 1995, 502.

142. Lessing 1984, 92.

143. Freud 1914, 228.

144. For Freud's naive attitude toward intentionality in Michelangelo's work see Bowie 1993, 71.

145. Beller 1989, 113–21, 125–27.

146. Robertson 1994, 266–85.

147. Lessing 1923, 283; see also Gurewitsch 2002.

148. Freud to Martha Bernays, 23 July 1882 (Ernst Freud 1992, 17).

149. Robertson 1994, 277; Freud 1923b, 28–39.

150. Trincia 2000, 266–85; Briefel 2003, 22.

151. Rudnytsky 1987, 47; Briefel 2003, 22–23.

152. Thode 1908, 199–203.

153. Freud 1914, 234.

154. Beck 1999, 19, 105.

155. Ibid., xvii.

156. Yerushalmi 1991, 63.

157. Beck 1999, xv–xvii. Extracts of letters from Michelangelo to his father, at times pleading for approval, were published in Thode 1908.

158. Vasari 1962, I:30.

159. See, for example, Hermann Grimm quoted in Thode 1908, 199, and the comment from Ernest Jones: "I have a strong fancy that the face bears resemblance to Michelangelo himself, especially in the mouth and the breadth of cheek-bones" (Paskauskas 1995, no. 107, 179). Paternity and filiation become circular, like the idea of motherhood in

Michelangelo's *Pietà* of 1498, which contained the idea of Dante's "Virgin mother, daughter of your son" (*Paradiso;* see Hibbard 1974, 45).

160. 4 June 1922 (Paskauskas 1995, no. 364, 483–87).

161. Ricouer 1970, 168–69.

162. This is similar to the figure of Joseph in Michelangelo's Holy Family of the *Doni Tondo* of 1503–4, see Hibbard 1974, 66–70.

163. Barolsky 1990, 41–43.

164. Thode 1908, 197.

165. Hall 1904, 2:200–201.

166. Freud 1939, 110; see Beck 1999, 155–56.

167. Beck 1999, 155–56.

168. Roth 2001, 29.

169. Gay 2002, 115.

170. Thode 1908, 195.

171. Philippson 1858, 3:1033.

172. Lessing 1923, 247.

173. Zweig 1964, 38.

174. Lamm 1969, 126–30.

175. Rizzuto 1998, 81–82.

176. Rudnytsky 1987, 20–23. Rudnytsky suggests that Freud was actually late to the funeral and then had a dream about it (1987, 363 n. 6, 366 n. 41).

177. Gilman 1995, 87, 93–95, 99. Nordau formulated the idea of "Muskeljudentum" at the second Zionist conference in Basel, 1898.

178. Ellis 1935, 388.

179. Roberts 2002, 207.

180. Leroy-Beaulieu 1895, 168–69.

181. Gilman 1995, 101–5.

182. Gilman 1991, 75–76.

183. Leroy-Beaulieu 1895, 172–73.

184. Weigel 1996, 60–61.

185. Grubrich-Simitis 1997, 76.

186. Freud-Ferenzci 1:506–9. The printed caption on the back of the postcard applied, in an approximate manner, a Vasarian legend from his life of Donatello to Michelangelo's work:

> Il Mosè s'erge nel mezzo del Sepolcro a Papa Giulio II in S. Pietro in Vincoli. Capolavoro sculture che rileva tanta sublimità di forza, dignità e vita da far esclamare allo stesso Michelangelo (dice la leggenda) meravigliato innanzi all'opera sua: Parla!

> The Moses arises in the middle of the sepulcher of Pope Julius II in San Pietro in Vincoli. This sculptural masterpiece expressed such great strength, dignity, and life, that (according to legend) Michelangelo himself exclaimed in front of his own statue, "Speak!"

In other words, the statue of *Moses* was such a marvelously convincing figure of sublime dignity and strength that Michelangelo challenged the figure to come to life and speak.

187. Grubrich-Simitis 1997, 73–76, follows the idea that Freud identified with *Moses;* whereas Fuller (1980, 52–55) thought that to Freud the statue's "angry gaze" might be that of Ernst Brücke, the physiologist who steered the impoverished young Freud away from a research career toward family practice.

188. Fuller 1980, 57.

189. McGuire 1974, 196–97.

190. Falzeder et al. 1993–2000, 1:411.

191. Ibid., 1:400.

192. McGuire 1974, 534–35.

193. The Arch had been erected to commemorate the triumph of the Romans in the Jewish Wars (AD 70). Abraham and Freud 1965, 146: "The Jew survives it! / Cordial greetings and coraggio, Casimiro! / Yours, Freud."

194. See Rudnytsky 1987, 47, 334.

195. Freud 1939, 115. For a deep psychoanalytic analysis of Freud's book on Moses see Assmann 1997, summarized in Assmann 2006.

Chapter 3. Delusions and Dreams

1. Musatti 1961, 9, 12, 230–34.

2. Freud 1907, 42.

3. My references are all to Helen M. Downey's English translation of Jensen's text (see Jensen 1917).

4. Hauser 1903, 79–107.

5. Griselda Pollock (2003, 205–8) has considered these "girls in motion" in her inclusion of *Gradiva* in the "Virtual Feminist Museum" of classical sculpture.

6. Cf. Dimock 1994 (239, 246), who interprets the whole display of images above Freud's couch as, "a pictorial construct analogous to those Freud found in dream interpretation," and describes the Gradiva as a maenad in a Dionysian state of frenzy.

7. Tögel 2002, 233.

8. Spector 1972, 53.

9. Freud-Benedicty 1923, 6.

10. See annotations in Falzeder et al. 1993–2000, 2:21–23, no. 511; 24–25, no. 513.

11. Baxandall 1972.

12. Geertz 1983.

13. For Gradiva as a case history see Rudnytsky 1994, 213.

14. In Freud's letters to Fliess he spoke of his wish to hold a meeting at Pompeii to discuss new psychoanalytic concepts (Masson 1985, 214); Freud described his one visit to Pompeii in 1902 as an enchanting "bezaubernde" experience (Tögel 1989, 78).

15. Bergstein 2003, 285–99.

16. According to James W. Hamilton, Hanold was unable to face the feelings of loss (object and parental) from childhood and his "lack of a nameless something" in the present without the therapeutic help of an equally lonely, misplaced statue.

17. Freud 1907, 73.

18. Tögel 2002, 166–67.

19. Freud 1907, 75.

20. Roscher 1909, 4:531; Rudnytsky 1994, 218; Freud 1992, 253.

21. Bergstein 2003, 293–98.

22. *Lexicon Iconographicum Mythologiae Classicae* (*LIMC*) II 1984, plate 302, nos. 53, 53a.

23. Tögel 1989, 31–33.

24. Löwy 1911a, 78.

25. Overbeck 1882, 2:36–37.

26. Freud 1907, 7.

27. Ibid., 7.

28. Freud 1900, 33–34, n. 1.

29. H.D. 1974, 50–51.

30. Ibid., 64–65, 101.

31. Freud 1907, 55, 60.

32. Ibid., 89.

33. Jervis and Bartolomei 1996, 70.

34. Ricouer 1970, 303.

35. Although it is tempting to recognize Anna Freud in Gradiva, she was only twelve when the essay was written. In a letter to Herbert and Loe Jones of 1914 Freud still referred to Anna, as "my little daughter" (Ernst Freud 1992, 305).

36. Jensen 1917, 97–98.

37. Bergstein 2003, 285–99.

38. Freud 1907, 7.

39. Freud 1900, 194.

40. Pile 1999, 219–20.

41. Musatti 1976, 103–9.

42. Hoffman 1919, 3–4 passim.

43. See White 2007, 24.

44. Malerba 2002, 34, 54–55, 61, 77, 87.

45. Cf. Lyotard 1997, 164.

46. Ray 2004, D2.

47. Breger 2000, 80.

48. See Lyotard 1997, 164–65.

49. Löwy 1922.

50. Löwy 1907, 10.

51. Tögel 2002, 333–34.

52. See Rose 2001, 105–6.

53. Spector 2003, 113.

54. Some of the casts now displayed in the *gipsoteca* at La Sapienza are from Löwy's acquisitions for the university at the beginning of the twentieth century, but no study has been undertaken to determine which ones were acquired by Löwy and which later.

55. Wolf 1998b, 37–41.

56. Tögel 2002, 57.

57. Ballerini 1996, 41–56.

58. Löwy 1900, 36–37, illus. 18–19.

59. Musatti 1961, 230–32.

60. Freud 1907, 45.

61. Ovid *Metamorphoses,* X:231–32.

62. Nead 2007, 58–68.

63. Ellis 1905, 4:186–88.

64. For this concept see Holly 2007.

65. Cacchietelli and Cleter 1865, II, np.

66. Löwy 1911a, 88–89.

67. Drost 1992, 467, 485, 489.

68. Quoted in Clark 1984, 128.

69. Rounding 2003, 150–53.

70. See Bernfeld 1951, 117.

71. Curtis 2003, 96–163.

72. Brownstein 1993, 174.

73. Fuller 1980, 76–98.

74. Reinach 1886, 186.

75. Bergstein 1992.
76. Ravaisson 1871; Curtis 2003, 117–21.
77. Canales 2006, 275–94.
78. Ernst Freud 1992, 173–74.
79. James 1968, 252–53.
80. Ahrem 1914, 192.
81. Freud 1907, 52.
82. Yourcenar 1990, 86.
83. Löwy 1911a, facing-plates 150–51.
84. Ibid., facing plates 146–47.
85. Ibid., 71 and fig. 149.
86. Ibid., 88–89.
87. See *LIMC* 5: plate 90, no. 5.
88. See Reinach 1886 and 1905–23.
89. Meige 1895: 56–64, plates X, XIII.
90. Charcot and Richer 1984, 91, 108.
91. Marinelli 1998, cat. no. 55, p. 132.
92. See Ricouer 1970, 303.
93. Hagen 2002, 123–24.
94. Freud 1922, 273–74.
95. Ibid., 273–74.
96. Kofman 1985, 82–89.
97. Furtwängler and Ulrichs 1914, 59–60.
98. Ibid., 60.
99. Ibid., 59.
100. Gilman 1993, 147–48.
101. Ibid., 54, 147–48.
102. Freud 1900, 139.
103. Löwy 1907, 53, 87.
104. Löwy 1900, 47–50.

105. Löwy 1911a, 110–11.

106. Ibid., 110.

107. Ibid., 111.

108. Freud 1907, 41.

109. Jensen 1917, 40.

110. Gay 1988, 172; Tögel 1989, 45.

111. Masson, 1985, 440–41.

112. Tögel 1989, 78.

113. Smith 2004, 29.

114. Ibid., 28.

115. Rudnytsky 1994, 219–20.

116. Freud 1919, 227.

117. Freud 1907, 17. For a wonderful essay on this topic, see "Archeology, Psychoanalysis, and Bildung in Freud and Wilhelm Jensen's Gradiva" in Downing 2006, 87–166.

118. Weichardt 1898, 3.

119. Ibid., 4.

120. Freud 1919, 195–226.

121. Jensen 1917, 57.

122. 18 September 1910, letter to his family from Syracuse (Tögel 2002, 356–57).

123. Finzi 1900, 149.

124. Jensen 1917, 40.

125. Freud 1919, 237.

126. Bergstein 2004, 101–7.

127. Freud 1919, 237–38.

128. Smith 2004, 30.

129. Simmons (2006, 169) made and published a black and white photo-collage of Freud's plaster Gradiva skipping across the stepping stones of a Pompeiian street. The photograph of the street is not given an attribution in Simmons's collage, but I believe the instinct to make such an image using turn-of-the-century photographs is almost inevitable. Jensen's novella and Freud's interpretation of Gradiva present itself as a wonderful

material for interpretation in photography or animated film, especially due to its oneiric content.

130. Miraglia 1996, 41–44.
131. Tögel 2002, 156–57.
132. Ibid., 167.
133. Ibid., 348–49.
134. Panofsky 2002, 42–43.
135. See below chapter 3.
136. Bergstein 1992, 484.
137. Freud 1907, 80.
138. Barkan 2000, 57–62.
139. Ibid., 62.
140. Barthes 1981, 76–707.
141. Pagano 1898, 16–18.
142. Jensen 1917, 101.
143. De Carolis and Patricelli 2003, 123.
144. Hake 1993, 147–73.
145. Havelock Ellis 1895, 458.
146. Ibid., 461.
147. Jensen 1917, 78–79.
148. Ibid., 79.
149. Frizot 1991, 67–75.
150. Overbeck 1884, 24; Pagano 1898, 18; Ellis 1895, 461.
151. Frizot 1991, 69–70.
152. Freud 1907.
153. See Robert 1966, 364–65.
154. Mundy 2001, 58, 64, 66, 68.
155. Dresden 1985, 111.
156. Romm 1983, 115–16.
157. Mundy 2001, 58.

158. Ibid., l, 64–65.

159. Brassaï 1993, 47, 72, 73.

Chapter 4. Uncanny Egypt and Roman Fever

1. My use of the term "ethnographic quest," meaning the never-ending exploration and representation of others (be they proximate or distant), was coined by Mieke Bal in 1997 in *The Mottled Screen,* p. 244.

2. Tögel 1989, 101.

3. Falzeder et al. 1993–2000, 1:512. See Handler Spitz 1989, 157–59; Gamwell and Wells 1989, 47, 54, 55.

4. I am grateful to Florence Friedman, professor of Egyptology at Brown University, for this information.

5. Falzeder et al. 1993–2000, 1:512.

6. 10 September 1908 (Tögel 2002, 243–44).

7. Jones 1955, 2:52.

8. Bernfeld 1951, 110.

9. Gilman 1995, 87, 93–95, 99, 101–5.

10. Meige 1893, 277–91.

11. Gilman 1995, 101–5.

12. Sobieszek 1999, 92–93; Frizot 1998, 259–71.

13. Curtis 2003, 45–46.

14. Jensen 1917, 25.

15. Sobieszek 1999, 113–26; Frizot 1998, 259–71.

16. See Turzio "Gli estremi della fotografia," in Turzio 2005, 3–21.

17. Galton 1869.

18. Sobieszek 1999, 125, cat. no. 48, Composite Portraits, ca. 1883; see "Alexander the Great from Six Different Medals."

19. Sekula 1986, 19, 44, 50–52.

20. Molnar 2002, 250–59.

21. Tögel 2002, 41–42.

22. Molnar 1998, 42.

23. Tögel 2002, 84.

24. Thode 1908, 200.

25. Freud 1900, 139–40.

26. Freud 1939, 52.

27. Said 2003, 27–30.

28. Freud 1939, 66.

29. Ibid., 59.

30. Spector 1972, 62–63.

31. Martin Bernal's revisionist ethnology of classical culture as put forth in *Black Athena: The Afroasiatic Roots of Classical Civilization* (1987) is not a precise parallel to Freud's casting of Moses as an Egyptian aristocrat, but a similar historiographic motivation—that of a defense against racist politics in twentieth-century society—may obtain. The cumulative pressures of racism to which Africans and their descendents have been subjected in the Americas can be compared, *mutatis mutandis,* with traditional European anti-Semitism.

32. Freud 1939, 115.

33. Ibid., 116.

34. Senyener 2004.

35. Masson 1985, 311.

36. Zweig 1964, 105.

37. Breasted 1905, e.g., illus. 77, 100, 120, 121, 122, 158, 170.

38. In a more avant-garde situation in the 1880s Paris artists such as Gauguin and Edvard Munch were fascinated by a Peruvian Mummy in the Musée de l'homme at the Trocadero: the mummy appears in expressionist paintings by Gauguin and in Edvard Munch's *Scream* (Rosenblum 1978, 7–8).

39. Bohrer 2003, 42–44, citing Gautier in Goncourt and Goncourt 1989, 2:1033.

40. Satzinger 1994, inside cover.

41. Steindorff 1900, 36.

42. Grasset 1896.

43. Jung 1961, 156. See also Freud's travel journal (August 1909, Tögel 2002, 285) where he commented on a mummy preserved in the Cathedral of Bremen: a medieval worker who had tumbled to his death from the roof was put aside in a space where the body accidentally dried, forming "an image like a mummy," which escaped the transitory nature of history and life.

44. Tögel 2002, 302.

45. Howe 1994, 41.

46. Pringle 2001, 164–65.

47. Howe 1994, pl. 94–96.

48. Maspero 1881, 34.

49. Baikie 1924, 162.

50. Pringle 2001, 23.

51. Said 2003, 33.

52. Steindorff 1900, plate 126, 144–46.

53. Jung 1961, 157.

54. Michelangelo's *Moses,* as Ernest Jones noted, bore a filial resemblance to Donatello's *Saint John.*

55. Nochlin 1989, 35, 38–39.

56. I am grateful to the Egyptologist Lanny Bell for this information.

57. Pringle 2001, 167.

58. Freud 1939, 380.

59. Boehlich 1990, 144.

60. Ibid., 152–53.

61. For the inscribed monument with the Lion of Venice, see Simmons 2006, 49. Simmons is one of the few to have written about the young Freud in Trieste (2006, 51–78).

62. Boehlich 1990, 152–53.

63. Ibid., 152–54.

64. Ibid., 155.

65. Freud 1908, 24.

66. Magherini 1995, 143.

67. See ibid., 29.

68. Taine 1869, 272.

69. Bergstein 1998, 35–37.

70. Freud to Fliess, 19 September 1901 (Masson 1985, 449).

71. Hehn 1896, 131–38.

72. Gay 2002, 51.

73. 9 April 1937, Morra 1965, 230.

74. Bergstein 1998, 35–37.

75. Jensen 1917, 27.

76. From Gogol's unfinished story "Roma," quoted in Negro 1966, 108–10, 120, 263–64, and 264, n. 5.

77. See Gregorovius 1907, 26–27.

78. Hawthorne 1992, 17.

79. Nowell-Smith 1966, 423–36.

80. Tögel 2002, 348–49.

81. Hehn 1896, 82.

82. Ibid., 82.

83. Frizot 1998, 271.

84. Hieronimus 1979, 1:4.

85. Schiff 1979, 198–201.

86. Ibid., 199–200.

87. Falzeder et al. 1993–2000, 1:214–15.

88. Gilman 1993, 147–48.

89. Hehn 1896, 82.

90. Goncourt 1958, 235.

91. Hehn 1896, 85.

92. Ibid., 80.

93. Leroy-Beaulieu 1895, 176–77.

94. Schorske 1998, 208.

95. Graetz 2002, 177.

96. 6 September 1902 (Tögel 2002, 164–66).

Chapter 5. Sympathetic Magic and Conclusion

1. Freud 1907, 7.

2. Freud 1901, 257–58.

3. Ibid., 259.

4. Pommier 2003, 52–55.

5. Fountain 2004, D3.

6. Frazer [1890] 1981, 9–12.

7. In 1913 Ernest Jones pleaded with Freud for a particular photographic portrait of the master, which he intended to hang on the wall of his home (Jones to Freud 19 November 1913, Paskauskas 1995, no. 156, 241).

8. Freud 1893, 11–17.

9. See Morlock 2007.

10. Freud 1893, 16.

11. 31 August 1909, Tögel 2002, 303.

12. Ernst Freud 1992, 8.

13. Ibid., 7–8.

14. Ibid., 9.

15. Ibid., 217.

16. Freud 1909, 229.

17. Freud 1909, 229.

18. Freud to Carrington, 24 July 1921 (Ernst Freud 1992, 334).

Bibliography

* books owned or definitely consulted by Sigmund Freud

Abraham, Hilda C., and Ernst L. Abraham, eds. *Freud, A Psychoanalytic Dialogue: The Letters of Sigmund Freud and Karl Abraham 1907–1926*. Trans. Bernard Marsh and Hilda C. Abraham (New York: Basic Books, 1965).

Ahrem, Maximilian. *Das Weib in der Antiken Kunst* (Jena: E. Diederischs, 1914).*

Anzieu, Didier. *Freud's Self-Analysis*. Trans. Peter Graham, preface Mohammed Masud Khan (London: The Hogarth Press and the Institute of Psychoanalysis, 1986).

Armstrong, Carol. *Scenes in a Library: Reading the Photograph in the Book, 1843–1875* (Cambridge, MA: MIT Press, 1998).

Armstrong, Richard H. *A Compulsion for Antiquity: Freud and the Ancient World* (Ithaca: Cornell University Press, 2005).

Assmann, Jan. *Moses the Egyptian: The Memory of Egypt in Western Monotheism* (Cambridge MA: Harvard University Press, 1997).

———. "Monotheism, Memory, and Trauma: Reflections on Freud's Book on Moses," in *Religion and Cultural Memory: Ten Studies*. Trans. Rodney Livingstone (Stanford: Stanford University Press, 2006), 46–62.

Baikie, James. *A Century of Excavation in the Land of the Pharaohs* (London: The Religious Tract Society, 1924).

Bal, Mieke. *The Mottled Screen: Reading Proust Visually*. Trans. Anna-Louise Milne (Stanford: Stanford University Press, 1997).

Ballerini, Julia. "Recasting Ancestry: Statuettes as Imaged by Three Inventors of Photography," in *The Object as Subject: Studies in the Interpretation of Still Life*, ed. Anne W. Lowenthal (Princeton: Princeton University Press, 1996), 41–56.

Bann, Stephen. "Photography by Other Means? The Engravings of Ferdinand Gaillard," *Art Bulletin* 88 (Spring 2006): 119–38.

Baraduc, Hippolyte. *The Human Soul: Its Movements, Its Lights, and the Iconography of the Fluidic Invisible* (Paris: Librairie Internationale de la Pensée Nouvelle, 1913).

Barkan, Leonard. *Unearthing the Past: Archaeology and Aesthetics in the Making of Renaissance Culture* (New Haven: Yale University Press, 2000).

Barker, Stephen. "Father Figures in Freud's Autoaesthetics," in *Excavations and Their Objects: Freud's Collection of Antiquity* (Albany: State University of New York Press, 1996), 81–106.

Barolsky, Paul. *Michelangelo's Nose: A Myth and Its Maker* (University Park: Pennsylvania State University Press, 1990).

Barthes, Roland. *Camera Lucida: Reflections on Photography* Trans. R. Howard (New York: Hill and Wang, 1981).

Baxandall, Michael. *Painting and Experience in Fifteenth-Century Italy* (Oxford: Oxford University Press, 1972).

Beck, James. *Three Worlds of Michelangelo* (New York: W. W. Norton, 1999).

Beller, Steven. *Vienna and the Jews, 1867–1938* (New York: Cambridge University Press, 1989).

Benjamin, Walter. *Selected Writings* vol. 2, pt. 2 1931–1934. Trans. Rodney Livingstone et al. Ed. Michael W. Jennings, Howard Eilans, and Gary Smith (Cambridge MA: Belknap Press of Harvard University Press, 1999).

Bergstein, Mary. "Lonely Aphrodites: On the Documentary Photography of Sculpture," *Art Bulletin* LXXIV (1992): 475–98.

———. "The Mystification of Antiquity under Pius IX: The Photography of Sculpture in Rome, 1846–1878," in Geraldine A. Johnson, ed. *Sculpture and Photography: Envisioning the Third Dimension* (New York: Cambridge University Press, 1998), 35–50.

———. "Art Enlightening the World," in *Image and Enterprise: The Photographs of Adolphe Braun*, ed. Maureen C. O'Brien and Mary Bergstein (London: Thames and Hudson, 1999), 121–39.

———. "Gradiva Medica: Freud's Model Female Analyst as Lizard-Slayer," *American Imago* 60, 3 (2003): 285–301.

Berkeley, George E. *Vienna and Its Jews: The Tragedy of Success 1880s–1980s* (Cambridge, MA: Abt Books, 1988).

Bernal, Martin. *Black Athena: The Afroasiatic Roots of Classical Civilization* (New Brunswick, NJ: Rutgers University Press, 1987).

Bernfeld, Suzanne Cassirer. "Freud and Archaeology," *American Imago* 8 (June 1951): 107–28.

Bernstein, Richard J. *Freud and the Legacy of Moses* (Cambridge: Cambridge University Press, 1998).

Bloom, Harold. "Freud and the Sublime," in *Agon: Towards a Theory of Revisionism* (New York: Oxford University Press, 1982), 91–118.

Blum, Harold. "Freud and the Figure of Moses: The Moses of Freud," *Journal of the American Psychoanalytic Association* 39 (1991): 513–35.

———. "Freud and the Figure of Moses: The Moses of Freud," in *Reading Freud's Reading*, ed. Sander L. Gilman et al. (New York: New York University Press, 1994), 109–28.

Boehlich, Walter, ed. *The Letters of Sigmund Freud to Eduard Silberstein 1871–1881*. Trans. Arnold J. Pomerans (Cambridge: Belknap Press of Harvard University Press, 1990).

Bohrer, Frederick N. *Orientalism and Visual Culture: Imagining Mesopotamia in Nineteenth-Century Europe* (Cambridge: Cambridge University Press, 2003).

Bonfante, Larissa. "Nudity as a Costume in Classical Art," *American Journal of Archaeology* 93 (1989): 543–70.

Bordieu, Pierre. *Distinction: A Social Critique of the Judgement of Taste* (Cambridge: Harvard University Press, 1984).

Bourneville, Désiré-Magloire and Paul Regnard. *L'Icongraphie photographique de la Salpêtrière*, 3 vols. Paris: Aux Bureaux du Progrès medical/Delahaye & Lecrosnier, 1876–80.*

Bowie, Malcolm. "Freud and Art, or What Will Michelangelo's *Moses* Do Next?" in Malcolm Bowie *Psychoanalysis and the Future of Theory* (Cambridge, MA: Blackwell, 1993), 55–85.

Brassaï. *Brassaï* Exhibition catalog Fundació Antoni Tàpies (Barcelona: Houk Friedman, 1993).

———. *Proust and the Power of Photography*, Trans, Richard Howard. (Chicago: University of Chicago Press, 2001.)

Breasted, James H. *Egypt: A Journey through the Land of the Pharaohs* (New York: Underwood & Underwood, 1905).

———. *A History of Egypt from the Earliest Times to the Persian Conquest* (London: Hodder and Stoughton, 1906).*

Breger, Louis. *Freud: Darkness in the Midst of Vision* (New York: John Wiley and Sons, 2000).

Friedrich Brein, ed. *Emanuel Löwy: Ein Vergessener Pionier* (Vienna: Kataloge der Archäologische Sammlung der Universität Wien, Sonderheft 1, 1998)

Briefel, Aviva. "Sacred Objects / Illusory Idols: The Fake in Freud's 'The *Moses* of Michelangelo,'" *American Imago* 60 (Spring 2003): 521–40.

Brownstein, Rachel. *Tragic Muse: Rachel of the Comédie-Française* (New York: Knopf, 1991).

Brugsch, Heinrich. *Die Ägyptologie: Abriss der Entzifferungen und Forschungen auf dem Gebiete der ägyptischen Schrift, Sprache, und Altertumeskunde* (Leipzig: A. Heitz, 1897).*

Burke, Janine. *The Sphinx on the Table: Sigmund Freud's Art Collection and the Development of Psychoanalysis* (New York: Walker and Company, 2006).

Buse, Peter. "Sinai Snapshot: Freud, Photography, and the Future Perfect," *Textual Practice* 19 (1996): 123–44.

Cacchiatelli, P. and Cleter, G. *Le Scienze e le arti sotto il pontificato di Pio IX*, 2 vols. (Rome: Aureli, 1865).

Canales, Jimena. "Movement before Cinematography: The High-Speed Qualities of Sentiment," *Journal of Visual Culture* 5 (December 2006): 275–94.

Charcot, Jean N. Martin, and Paul Richer. *Les Démoniaques dans l'Art* (Paris: Delahaye and Lecrosnier, 1887) (Paris: Editions Macula 1984).

Charcot, Jean-Martin, Paul Richier, Gilles de la Tourette, and Albert Londe, *La Nouvelle Iconographie de la Salpêtrière, clinique des maladies du système nerveux, publiée sous la direction de Professeur Charcot (de l'Institut)* (Paris: Lecroisnier et Babé, 1888–1918).

Clark, T. J. *The Painting of Modern Life: Paris in the Art of Manet and His Followers* (Princeton: Princeton University Press, 1984).

Crary, Jonathan. *Techniques of the Observer: On Vision and Modernity in the Nineteenth Century* (Cambridge: MIT Press, 1992).

———. *Suspensions of Perception: Attention, Spectacle, and Modern Culture* (Cambridge: MIT Press, 2001).

Curtis, Gregory. *Disarmed: The Story of Venus de Milo* (New York: Alfred A. Knopf, 2003).

Danius, Sara. *The Senses of Modernism: Technology, Perceptions, and Aesthetics* (Ithaca: Cornell University Press, 2002).

Davies, Erica. "'Eine Welt wie im Traum': Freuds Antikensammlung," in *"Meine...alten und dreckigen Götter" Aus Sigmund Freuds Sammlung*, ed. Lydia Marinelli (Vienna: Freud Museum, Stroemfeld Verlag, 1998), 95–102.

De Carolis, Ernesto and Giovanni Patricelli. *Vesuvius, A.D. 79: The Destruction of Pompeii and Herculaneum* (Rome: 'L'Erma' di Bretschneider, 2003).

De Sanctis, Sante. *I sogni: Studi psicologici e clinici di un alienista* (Turin: Fratelli Bocca: 1899).*

Didi-Huberman, Georges. *Invention of Hysteria: Charcot and the Photographic Iconography of the Salpêtrière.* Trans. Alisa Hartz (Cambridge: MIT Press, 2003).

Dimock, George. "The Pictures over Freud's Couch," in *The Point of Theory: Practices of Cultural Analysis*, ed. Mieke Bal and Inge E. Boer (New York: Continuum, 1994), 239–50.

Doane, Mary Ann. *The Emergence of Cinematic Time: Modernity, Contingency, and the Archive* (Cambridge, MA: Harvard University Press, 2002).

Downing, Eric. *After Images: Photography, Archaeology, and Psychoanalysis and the Tradition of Bildung* (Detroit: Wayne State University Press, 2006).

Dresden, Susan. "Psychoanalysis and Surrealism," in *Freud and the Humanities,* ed. Peregrine Horden (New York: St. Martin's Press, 1985), 110–29.

Drost, Wolfgang. "Gautier critique d'art en 1859," in *Théophile Gautier, Exposition de 1859,* ed. Wolfgang Drost and Ulrike Hennings (Heidelberg: Carl Winter Universitätsverlag, 1992) 462–99.

Duchenne de Boulogne, Guillaume Benjamin-Armand. *Mécanisme de la physionomie humaine ou analyse électrophysiologique de l'expression des passions Atlas.* 2nd ed. (Paris: J. B. Baillière et Fils, 1876).*

Duve, Thierry de. "Time Exposure and Snapshot: The Photograph as Paradox," in *Photography Theory*, ed. James Elkins (New York and London: Routledge, 2007), 109–24.

Eder, Josef Maria., ed. *Ausführliches Handbuch der Photographie* (Halle: Wilhelm Knapp, 1893).

——. *Jahrbuch für Photographie und Reproduktionstechnik*, vols. 1895–1914 (Halle: Wilhelm Knapp).

Elliot, Anthony, ed. *Freud 2000* (New York: Routledge, 1999).

Engelman, Edmund. *Berggasse 19: Sigmund Freud's Home and Offices, Vienna 1938. The Photographs of Edmund Engelman* (New York: Basic Books, 1976).

Falzeder, Ernst et al., eds. The Correspondence of Sigmund Freud and Sándor Ferenczi. Trans. Peter T. Hoffer. 3 vols. (Cambridge, MA: Harvard University Press, 1993–2000).

Ferenczi, Sander. "On the Symbolism of the Head of Medusa," in *Further Contributions to the Theory and Technique of Psycho-Analysis,* ed. Sandor Ferenczi, compiled by John Rickman (London: Hogarth Press, 1926), 360.

Ferguson, Harvie. *The Lure of Dreams: Sigmund Freud and the Construction of Modernity* (New York: Routledge, 1996).

Finzi, Jacopo. *Schwankungen der Seelenthärttigkeiten*. Trans. E. Jentsch (Wiesbaden: J. F. Bergmann, 1900)*

Flem, Lydia. *Freud the Man: An Intellectual Biography*. Trans. Susan Fairfield (New York: The Other Press, 2003).

Fothergill, John. "Translator's Preface," in Emanuel Löwy, *The Rendering of Nature in Early Greek Art* (London: Duckworth, 1907).

Fountain, Henry. "For Stress, Try Face Time," *New York Times,* 14 September 2004, D3.

Frazer, James George. *The Golden Bough: The Roots of Religion and Folklore* (New York: Gramercy Books, 1981).

Freud, Ernst L., ed. *Letters of Sigmund Freud*. Trans. Tania and James Stern (New York: Dover, 1992).

Freud, Ernst, Lucie Freud, and Ilse Grubrich-Simitis, eds. *Sigmund Freud: His Life in Pictures and Words* (New York: W. W. Norton, 1998).

Freud, Sigmund. *The Standard Edition of the Complete Psychological Works of Sigmund Freud. (SE)*Ed. and Trans. James Strachey in collaboration with Anna Freud, assisted by Alix Strachey and Alan Tyson (London: Hogarth Press).

——. *Charcot*, 1893, *SE* 3:9–23.

——. *Screen Memories*, 1899, *SE* 3:301–22.

——. *The Interpretation of Dreams*, 1900, *SE* 4 and 5: 1–626.

——. *Delusions and Dreams in Jensen's Gradiva*, 1907, *SE* 9:7–95.

——. *"Civilized" Sexual Morality and Modern Nervous Illness*, 1908, *SE* 9:179–204.

——. *Notes upon a Case of Obsessional Neurosis*, 1909, *SE* 10: 158–259.

——. *Five Lectures on Psychoanalysis* 1910a, *SE* 11:3–36.

——. *Leonardo da Vinci and a Memory of His Childhood*, 1910b, *SE* 11:59–137.

——. *A Note on the Unconscious in Psychoanalysis*, 1912, *SE* 12:257–66.

——. *On Beginning the Treatment (Further Recommendations on the Technique of Psycho-Analysis I)*, 1913a, *SE* 13:121–44.

——. *Totem and Taboo*, 1913b, *SE* 13:1–175.

——. *The Moses of Michelangelo*, 1914, *SE* 13:211–36.

——. *The Uncanny* 1919, *SE* 17: 219–56.

——. "Origine et development de la psychoanalyse, III," *Revue de Genève* (February 1921): 196–220.

——. *Medusa's Head*, 1922, *SE* 18:273–74.

——. *Delirio e sogni nella "Gradiva" di W. Jensen*. Trans. Gustavo de Benedicty, preface by Marco Levi-Bianchini (Nocera Inferiore: Libreria Psiconanalitica Internazionale, 1923a).*

——. *The Ego and the Id* 1923b, *SE* 19:12–66.

——. *Civilization and Its Discontents* 1930, *SE* 21:64–148.

——. *A Disturbance of Memory on the Acropolis* 1936, *SE* 22: 239–50.

——. *Moses and Monotheism*, 1939 *SE* 23:3–37.

——. "Der *Moses* des Michelangelo," in Freud, Sigmund. *Gesammelte Werke*, 18 vols. (London: Imago, 1942–50), vol. 10, 172–201.

——. *Writings on Art and Literature from the Standard Edition of the Complete Psychological Works of Sigmund Freud edited by James Strachey*. Foreword Neil Hertz (Stanford: Stanford University Press, 1997).

——. *The Interpretation of Dreams*. Trans. Joyce Crick, Introduction and Notes Ritchie Robertson (Oxford: Oxford University Press, 1999).

Frizot, Michel. "Le monument au sculpteur anonyme," in *Sculpter-Photographier: Photographie-Sculpture, actes du colloque organisé au musée du Louvre 1991,* ed. Michel Frizot and Dominique Païni (Paris: Louvre/Marval 1993), 67–75.

——. "The All Powerful Eye: The Forms of the Invisible," in *A New History of Photography* (Cologne: Könemann, 1998), 273–91.

Fuller, Peter. *Art and Psychoanalysis* (London: Writers and Readers, 1980).

Furtwängler, Adolf and H. L. Ulrichs. *Denkmäler griechischer und römischer Skulptur.* 2nd ed. (Munich: F. Bruckmann, 1904).*

——. *Greek and Roman Sculpture.* Trans. Horace Taylor (London: J. M. Dent, 1914).

Fuss, Diana. *The Sense of an Interior: Four Writers and the Rooms that Shaped Them* (New York: Routledge, 2004).

Galton, Francis. *Hereditary Genius: An Inquiry into Its Laws and Consequences* (London: Macmillan, 1869).

——. "Photographic Composites," *The Photographic News* 29, no. 1389 (April 17, 1885): 1–2.

Gamwell, Lynn and Peter Wells, eds. *Sigmund Freud and Art: His Personal Collection of Antiquities* (Binghamton: SUNY Press, 1989).

Gay, Peter. *Freud: A Life for Our Time* (New York: Anchor Books, 1988).

——. *Schnitzler's Century: The Making of Middle-Class Culture, 1815–1914* (New York: W. W. Norton, 2002).

Geertz, Clifford. *Local Knowledge: Further Essays in Interpretive Anthropology* (New York: Basic Books, 1983).

Gilman, Sander L. *The Jew's Body* (New York: Routledge, 1991).

——. *The Case of Sigmund Freud: Medicine and Identity at the Fin de Siècle* (Baltimore: Johns Hopkins University Press, 1993).

——. "'Die Rasse ist nicht schön,' 'Nein, wir Juden sind Keine hübsche Rassel' Der Schöne und der Hässliche Jude," in *"Der Schejne Jid": Das Bild des "jüdischen Körpers" in Mythos und Ritual,* ed. Sander L. Gilman et al. (Vienna: Picus Verlag, 1998), 57–74.

Gilman, Sander L. et al., eds. *Reading Freud's Reading* (New York: New York University Press, 1994).

Gilman, Sander L. *Freud, Race, and Gender.* 3d ed. (Princeton: Princeton University Press, 1995).

Ginzburg, Carlo. "Morelli, Freud and Sherlock Holmes: Clues and Scientific Method," *History Workshop Journal* 9 (1980): 5–36.

Goethe, J. W. von. *Italian Journey* Trans. W. H. Auden (San Francisco: North Point Press, 1982).

Gombrich, E. H. "Freud's Aesthetics," *Encounter* XXVI, no. 1 (January 1966): 30–34.

Goncourt, Edmond and Jules Goncourt. *The Goncourt Journals 1851–1870*. Ed. and trans. by Lewis Galantière (New York: Doubleday, 1958).

Graetz, Heinrich. "The Structure of Jewish History," in, *The Structure of Jewish History and Other Essays*. Trans. and ed. Ismar Schorsch. 2nd ed. (New York: KTAV, 2002), 63–124.

Grasset, Joseph. "Un 'homme momie,'" *Nouvelle Iconographie* 9 (1896): 257–64.

Gregorovius, Ferdinand. *The Roman Journals of Ferdinand Gregorovius 1852–1874*. Ed. Friedrich Althous, trans. Mrs. Gustavus W. Hamilton (London: G. Bell & Sons, 1907).

Gronberg, Tag. "The Inner Man: Interiors and Masculinity in Early Twentieth-Century Vienna," *Oxford Art Journal* 24, no. 1 (2001): 67–88.

——. *Vienna: City of Modernity, 1890–1914* (Bern: Peter Lang, 2007).

Grubrich-Simitis, Ilse. *Freuds Moses—Studie als Tagtraum, Ein biographischer Essay* (Frankfurt: Fischer Taschenbuch Verlag, 1994).

——. *Back to Freud's Texts: Making Silent Documents Speak*. Trans. Philip Slotkin (New Haven: Yale University Press, 1996).

——. *Early Freud and Late Freud: Reading Anew Studies on Hysteria and Moses and Monotheism*. Trans. Philip Slotkin (New York: Routledge, 1997).

——. *Michelangelos Moses und Freuds "Wagstück," Eine Collage* (Frankfurt: Fischer Verlag, 2004).

Gsell Fels, Theodore. *Rom und die Campagna*. 7th ed. (Leipzig: Bibliographisches Institut, 1912)*.

Gurewitsch, Matthew. "An Eighteenth-Century Plea for Tolerance Resounds Today," *New York Times,* October 20, 2002.

Haas, Hippolyt. *Neapel, seine Umgebung und Sizilien*. "Land und Leute: Monografien zur Erfunde" series (Bielefeld: Velhagen & Klasing, 1904).

Haddad, Antonietta, and Gérard Haddad. *Freud en Italie: Psychoanalyse du Voyage* (Paris: Editions Albin Michel, 1995).

Hagen, Bettina. *Antike in Wien: Die Akademie und der Klassizismus um 1800* (Mainz am Rhein: Verlag Philipp von Zabern, 2002).

Hake, Sabine. "'Saxa loquuntur': Freud's Archaeology of the Text," *boundary* 2 (Spring 1993): 147–73.

Hall, G. Stanley. *Adolescence, Its Psychology,* 2 vols. (New York: D. Appleton, 1904).*

——. "Introduction," in Jensen 1917.

Hambourg, Maria Morris, Pierre Apraxine, Malcolm Daniel, Jeff L. Rosenheim, and Virginia Heckert. *The Waking Dream: Photography's First Century* (New York: Metropolitan Museum of Art / Harry N. Abrams, 1993).

Hamilton, James W. "Jensen's 'Gradiva': A Further Interpretation," *American Imago* 30 (Winter 1973): 380–412.

Hammond, William A. *Sleep, Sleeplessness, and the Derangements of Sleep* (London: Simpkin, Marshall, 1892).*

Handbuch des National Museums zu Neapel und hauptsächliche illustrierten Monumente (Naples: S. P. A. Maiella, 1860s).

Handler Spitz, Ellen. "Psychoanalysis and the Legacies of Antiquity," in *Sigmund Freud and Art: His Personal Collection of Antiquities,* ed. Lynn Gamwell and Peter Wells (Binghamton: State University of New York Press, 1989), 153–71.

Hauser, Friedrich. "Disiecta membra neuattischer Reliefs," *Jahreshefte des Österreicheschen Archäologischen Institutes in Wien* 6 (1903): 70–109.

Havelock Ellis, Henry. "On Dreaming of the Dead," *The Psychological Review* II, no. 5 (September, 1895): 458–61.*

——. "The Stuff That Dreams Are Made of," *Appleton's Popular Science Monthly* LIV, no. 54 (April 1899): 721–35.*

——. *Studies in the Psychology of Sex,* 7 vols. (Philadelphia: F. A. Davis, 1905).

——. "In Search of Proust," in *From Rousseau to Proust* (Boston: Houghton Mifflin, 1935), 363–96.

Hawthorne, Nathaniel. *The Marble Faun: Or, The Romance of Monte Beni* (New York: Viking Penguin, 1992).

——. *Transformations: Or, The Romance of Monte Beni,* 2 vols. (Leipzig: Tauchnitz, 1860).

H.D. [Hilda Doolittle] *Tribute to Freud* (Boston: David R. Godine, 1974).

Hehn, Victor. *Italien: Ansichten und Streiflichter mit Lebensnachrichtungen über der Verfasser.* 5th ed. (Berlin: Gebrüder Borntraeger, 1896).*

Heilbrun, Francoise. "The Posthumous Life," in *La Divine comtesse: Photographs of the Countess de Castiglione,* ed. Pierre Apraxine and Xavier Demange (New York: Yale University Press, Metropolitan Museum of Art, 2000), 75–87.

Hello, Ernest. *L'Homme: La Vie—La Science—L'Art* (Paris: Victor Palmé, 1872.)

Helsted, Dyveke et al., eds. *Rome in the Early Photographs, The Age of Pius IX: Photographs 1846–1878 from Roman and Danish Collections.* Trans. Ann Thornton (Copenhagen: Thorvaldsen Museum, 1977).

Hertl, Michael and Renate Hertl. *Laokoon: Ausdruck des Schmerzes durch zwei Jahrtausende* (Munich: K. Thiemig, 1968).

Hibbard, Howard. *Michelangelo* (New York: Harper Row, 1974).

Hielscher, Kurt. *Italien: Baukunst und Landschaft.* Foreword by Wilhelm von Bode (Berlin: Verlag Ernst Wasmuth, 1925).

Hieronimus, Ekkehard. "Wilhelm von Gloeden (1856–1931)," in *Otto Myer-Amden, Wilhelm von Gloeden, Elisar von Kupffer,* 4 vols. (Basel: Kunsthalle, 1979), vol. 1, 3–13.

Hofman, Paul. *Empfindung und Vorstellung* (Berlin: Verlag von Reuther & Reichard, 1919).*

Holly, Michael Ann. *Panofsky and the Foundations of Art History* (Ithaca: Cornell University Press, 1984).

——. "Interventions: The Melancholy Art," *Art Bulletin* 89 (March 2007): 7–17.

Howe, Kathleen Stewart. *Excursions Along the Nile: The Photographic Discovery of Ancient Egypt* (Santa Barbara: Santa Barbara Museum of Art, 1994).

Hutton, Edward. *Rome* (New York: Macmillan, 1909).*

Jacobs, Joseph. "The Jewish Type and Galton's Composite Photographs," *Photographic News* 29, no. 1390 (April 24, 1885): 268.

James, Henry. "The Lonely Aphrodite," in *The American Scene,* ed. Leon Edel (Bloomington: Indiana University Press, 1968): 252–53.

——. *The Tragic Muse* (London: Penguin, 1995).

Janson, H. W. "The Right Arm of Michelangelo's Moses," in *Festschrift Ulrich Middeldorf,* eds. Antje Kosegarten and Peter Tigher (Berlin: De Gruyter, 1968), 241–47.

Jensen, Wilhelm. *Gradiva: ein Pompejanisches Phantasiestück* (Dresden: C. Reissner, 1903).*

———. *Delusion and Dream: An Interpretation in the Light of Psychoanalysis of Gradiva, a Novel, by Wilhelm Jensen, Which Is Here Translated.* Trans. Helen M. Downey (New York: Moffat, Yard 1917).

Jervis, Giovanni and Giorgio Bartolomei. *Freud* (Rome: Carocci, 1996).

Johnson, Géraldine A. "Idol or Ideal? The Power and Potency of Female Public Sculpture," in *Picturing Women in Renaissance and Baroque Italy,* ed. Géraldine A. Johnson and Sara F. Matthews Grieco (Cambridge: Cambridge University Press, 1997), 222–45.

Jones, Ernest. *The Life and Work of Sigmund Freud,* 3 vols. (New York: Basic Books, 1953–57).

Jung, C. G. *Memories, Dreams, Reflections.* Recorded and edited by Aniela Jaffé. Trans. Richard and Clara Winston (New York: Vintage Books, 1961).

Kaemmel, Otto. *Rom und die Campagna.* "Land und Leute Monographien zur Erdfunde" series (Bielefeld: Verlag von Velhagen, 1902).*

Kaufmann, James C. A. "Photographs and History: Flexible Illustrations," in *Reading into Photography: Selected Essays 1959–1980,* ed. S. Armitage, T. F. Barrow, and W. E. Tydeman (Albuquerque: University of New Mexico Press, 1982), 193–99.

Kendl, Doris. "'Die Griechische Plastik': Emanuel Löwy zur Skulptur der Griechen," in *Emanuel Löwy: Ein Vergessener Pionier,* ed. Friedrich Brein (Vienna: Kataloge der Archäologische Sammlung der Universität Wien, Sonderheft 1, 1998), 91–98.

Kofman, Sarah. *The Enigma of Woman in Freud's Writings.* Trans. Catherine Porter (Ithaca: Cornell University Press, 1985).

———. *Freud and Fiction.* Trans. Sarah Wykes (Boston: Northeastern University Press, 1991).

Krauss, Rosalind. *The Optical Unconscious* (Cambridge: MIT Press, 1993).

Kreibel, Sabine T. "Theories of Photography: A Short History," in *Photography Theory, ed. James* Elkins (New York: Routledge, 2007), 3–49.

Kristeva, Julia. *Time and Sense: Proust and the Experience of Literature.* Trans. R. Guberman (New York: Columbia University Press, 1996).

Kuspit, Donald. "A Mighty Metaphor: The Analogy of Archaeology and Psychoanalysis," in *Sigmund Freud and Art: His Personal Collection of Antiquities,* ed. Lynn Gamwell and Peter Wells (Binghamton: State University of New York Press, 1989), 133–51.

Lalvani, Suren. *Photography, Vision, and the Production of Modern Bodies* (Albany: State University of New York Press, 1996).

Lamm, Maurice. *The Jewish Way in Death and Mourning* (New York: Jonathan David, 1969).

Lanciani, Rodolfo. *The Destruction of Ancient Rome: A Sketch of the History of the Monuments* (London: Macmillan, 1901).*

Leonardo da Vinci, *The Notebooks of Leonardo da Vinci*. Ed. and trans. Irma A. Richter (New York: Oxford University Press, 1980).

Leoni, Umberto, and Giovanni Staderini. *On the Appian Way: A Walk from Rome to Albano* (Rome: Bemporad, 1907).*

Leroy-Beaulieu, Anatole. *Israel among the Nations: A Study of the Jews and Antisemitism.* Trans. Frances Hellman (London: William Heinemann; New York: G. P. Putnam's Sons, 1895).

Lessing, Gotthold Ephraim. *Nathan the Wise: A Dramatic Poem.* Trans. Patrick Maxwell. Ed. George Alexander Kohut (New York: Bloch, 1923).

——. *Laocoön: An Essay on the Limits of Painting and Poetry.* Ed. and trans. Edward Allen McCormick. Foreword Michael Fried (Baltimore: Johns Hopkins University Press, 1984).

Lexicon Iconographicum Mythologiae Classicae (LIMC) II/2 (Zurich: Artemis Verlag, 1984).

Londe, Albert. *La Radiographie et ses diverses applications* (Paris: Gauthier-Villars, 1889).

——. *La Photographie médicale: Application aux sciences médicales et physiologiques* (Paris: Gauthier-Villars, 1893).

Löwy, Emanuel. *Lysipp und seine Stellung in der Griecheschen Plastik* (Hamburg: Verlangenstalt und Druckerei, 1891).*

——. *Die Naturwiedergabe in der älteren griechischen Kunst* (Rome: Loescher, 1900).*

——. *The Rendering of Nature in Early Greek Art.* Trans. John Fothergill (London: Duckworth, 1907).

——. "Typenwandering I," *Jahreshefte des Österreichischen Archäologischen Institutes* 12 (1909): 243–304.*

——. *Die Griechesche Plastik* (Leipzig: Klinkhardt and Biermnann, 1911a).*

——. "Typenwanderung II," *Jahreshefte des Österreichischen Archäologischen Institutes* 14 (1911b): 1–34.*

———. *Die Griechesche Plastik* (Leipzig: Klinkhardt and Biermnann, 1916).*

———. *Neuattische Kunst* (Leipzig: E. A. Seeman, 1922).*

Luckenbach, H. *Die Akropolis von Athen* (Munich and Berlin: R. Oldenbourg, 1905).*

Luxenberg, Alisa. "'The Art of Correctly Painting the Expressive Lines of the Human Face': Duchenne de Boulogne's Photographs of Human Expression and the École des Beaux-Arts," *History of Photography* 25, no. 2 (Summer, 2001): 201–12.

Lyotard, Jean-Francois. "The Unconscious as Mise-en-Scène," in *Mimesis, Masochism, and Mime: The Politics of Theatricality in Contemporary French Thought*. Trans. Joseph Maier. Ed. Timothy Murray (Ann Arbor: University of Michigan Press, 1997), 163–74.

Macmillan, Malcolm and Peter J. Swales. "Observations from the Refuse Heap: Freud, Michelangelo's Moses, and Psychoanalysis," *American Imago* 60 (2003): 41–104.

Magherini, Graziella. *La Sindrome di Stendahl*. 2nd ed. (Florence: Ponte alle Grazie, 1995).

Malerba, Luigi. *La Composizione del Sogno* (Turin: Einaudi, 2002).

Marinelli, Lydia, ed. *"Meine…alten und dreckigen Götter" Aus Sigmund Freuds Sammlung* (Vienna: Freud Museum, Stroemfeld Verlag, 1998).

Martial. *Epigrammi di Marco Valerio Marziale*. Ed. Giuseppe Norcio (Turin: Unione Tipografico-Editrice Torinese, 1980).

Maspero, Gaston. *La Trouvaille de Deir-el-Bahari* (Cairo: F. Mourés, 1881).

Masson, Jeffrey Moussaieff, ed. and trans. *The Complete Letters of Sigmund Freud to Wilhelm Fliess, 1887–1904* (Cambridge, MA and London: Harvard University Press, 1985).

Mau, August. *Pompeji in Leben und Kunst* (Leipzig: W. Engelmann, 1900).*

Mayer, Andreas. "'Ein Übermass an Gefalligkeit' Der Sammler Jean-Martin Charcot und Seine Objekte," in *"Meine…alten und dreckigen Götter" Aus Sigmund Freuds Sammlung*, ed. Lydia Marinelli (Vienna: Freud Museum, Stroemfeld Verlag, 1998), 47–59.

McGuire, William, ed. *The Freud/Jung Letters: The Correspondence between Sigmund Freud and C. G. Jung*. Trans. Ralph Mannheim and R. F. C. Hull (Princeton: Princeton University Press, 1974).

Meige, Henry. "Le Juif-Errant a la Salpêtrière," *Nouvelle Iconographie* 6 (1893): 277–91.*

———. "Deux Cas d'Ermaphrodisme Antique," *Nouvelle Iconographie* 8 (1895): 56–64.*

Miraglia, Marina. "Giorgio Sommer's Italian Journey: Between Tradition and the Popular Image," *History of Photography* 20 (Spring, 1996): 41–48.

Molnar, Michael. "Notes on Faces and Men: National Portrait Gallery, September 13, 1908," unpublished notes by Freud in Tögel 2002, 250–59.

——. "From Image to Evidence: At the Historic Corner Window. 17.6.1897," in *Visual Documentation in Freud's Vienna*, special issue of *Visual Resources: an International Journal of Documentation,* ed. Mary Bergstein, 23, nos. 1–2 (March-June 2007), 119–27.

Morelli, Giovanni. *Della pittura italiana: Studii storico-critici* (Milan: Fratelli Treves, 1897).*

Morlock, Forbes. "The Very Picture of a Primal Scene: Une leçon clinique a la Salpêtrière," in *Visual Documentation in Freud's Vienna*, special issue of *Visual Resources: an International Journal of Documentation,* ed. Mary Bergstein, 23, nos. 1–2 (March-June 2007), 129–46.

Morra, Umberto. *Conversations with Berenson* (Boston: Houghton Mifflin, 1965).

Mundy, Jennifer et al., eds. *Surrealism: Desire Unbound* (Princeton: Princeton University Press, 2001).

Musatti, Cesare L. *Cinema e psicoanalisi* (Turin: Editore Boringhieri, 1950).

——. *Gradiva: Un racconto di Wilhelm Jensen e uno studio analitico di Sigmund Freud con un commento di Cesare L. Musatti* (Turin: Editore Boringhieri, 1961).

——. *Trattato di psicoanalisi* (Turin: Einaudi, 1980).

——. "Il sogno come psicosi allucinatoria nella metapsicologia freudiana," in *Riflessioni sul pensiero psicoanalitico e incursioni nel mondo delle immagini* (Turin: Einaudi, 1976), 98–112.

National Portrait Gallery. Complete Illustrated Catalogue 1856–1979. Compiled by K. K. Yung, ed. Mary Pettman (London: National Portrait Gallery, 1981).

Nead, Lynda. *The Haunted Gallery: Painting, Photography, Film c. 1900* (New Haven and London: Yale University Press, 2007).

Negro, Silvio. *Seconda Roma, 1850–1870.* Rev. ed. Collana di Varia Critica, vol. 29 (Vicenza: Neri Pozza, 1966).

Nikolow, Sybilla. "Der soziale und der biologische Körper der Juden," in *"Der Schejne Jid": Das Bild des "jüdischen Körpers" in Mythos und Ritual,* ed. Sander L. Gilman et al. (Vienna: Picus Verlag, 1998), 45–56.

Nochlin, Linda. "The Imaginary Orient," in *The Politics of Vision: Essays in Nineteenth-Century Art and Society* (Boulder and Oxford: Westview Press, Icon Editions, 1989), 33–59.

——. *The Body in Pieces: The Fragment as a Metaphor of Modernity* (London: Thames & Hudson, 1994).

Nowell-Smith, Simon. "Firma Tauchnitz 1837–1900," *Book Collector* 15 (Winter 1966): 423–43.

O'Donoghue, Diane. "Negotiations of Surface: Archaeology in the Early Strata of Psychoanalysis," *Journal of the American Psychoanalytic Society* 52, no. 3 (2004): 653–71.

Overbeck, Johannes. *Geschichte der Griechischen Plastik*. 2 vols. (Leipzig: J. C. Hinrichs'sche Buchhandlung, 1882).*

——. *Pompei in seinen Gebäuden, Alterthümern, und Kunstwerken dargestellt.* Ed. August Mau (Leipzig: Wilhelm Engelmann, 1884).*

Ovid. *Metamorphoses*. Trans. and ed. Mary M. Innes (Middlesex: Penguin, 1973).

Pagano, Nicola. *Guida di Pompei* (Naples: Tipografia dei fratelli Testa, 1898).

Panofsky, Erwin. "The Neoplatonic Movement and Michelangelo," in *Studies in Iconology* (New York: Harper Torchbooks 1962), 171–230.

——. *Early Netherlandish Painting*. 2 vols. (Cambridge: Harvard University Press, 1953).

——. *Perspective as Symbolic Form*. Trans. Christopher S. Wood (New York: Zone Books, 2002).

Paskauskas, R. Andrew, ed. *The Complete Correspondence of Sigmund Freud and Ernest Jones 1908–1939* (Cambridge MA and London: Belknap Press of Harvard University Press, 1995).

Pfeiffer, Ernest, ed. *Sigmund Freud and Lou Andreas-Salomé: Letters*. Trans. Elaine and William Robson-Scott (New York: Harcourt, Brace, Jovanovich, 1972).

Philippson, Ludwig. *Die israelitische Bibel, enthaltend den heiligen Urtext, die deutsche Übertragung mit Erläuterung und Einleitungen.* 3 vols. (Leipzig: Baumgärtner, 1858).

Pile, Steve. "Freud, Dreams, and Imaginative Geographies," in *Freud 2000,* ed. Anthony Elliot (New York: Routledge, 1999), 204–34.

Pliny the Elder. *The Elder Pliny's Chapters on the History of Art*. Trans. K. Jex-Blake (London and New York: Macmillan, 1896).

Podro, Michael. "Panofsky," in *The Dictionary of Art,* ed. Jane Turner, 34 vols. (London and New York: Macmillan, 1996), vol. 24, 16–17.

Poliakoff, Michael. *Combat Sports in the Ancient World* (New Haven: Yale University Press, 1987).

Pollock, Griselda. *Encounters in the Virtual Feminist Museum: Time, Space, and the Archive* (London: Routledge, 2003).

Pommier, Edouard. *Il Ritratto: Storia e teorie dal Rinascimanto al'Età dei Lumi.* Trans. Michela Scolaro (Turin: Einaudi, 2003).

Ponstingl, Michael. "The Publishing House Karl Robert Langewiesche's Illustrated Books Series 1904–1960: Heimatschutz and Art Education," in *The Eye and the Camera: The Albertina Collection of Photographs,* ed. Monika Faber and Klaus Albrecht Schröder (Paris and Vienna: Seuil, 2003), 200–223.

Pringle, Heather. *The Mummy Congress: Science, Obsession, and the Everlasting Dead* (New York: Theia, 2001).

Ravaisson, Jean-Gaspard-Félix. *La Vénus de Milo* (Paris: Librairie Hachette, 1871).

——. "La Vénus de Milo," *Revue Archeologique* 16 (1890).

Ray, C. Clairborne. "Technicolor Dreams," *New York Times* January 27, 2004, D2.

Reik, Theodor. "Der Schöpfer der Neuen Seelenkunde: Professor Sigmund Freud," in *Ost und West: Illustrierte Monatsschrift für das gesamte Judentum, Organ der Alliance Israelite Universelle,* Heft 6, 1914 (Juni) XIV Jahrgang, 433–36.

Reinach, Salomon. "L'Art antique," *Gazette des beaux-arts* 33–32 (1886): 414–31.

——. *Cultes, Mythes, et Religions,* 5 vols. (Paris: E. Leroux, 1905–23).

Ricouer, Paul. *Freud and Philosophy: An Essay in Interpretation.* Trans. Denis Savage (New Haven and London: Yale University Press, 1970).

Rizzuto, Ana-Maria. *Why Did Freud Reject God? A Psychodynamic Interpretation* (New Haven: Yale University Press, 1998).

Robert, Marthe. *The Psychoanalytic Revolution: Sigmund Freud's Life and Achievement.* Trans. Kenneth Morgan (New York: Harcourt, Brace & World, 1966).

Roberts, Mary Louise. *Disruptive Acts: The New Woman in Fin-de-siècle France* (Chicago: University of Chicago Press, 2002).

Robertson, Ritchie. "On the Sources of Moses and Monotheism," in *Reading Freud's Reading,* ed. Sander L. Gilman et al. (New York and London: New York University Press, 1994), 266–85.

Rodenwaldt, Gerhart. *Die Kunst der Antike (Hellas und Rom).* 2nd ed. (Berlin: Propyläen, 1927).*

Romm, Sharon. *The Unwelcome Intruder: Freud's Struggle with Cancer* (New York: Praeger Scientific, 1983).

Roscher, W. H. *Ausfürliches Lexikon der Griechischen und Römischen Mythologie* (Leipzig: B. G. Teubner, 1909).

Rose, Louis. *The Survival of Images: Art Historians, Psychoanalysts, and the Ancients* (Detroit: Wayne State University Press, 2001).

Rosenblum, Robert. *Edvard Munch: Symbols and Images* (Washington: National Gallery of Art, 1978).

Rosenthal, Earl L. "Michelangelo's *Moses, Dal di sotto in sù,*" *Art Bulletin* XLVI (1964): 544–50.

Roskill, Mark and David Carrier. *Truth and Falsehood in Visual Images* (Amherst: University of Massachusetts Press, 1983).

Roth, Joseph. *The Wandering Jews.* Trans. Michael Hofmann (New York and London: W. W. Norton, 2001).

Rouille, André, and Bernard Marbot. *Le Corps et son Image: Photographies du Dix-Neuvième Siècle* (Paris: Contrejour, 1986).

Rounding, Virginia. *Grandes Horizontales: The Lives and Legends of Four Nineteenth-Century Courtesans* (New York: Bloomsbury, 2003).

Rubin, Patricia L. *Giorgio Vasari: Art and History* (New Haven and London: Yale University Press, 1995).

Rudnytsky, Peter. *Freud and Oedipus* (New York: Columbia University Press, 1987).

——. "Freud's Pompeian Fantasy," in *Reading Freud's Reading,* ed. Sander L. Gilman et al. (New York and London, 1994), 211–31.

Said, Edward. *Orientalism* (New York: Pantheon, 1978).

——. *Freud and the Non-European* (New York and London: Verso, 2003).

Saslow, James M., ed. and trans. *The Poetry of Michelangelo* (New Haven and London: Yale University Press, 1991).

Satzinger, Helmut. *Die Ägyptisch-Orientalische Sammlung. Das Kunsthistorische Museum in Wien* (Mainz: Verlag Philipp Von Zabern, 1994).

Sauerlandt, Max, ed. *Michelangelo. Mit hundert Abbildungen: Skulpturen und Gemälde* (Leipzig: "Die Blauen Bücher—Die Welt des Schönen," Karl Robert Langewiesche Verlag, 1912).*

Schade, Sigrid. "Charcot and the Spectacle of the Hysterical Body: The 'Pathos Formula' as an Aesthetic Staging of Psychiatric Discourse—a Blind Spot in the Reception of Warburg," *Art History* 18 (1995): 499–517.

Schiff, Gert. "The Sun of Taormina," *Print Collector's Newsletter* IX (January-February, 1979): 198–201.

Schorn, Ludwig and Ernst Förster. *Leben der ausgezeichnesten Maler, Bildhauer, und Baumeister von Cimabue bis zum Jahre 1567 beschreiben von Giorgio Vasari, Maler und Baumeister,* 6 vols. (Stuttgart and Tübingen: J. G. Cotta, 1832–49).

Schorske, Carl E. *Fin-de-Siècle Vienna: Politics and Culture* (New York: Albert A. Knopf, 1980).

———. "To the Egyptian Dig: Freud's Psycho-Archeology of Cultures," in *Thinking with History: Explorations in the Passage to Modernism* (Princeton: Princeton University Press, 1998), 191–215.

Sciolino, Elaine. "Hair as a Battlefield for the Soul," *New York Times,* November 18, 2001.

Sekula, Allan. "The Body and the Archive," *October* 39 (Winter 1986): 3–64.

Senyener, Sebnem. "How the 'Divan' Became the 'Couch'," *Eurozine, 9 January 2004,* www.Eurozine.com/articles/2004-03-03-senyener-en.html.

Settis, Salvatore. *Laocoonte: Fama e Stile* (Rome: Donzelli, 1999).

———. *Futuro del "classico"* (Torino: Einaudi, 2004).

Simmons, Laurence. *Freud's Italian Journey* (Amsterdam and New York: Radopi, 2006).

Smith, Graham. "The Past in the Present: Photographs of Classical Art in the Writings of E. M. Forster," *Arion: A Journal of Humanities and the Classics* 11, no. 1 (Spring–Summer 2003): 71–102.

———. "Calvert Richard Jones at Pompeii," *Source: Notes in the History of Art* XXIII (Winter 2004): 28–34.

Sobieszek, Robert A. *Ghost in the Shell: Photography and the Human Soul, 1850–2000* (Cambridge, MA: MIT Press, 1999).

Solomon, Solomon J. "Art and Judaism," *Jewish Quarterly Review* 13 (July 1901): 553–66.

Sontag, Susan. *On Photography* (New York: Anchor Books Doubleday, 1977).

———. *The Volcano Lover: A Romance* (New York: Anchor Books Doubleday, 1992).

———. *Regarding the Pain of Others* (New York: Farrar, Straus and Giroux, 2003).

Spector, Jack J. *The Aesthetics of Freud: A Study in Psychoanalysis and Art* (New York: McGraw-Hill, 1972).

———. "Is There a Life after Antiquity?" *American Imago* 60 (2003): 105–15.

Spero, Moshe Halevi. "Self-Effacement and Self-Inscription: Reconsidering Freud's Anonymous 'Moses of Michelangelo,'" *Psychoanalysis and Contemporary Thought* 24 (2001): 359–462.

Steindorff, Georg. *Die Blütezeit des Pharaonenreichs* (Bielefeld and Leipzig: Velhagen & Klasing, 1900).*

Steinmann, Ernst. *Rom in der Renaissance von Nicolaus V bis auf Julius II* (Leipzig: E. A. Seeman, 1899).*

———. *Michelangelo in Spiegel seiner Zeit* (Rome: Biblioteca Hertziana, 1930).*

Taine, Hippolyte. *Italy: Rome and Naples*. Trans. J. Durand (New York: Leypoldt and Holt, 1869).

Thode, Henry. *Michelangelo: Kritische Untersuchungen über seine Werke* (Berlin: G. Grote, 1908).*

———. *Michelangelo und das Ende der Renaissance*. 3 vols. (Berlin: G. Grote, 1912).

Tisseron, S. *Psychoanalyse de l'image, De l'imago aux images virtuelles* (Paris: Dunod, 1995).

Todd, William B., and Ann Bowden. *Tauchnitz International Editions in English 1841–1955* (New York: Bibliographic Society of America, 1988).

Tögel, Christfried. *Berggasse-Pompeji und Zurück: Sigmund Freuds Reisen in die Vergangenheit* (Tübingen: Diskord, 1989).

Tögel, Christfried, ed., with Michael Molnar. *Sigmund Freud: Unser Herz zeigt nach dem Süden, Reisebriefe 1895–1923* (Berlin: Aufbau Verlag, 2002).

Trincia, Francesco Saverio. *Freud e il Mosè di Michelangelo: tra Psicoanalisi e filosofia* (Rome: Donzelli, 2000).

Trosman, Harry. "Freud's Cultural Background," *Annual of Psychoanalysis* 1 (1973): 318–35

Turzio, Silvana. "Gli estremi della fotografia," in *Lombroso e la fotografia,* ed. Silvana Turzio et al. (Milan: Bruno Mondadori, 2005), 3–21.

Valéry, Paul. *Discours du Centenaire de la photographie* (Paris: Firmin-Didot, 1939). French text reprinted with Italian translation in Paul Valéry, *Discorso sulla fotografia* (Naples: Filema edizioni, 2005).

Vasari, Giorgio. *La Vita di Michelangelo,* ed. Paola Barocchi 5 vols. (Milan and Naples: Documenti di Filologia, 1962).

Vital, David. *A People Apart: The Jews in Europe, 1789–1939* (Oxford: Oxford University Press, 1999).

Webster, Richard. *Why Freud Was Wrong: Sin, Science, and Psychoanalysis* (New York: Harper-Collins/Basic Books, 1995).

Weichardt, Carl Friedrich Wlhelm. *Pompei: vor der Zerstörung: Reconstructionen der Tempel und ihrer Umgebung* (Leipzig: K. F. Koehler, 1898).*

Weigel, Sigrid. "Freuds Schriften zu Kunst und Literatur zwischen Rätsellösing, Deutung, und Lektüre: Die Studien zur *Gradiva* und zur Mosesstatue," in *Mimesis, Bild, und Schrift: Änlichkeit und Entstellung in Verhältnis der Künste,* Ed. Brigit Erdle und Sigrid Weigel (Cologne, Weimar, and Vienna: Böhau Verlag, 1996), 41–61.

Weinke, Wilfried. *Verdrängt, vertrieben, aber nicht vergessen. Die Photografen Emil Bieber, Max Halberstadt, Erich Kastan, Kurt Schallenberg* (Hamburg: Weingarten, 2003).

Wharton, Edith. "Roman Fever," in *Collected Short Stories, 1911–1937,* 2 vols. (New York: Library of America, 2001), vol. 2, 749–62.

White, Hayden. "Response: The Dark Side of Art History," *Art Bulletin* 89 (March 2007): 21–26.

Wilde, Johannes. *Michelangelo's "Victory"* (London, New York, and Toronto: Oxford University Press, 1954).

Wolf, Ernest S. "Saxa Loquuntur: Artistic Aspects of Freud's 'The aetiology of Hysteria," *Psychological Issues* IX, nos. 2–3 (1975): 208–28.

Wolf, Harald. "Archäologische Freundschaften Emanuel Löwys und Ludwig Pollaks Bedeutung für den Sammler Freud," in *"Meine…alten und dreckigen Götter" Aus Sigmund Freuds Sammlung,* ed. Lydia Marinelli (Vienna: Freud Museum, Stroemfeld Verlag, 1998a), 60–71.

——. "Emanuel Löwy, Leben und Werk eines vergessenen Pioniers," in *Emanuel Löwy: Ein Vergessener Pionier,* ed. Friedrich Brein (Vienna: Kataloge der Archäologischen Sammlung der Universität Wien, 1998b), 15–46.

——. "Sir Ernst Gombrich über seinen Lehrer Emanuel Löwy," in *Emanuel Löwy: Ein Vergessener Pionier,* ed. Friedrich Brein (Vienna: Kataloge der Archäologischen Sammlung der Universität Wien, 1998c), 65.

Yerushalmi, Yosef Hayim. *Freud's Moses: Judaism Terminable and Interminable* (New Haven: Yale University Press, 1991).

Yourcenar, Marguerite. "That Mighty Sculptor, Time," *New Criterion* (June 1990): 85–87.

Zweig, Stefan. *The World of Yesterday* (Lincoln and London: University of Nebraska Press, 1964).

Index

9 780801 448195